100 Years of
Fashion
Twentieth Century in Pictures

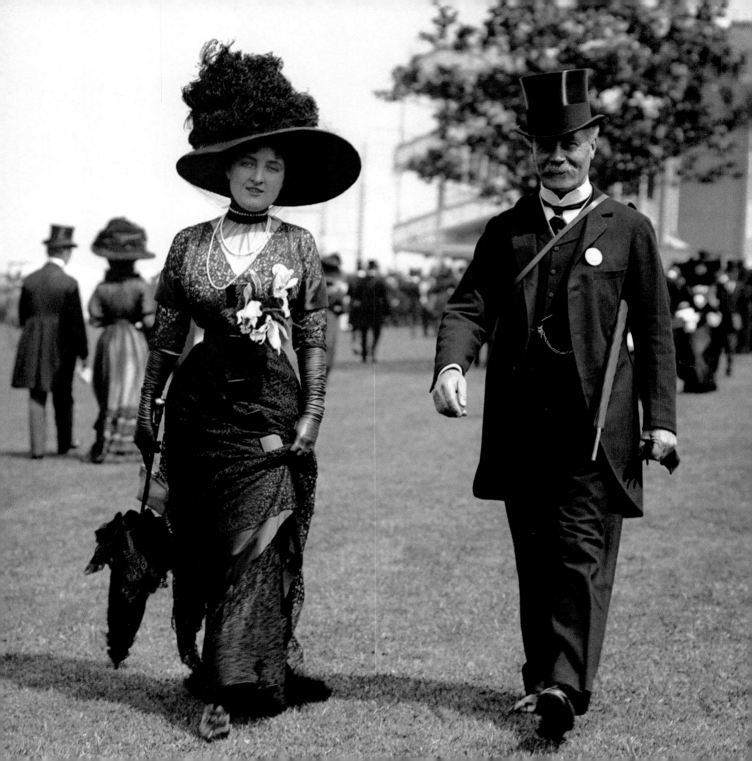

100 Years of
Fashion
Twentieth Century in Pictures

AMMONITE
PRESS

PRESS
ASSOCIATION
Images

First Published 2009 by
Ammonite Press
an imprint of AE Publications Ltd,
166 High Street, Lewes, East Sussex, BN7 1XU,
United Kingdom

Reprinted 2010

Text © AE Publications Ltd
Images © Press Association Images
Copyright © in the Work AE Publications Ltd

ISBN 978-1-906672-26-3

British Cataloguing in Publication Data. A catalogue
record of this book is available from the British Library.

Editor: Elizabeth Roberts
Series editor: Paul Richardson
Picture research: Press Association Images
Design: Gravemaker + Scott

Colour reproduction by GMC Reprographics
Printed and bound by Kyodo Nation Printing, Thailand

Page 2: Lady Newborough
and companion at Ascot.
June, 1910

Page 5: Supermodel Twiggy
wears hotpants at Bertram
Mills Circus.
January, 1967

Page 6: Models, including
supermodel Kate Moss
(2nd R) and Mick Jagger's
daughter, Jade (R), wait
behind the scenes of the
Matthew Williamson show at
London Fashion Week at the
Natural History Museum.
26th September, 1997

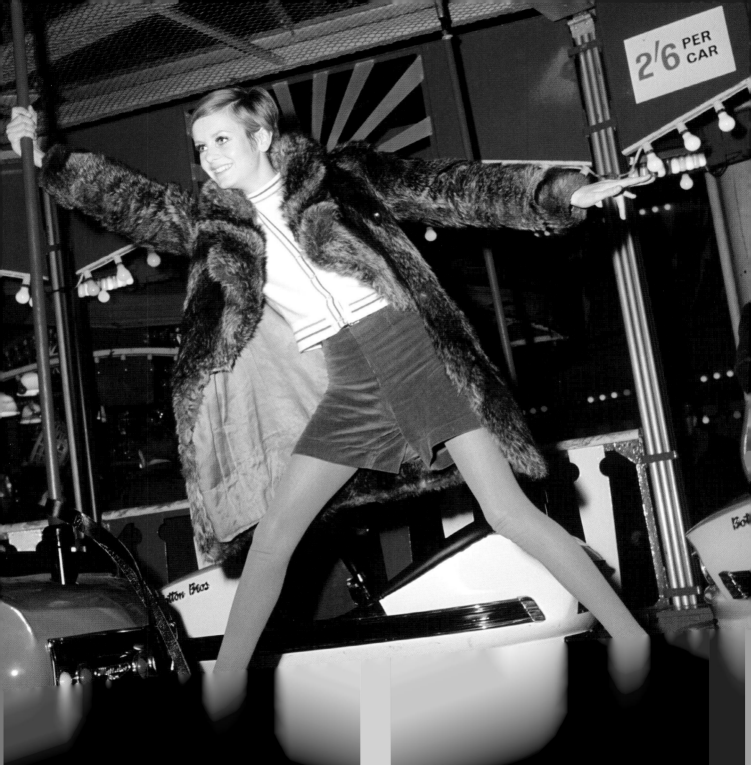

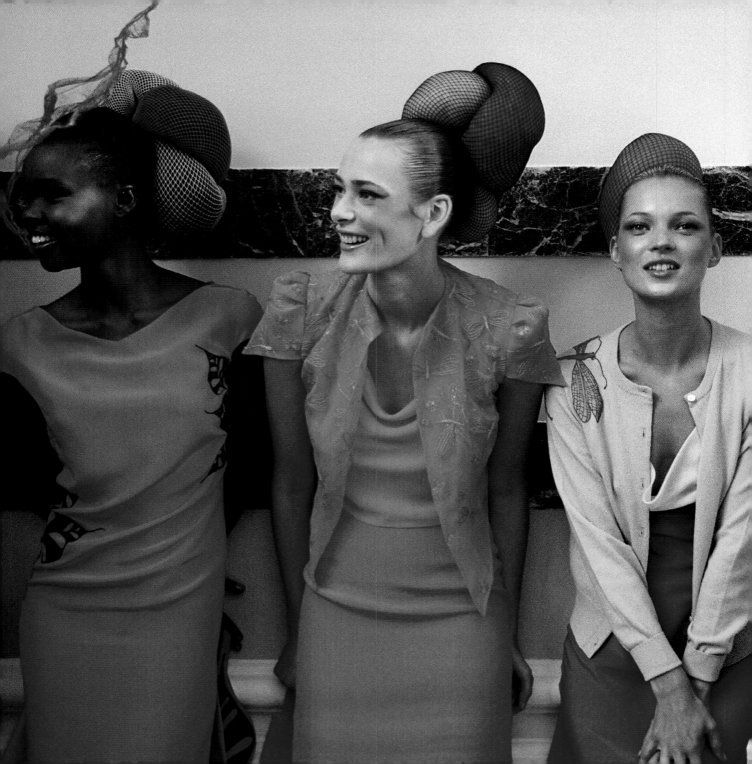

Introduction

Fashion is all about change – hemlines go up and down, waists are nipped in or disappear altogether, trousers are wide then narrow, collars large then small. But these changes take place almost without our noticing – until, that is, we look back at the clothes we wore 10, 20 or 50 years ago, and suddenly they seem so 'dated'. We regard them with derision and laughter, or we become nostalgic. We can identify a piece of clothing as having belonged to a particular decade, just by looking at it. But, unless we have vast wardrobes and never throw anything away, the best way to discover fashions of the past is to look at photographs. We might even want to go beyond the span of our own lifetime and discover how our parents and grandparents dressed.

The Press Association's archive is a quite astonishing source of fashion history for, quite apart from the deliberate images of fashion taken by the press photographers of the day, there are millions of pictures of people who, for whatever reason, were deemed newsworthy – and they all wore clothes. One can discover, by looking at pictures of the Suffragettes on a march through London, or Twiggy in a mini-skirt, how history developed and changed the way we thought, and dressed. From the sobriety of the Suffragettes to the radical designs of Vivienne Westwood was a giant step. And the Press Association captured all of these changes on film in a way that is quite unprecedented.

As the century wore on, photography more self-consciously charted history. Different things became newsworthy – and fashion itself took on a more prominent role. From the rock and pop idols of the 1960s to the designer labels of the 1990s, we became interested in fashion in a way that other centuries had not seen. With greater affluence and a culture that revered youth, we had more time and leisure to think about our clothes, and more money to spend on them.

The 20th century was a time of extreme change: politically, technologically and culturally, and all these things have influenced the fashions that have come and gone over the past 100 years. To have a record of these changes, in the form of the photographs reproduced here, allows us to trace our heritage, rediscovering our past selves and those of our forebears. It is our history, spelt out through fashion.

Ada Reeve, an English
actress of stage and film.
1903

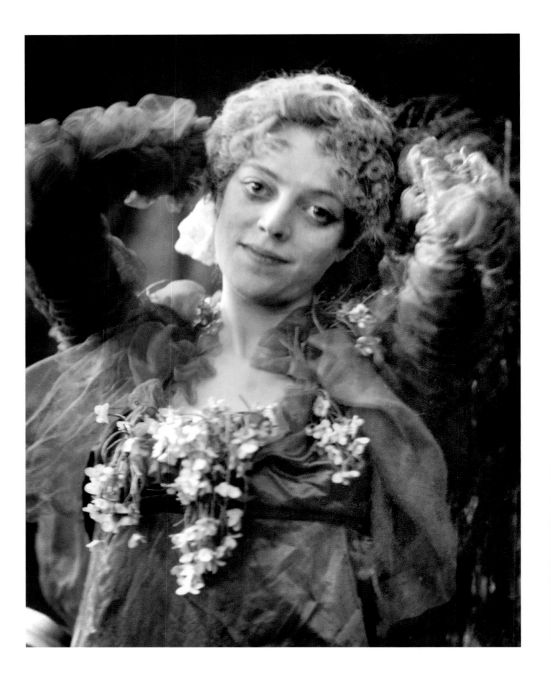

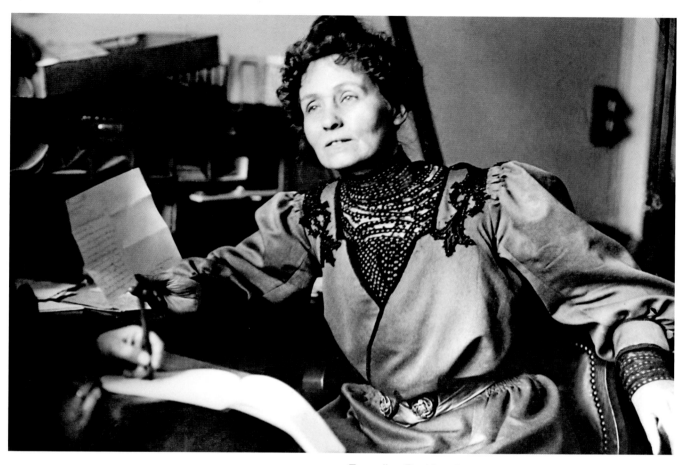

Emmeline Pankhurst,
founder of the Women's
Social and Political Union,
and a leading light in the
Suffragette movement.
March, 1903

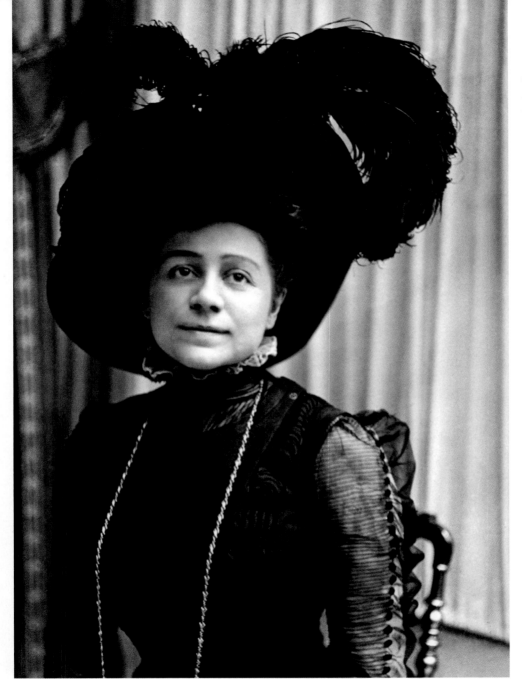

Facing page: A young woman, who was a member of 'The Butterflies' acrobat troupe, sits by a window sewing.
1906

The actress Lydia Yavorska, who became Princess Bariatinsky.
1904

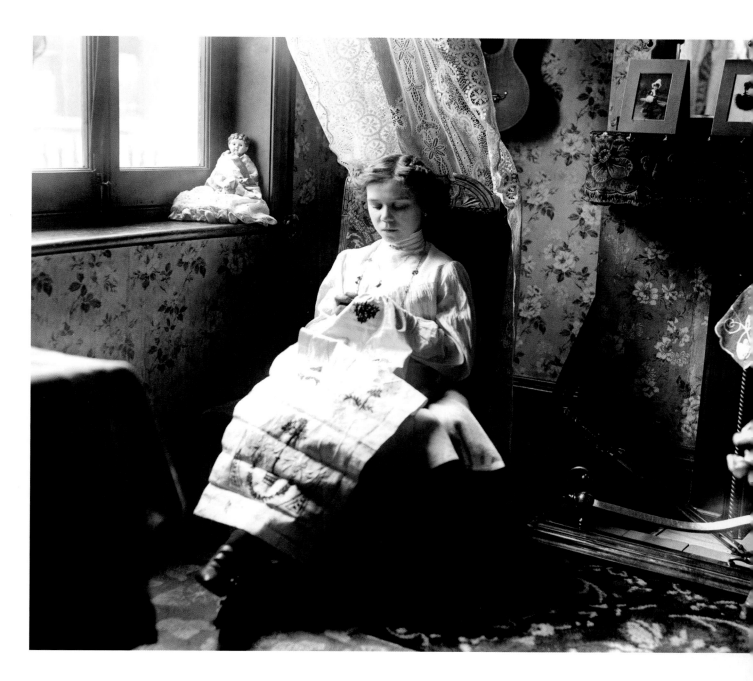

Angela Burdett-Coutts,
1st Baroness Burdett-Coutts,
one of the wealthiest women
in England in the latter
part of the 19th century and
a close friend of Charles
Dickens. She was active in
prison reform.
1906

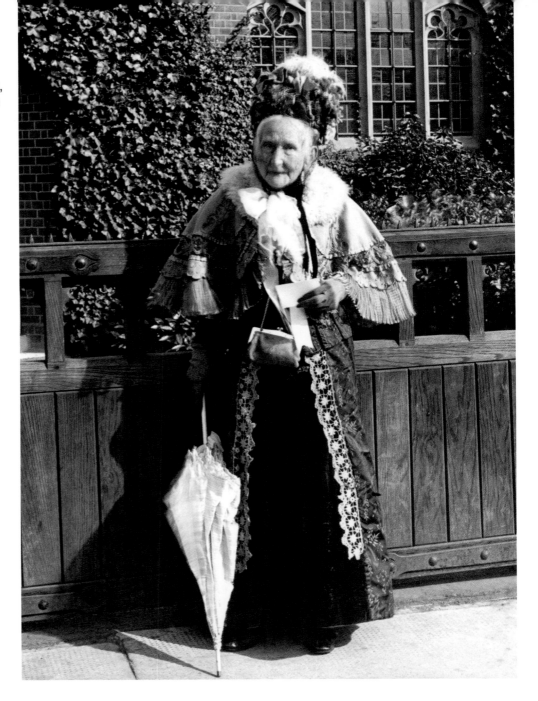

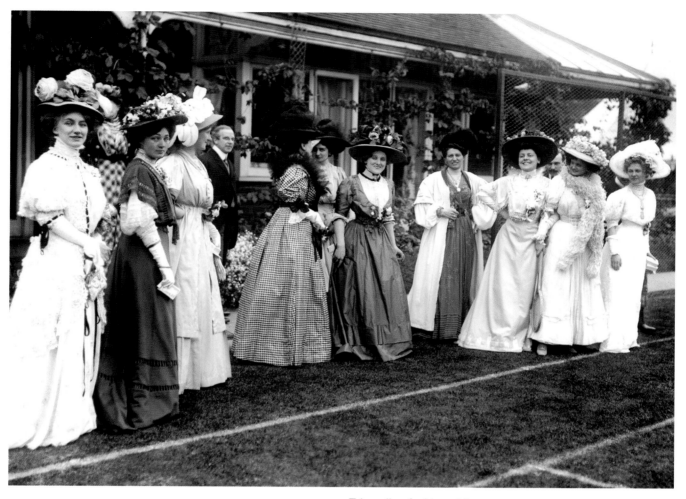

Edwardian fashion at its
most elegant, worn by
guests during a tennis party
at stage celebrity Edna
May's wedding.
August, 1906

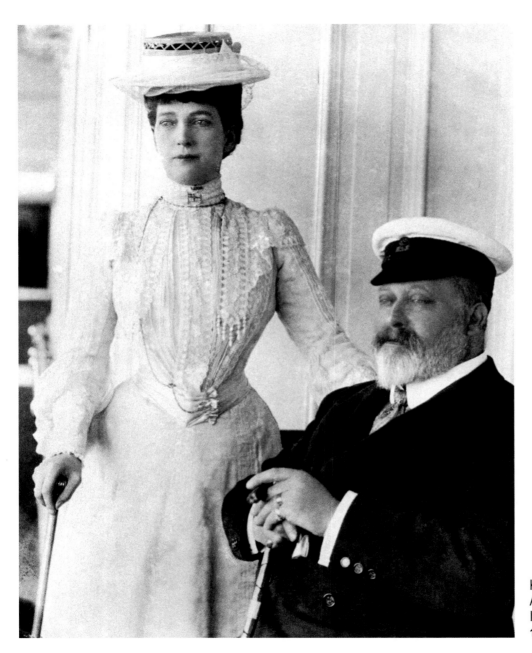

King Edward VII and Queen Alexandra at Cowes in the Isle of Wight.
1907

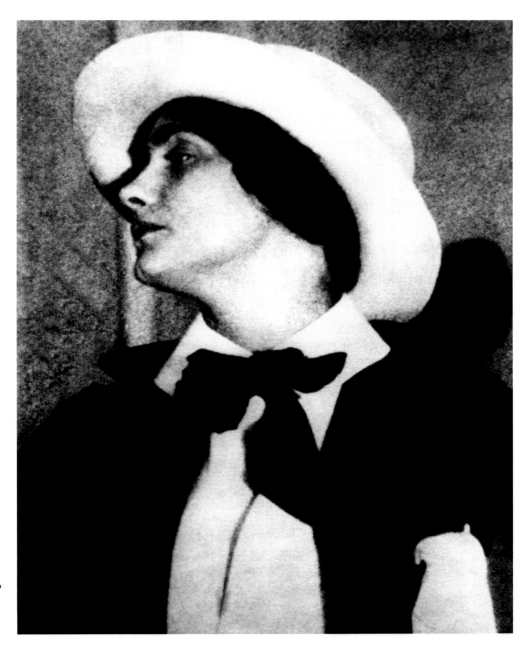

The French fashion designer, Gabrielle Bonheur Coco Chanel.
1907

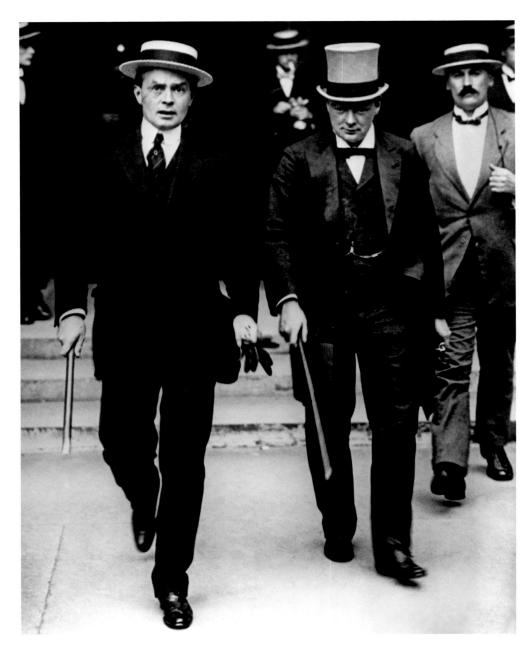

Winston Churchill (R),
who was then President
of the Board of Trade.
1908

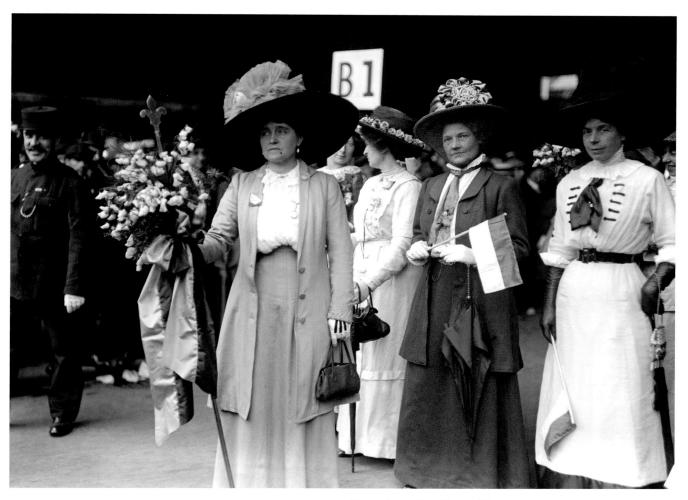

The actress Eva Moore (L)
joins a Suffragette march.
1908

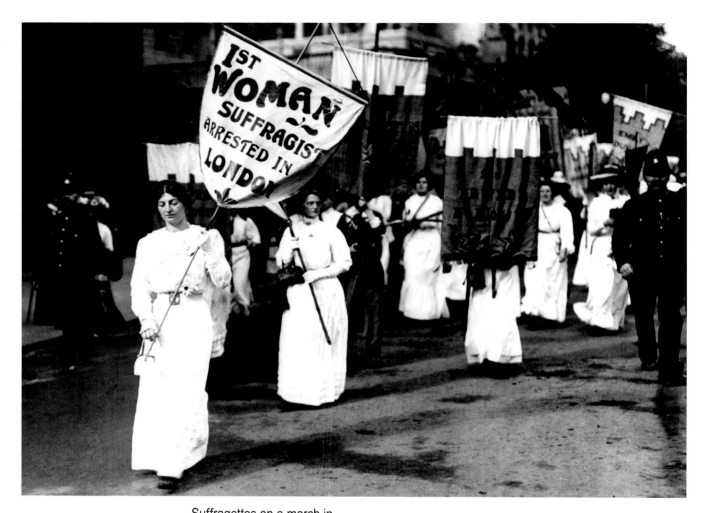

Suffragettes on a march in
London protesting against
the first arrest of one of their
members.
1908

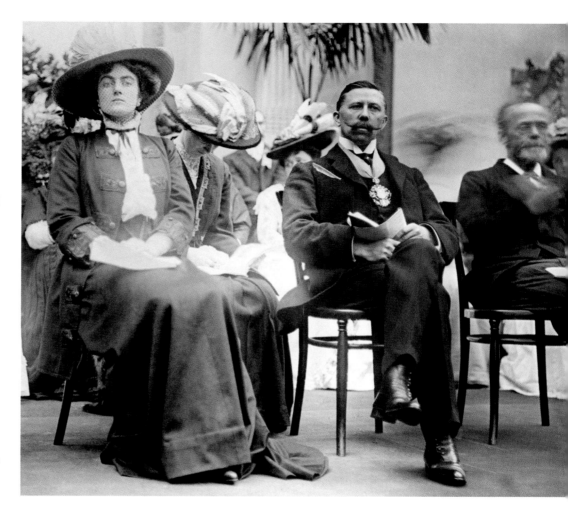

Clementine, wife of
Winston Churchill, and
Lord Cheyllsmore, Mayor of
Westminster, at a bazaar at
the Royal Horticultural Halls
in Westminster.
1909

A Directoire dress.
The Directoire style was fashionable in the late 1700s and drew from the neo-classical with high waists and draped skirts. The look became popular again when the actress Sarah Bernhardt wore it in a play called *Tosca* in the late 1800s, and Paris fashion designers were quick to take up the idea and design dresses based loosely upon it.
1910

An early photograph of Queen Alexandra with her dogs, taken on the Royal Yacht during a visit to Cowes.
1910

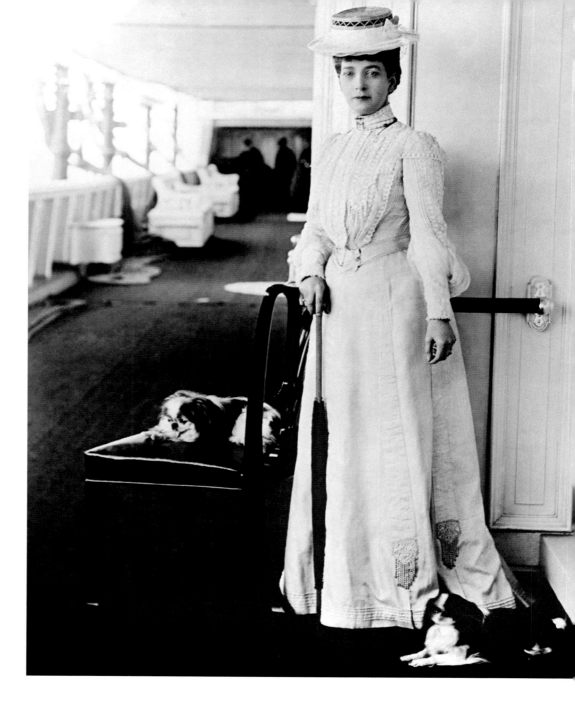

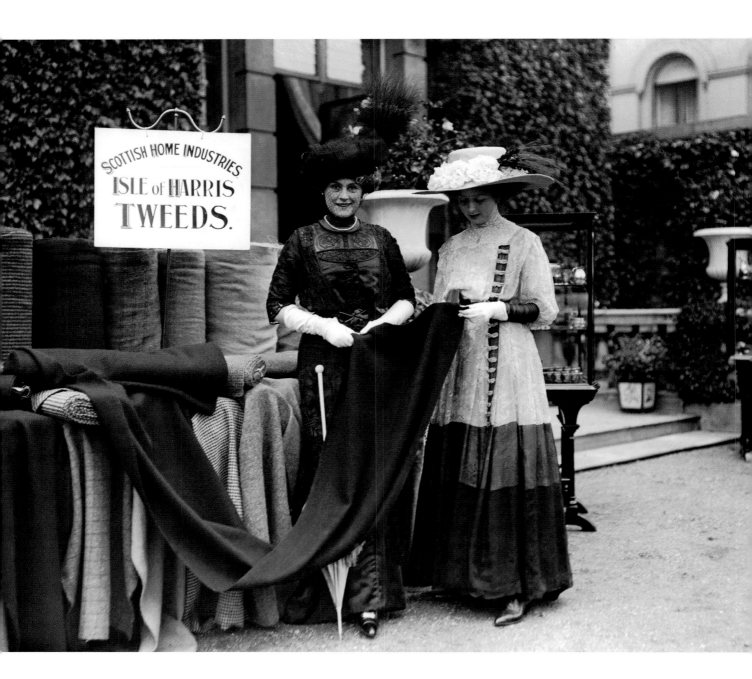

Facing page: The Duchess of Sutherland (L) and Lady Rosabelle Erskine at the Duchess's garden party.
1910

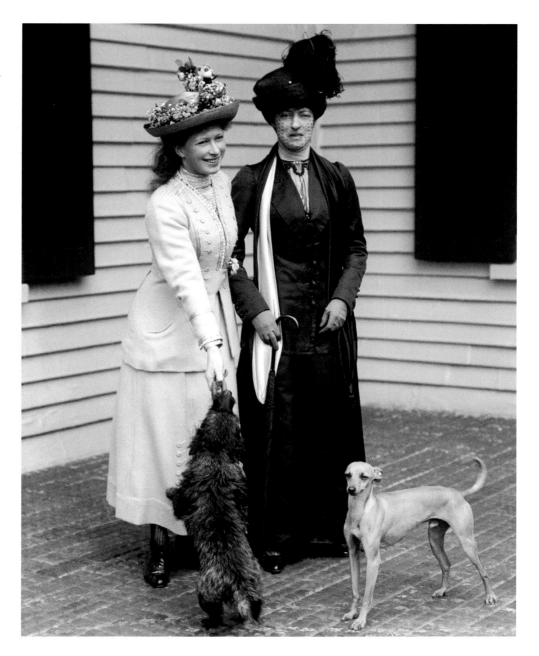

Princess Victoria of Prussia and Princess Mary, with their dogs, outside the Royal Pavilion in Aldershot, Hampshire.
1911

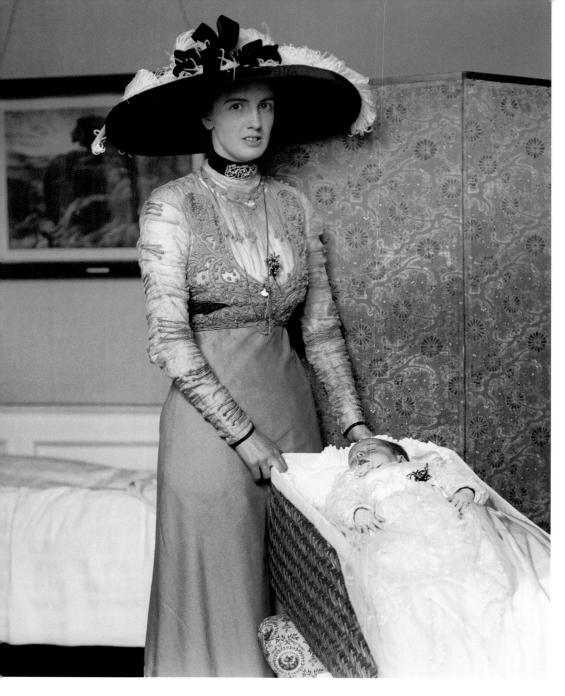

Lady Brooke at the christening of her child.
1911

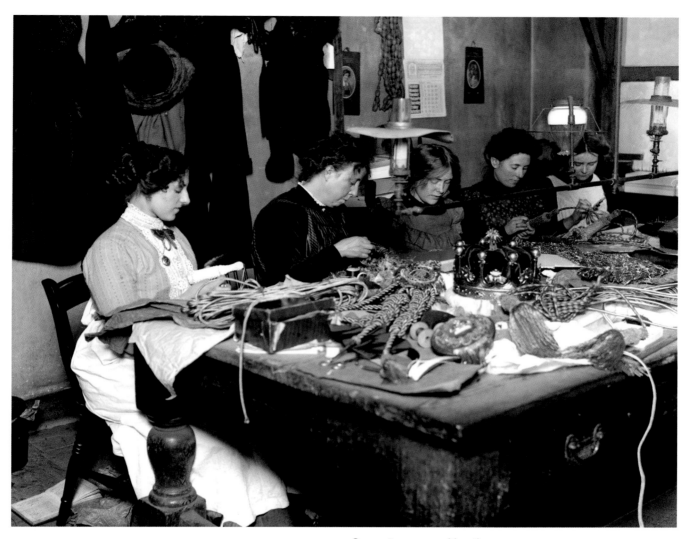

Seamstresses making the
robes for the Coronation of
George V.
1911

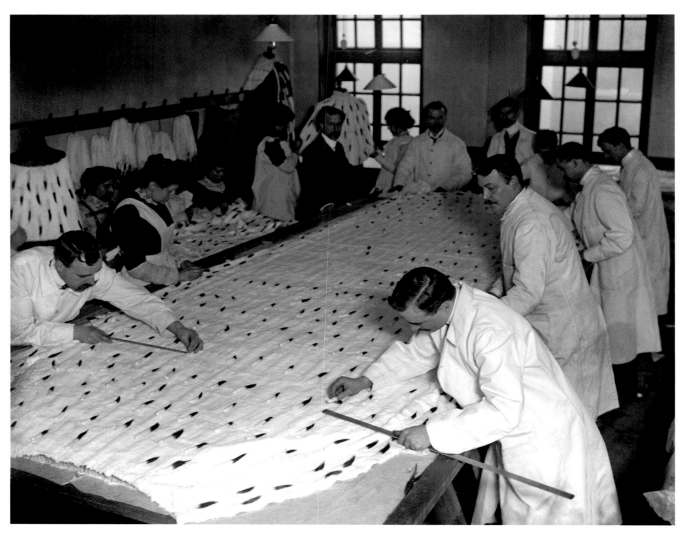

The making of the King's
Coronation train, in which
ermine was used.
1911

Actress Eva Moore (L)
in a Suffragette march.
1911

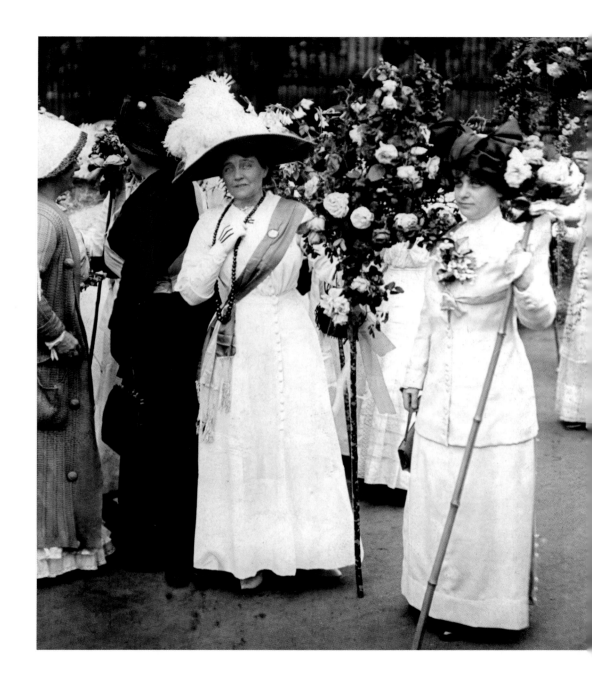

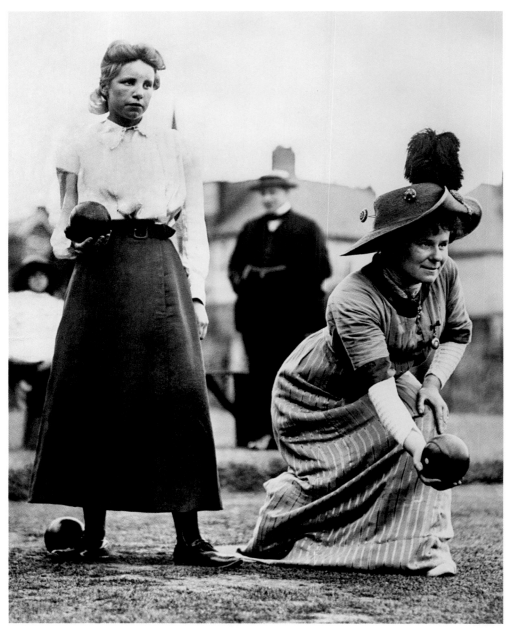

Facing page: Guests at a garden party.
August, 1911

Women playing bowls.
1911

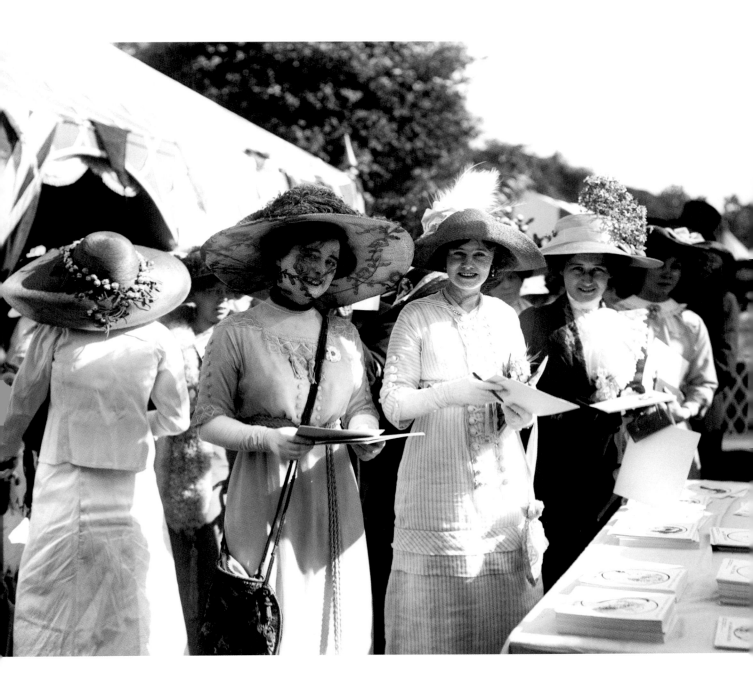

Queen Mary in her
Coronation robes. These
were to be worn at the
Delhi Durbar in India
when she was crowned
Empress of India.
December, 1911

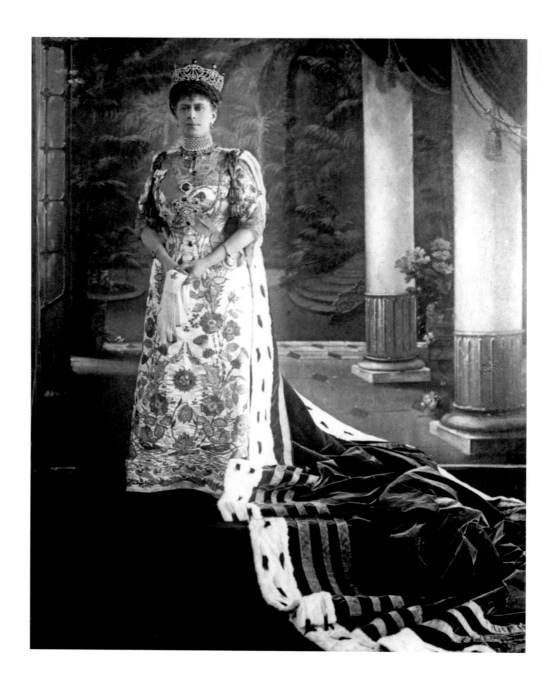

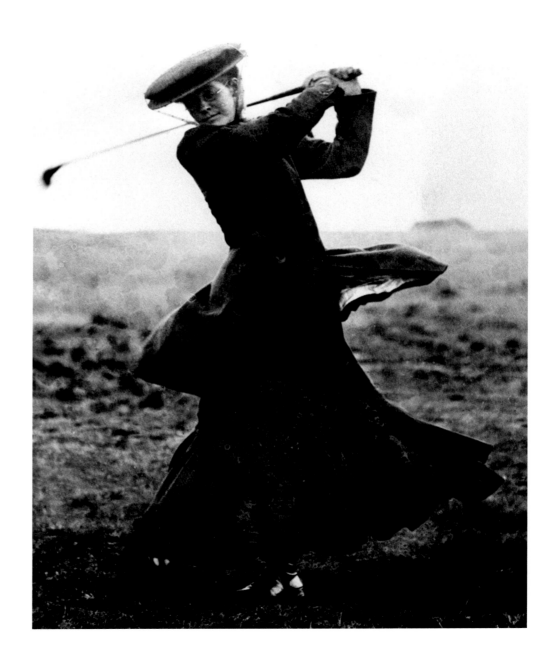

Mrs Wilcock, playing an
energetic game of golf.
1912

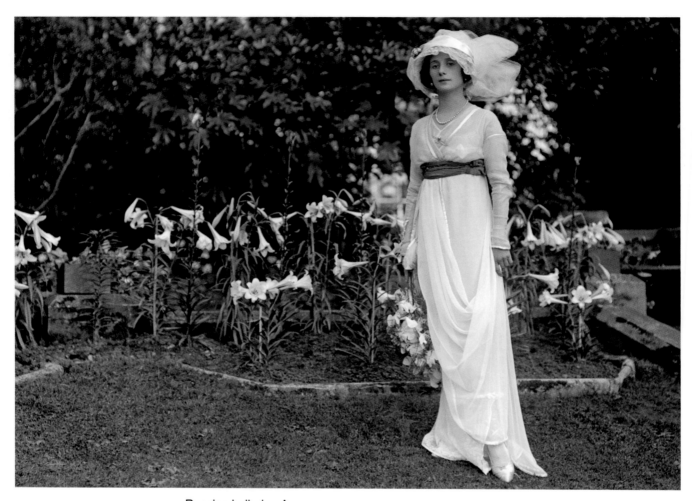

Russian ballerina Anna
Pavlova, who is regarded
as one of the most famous
classical ballet dancers in
history. Here she is wearing
a Directoire style dress.
June, 1912

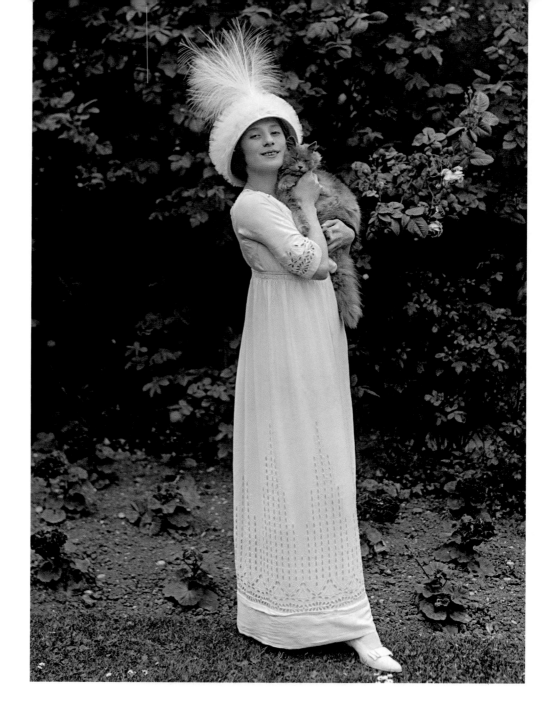

Pavlova and her cat
in the garden.
June, 1912

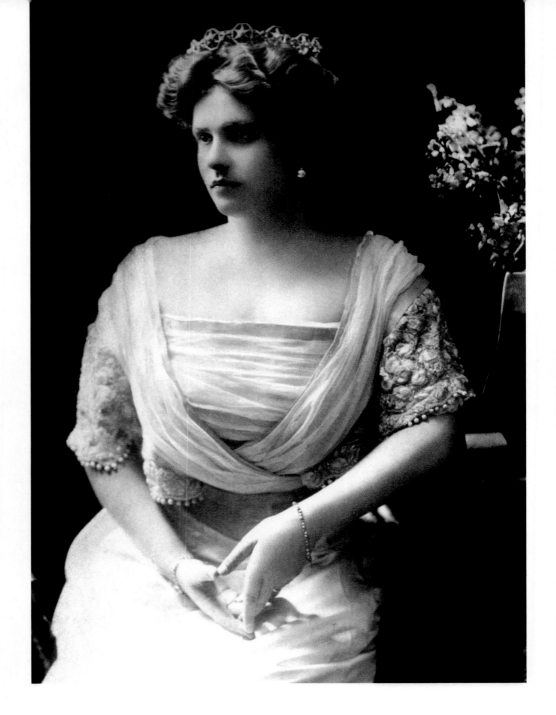

Princess Alice of Greece,
wife of Prince Andrew
and mother of the Duke
of Edinburgh.
1913

Tango dancers, *Petit* and *Petite* at the London Opera House.
1913

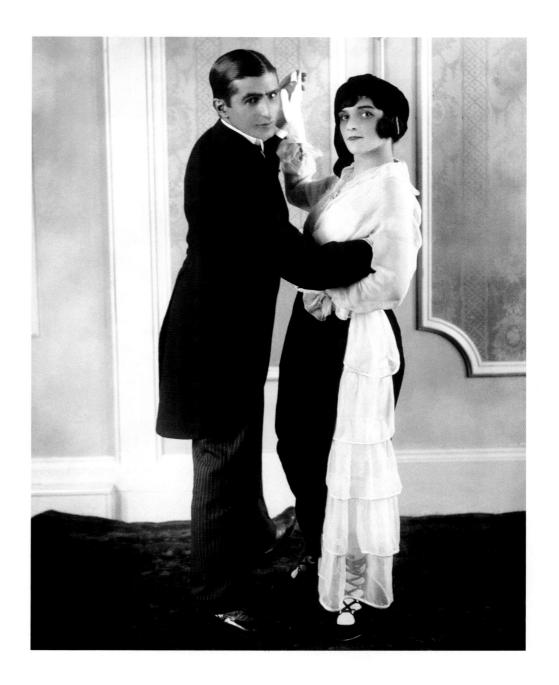

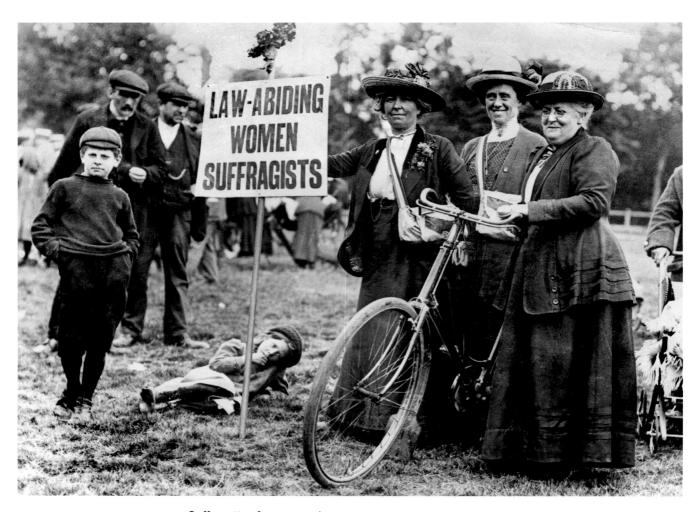

Suffragettes from around
the country cycled to
London for a meeting of
the Suffragette movement.
1913

Princess Victoria
Louise of Prussia,
Duchess of Brunswick.
1914

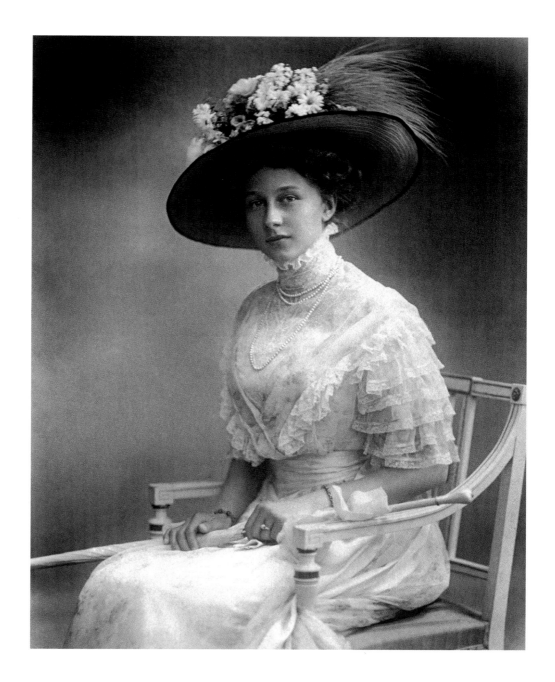

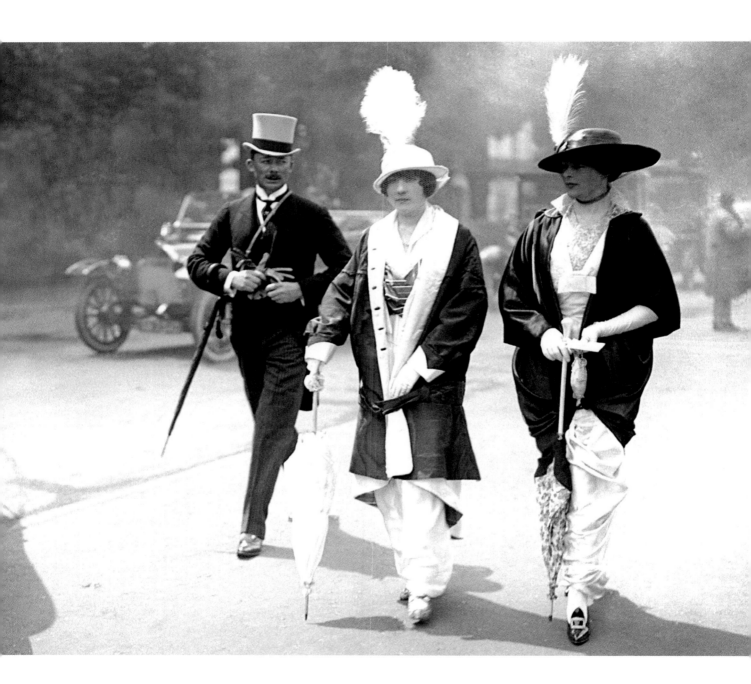

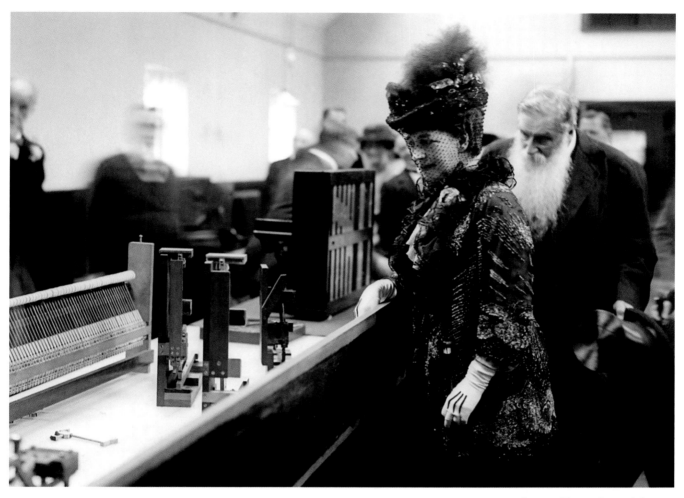

Queen Alexandra watches
blind workers making piano
parts. Sir Dighton Probyn
stands behind her.
1915

Facing page: The Honorable
Mrs Dillon (R) and
companions at Ascot races.
20th June, 1914

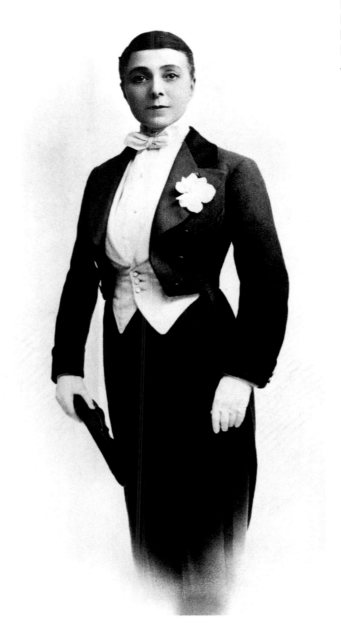

Facing page: Lady Baden Powell inspects a guard of honour of Girl Guides at Battersea Park.
June, 1916

Vesta Tilly, a male impersonator and leading music hall star of her day.
1915

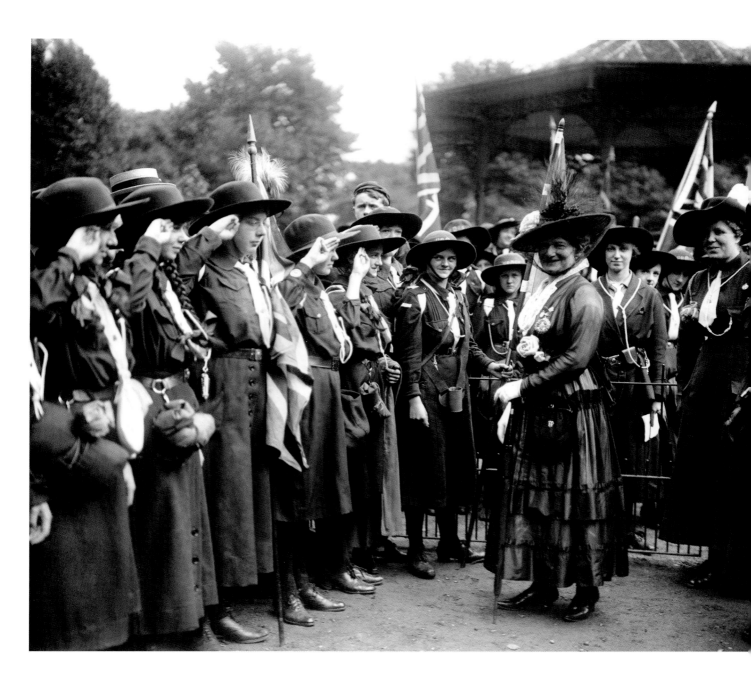

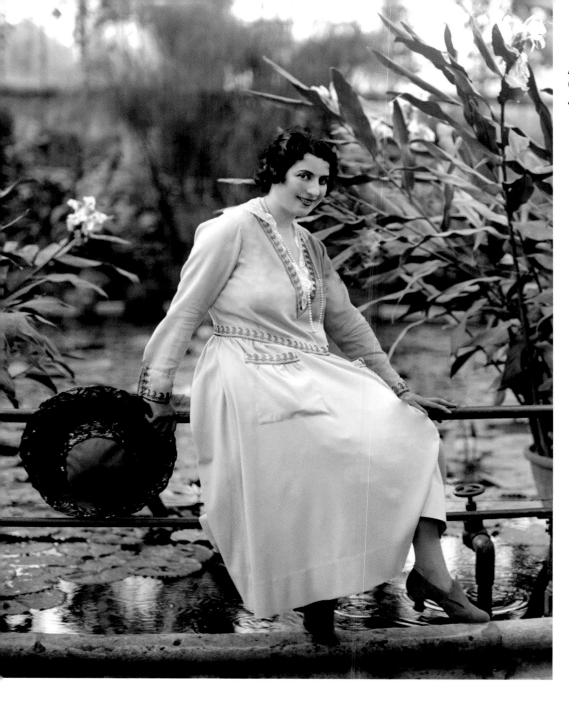

Actress and singer José
Collins in Kew Gardens.
June, 1917

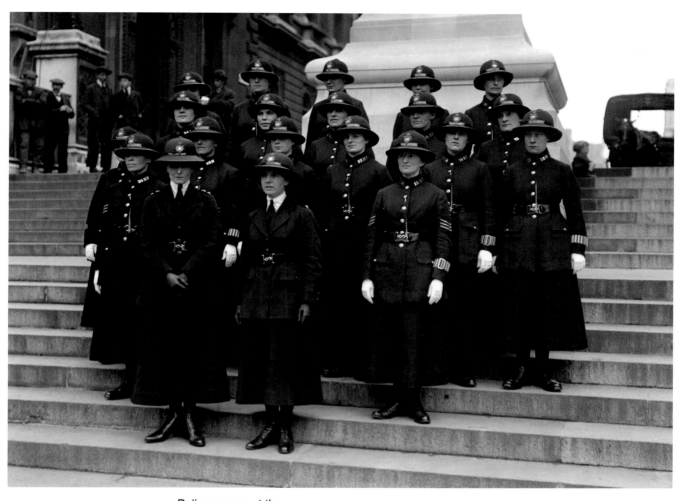

Policewomen at the
Duke of York steps at
Buckingham Palace.
25th July, 1919

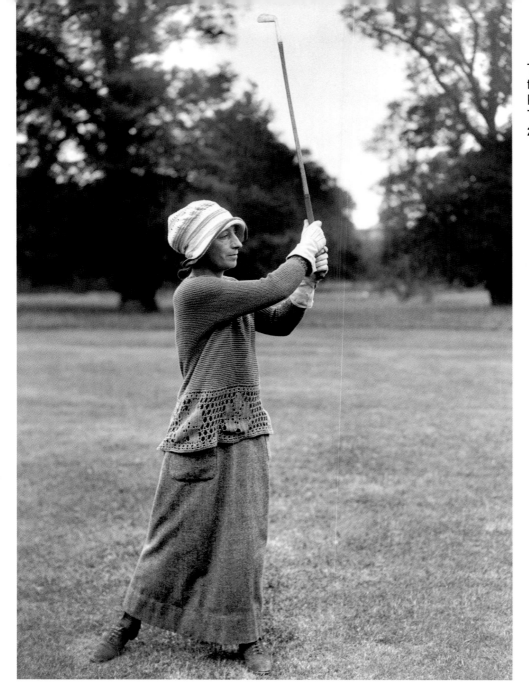

The Countess of Wilton taking part in the Ladies' Parliamentary Golf Tournament at Edgware.
25th June, 1920

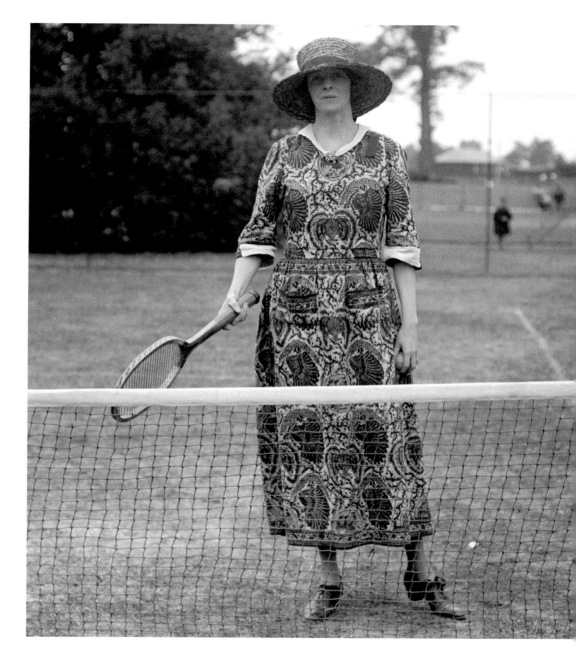

Actress Viola Tree takes time out for a game of tennis at the Stage Cricket Test Match at Langley, Buckinghamshire.
20th June, 1921

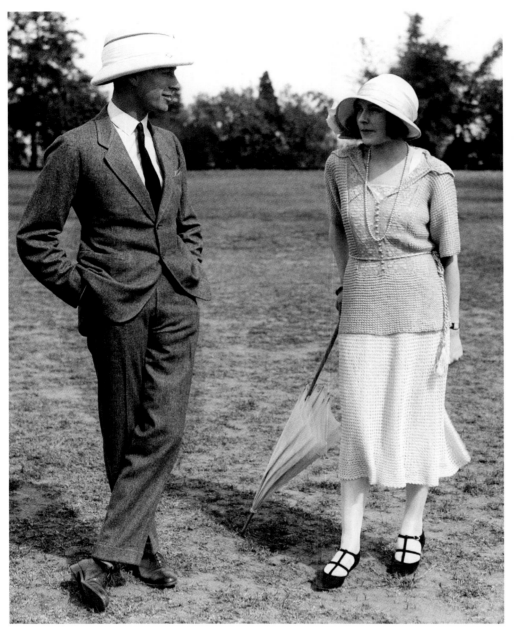

Facing page: Lady Diana Duff Cooper and her husband, Alfred Duff Cooper the British diplomat, arriving at a charity showing of the silent film *When Knighthood was in Flower* at the Scala Theatre in London.
2nd October, 1922

Lord Louis Mountbatten and Edwina Ashley, later Lady Mountbatten, in India during the visit of the Prince of Wales.
10th February, 1922

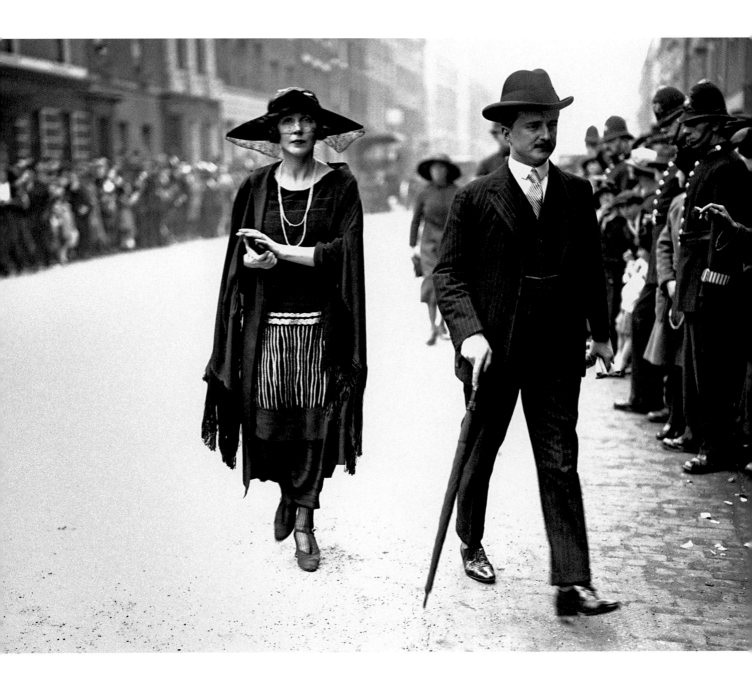

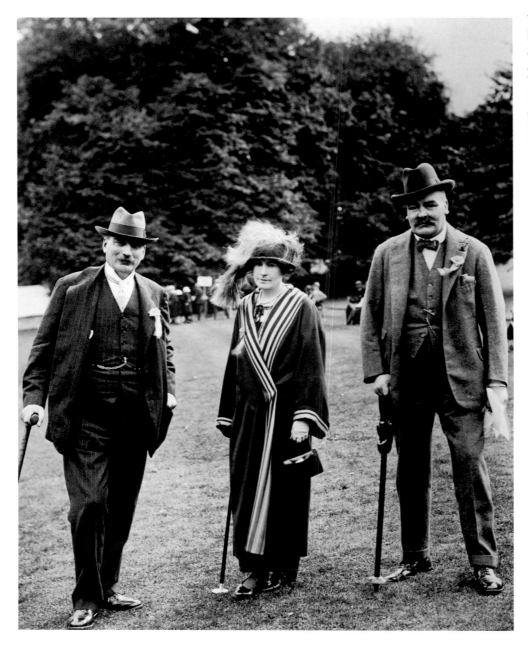

The Duke of Buccleuch (L), Lady Buchanan-Jardine and Sir Robert Buchanan-Jardine at the Scottish YMCA National Services Fund Garden Fete in the grounds of Castle Milk, Lockerbie.
1st June, 1923

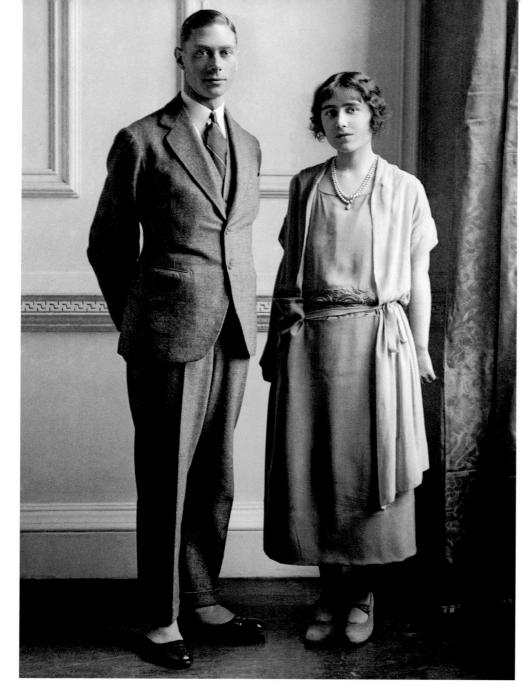

The Duke of York (later King George VI) with Lady Elizabeth Bowes-Lyon (later Queen Elizabeth, the Queen Mother), posing for their official engagement photograph.
18th January, 1923

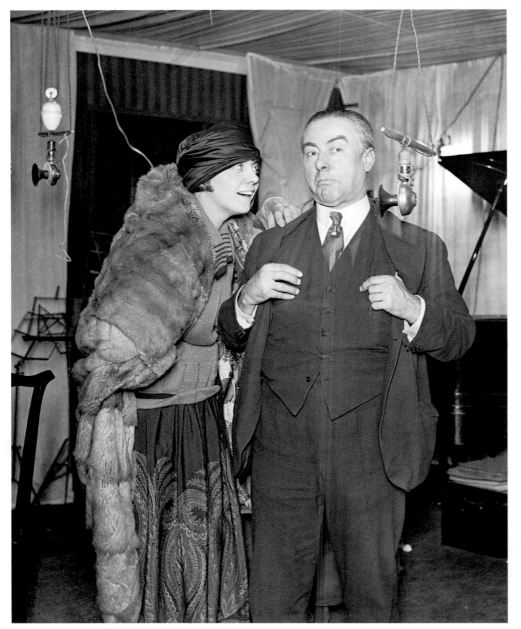

Facing page: Lady Elizabeth Bowes-Lyon leaving her Bruton Street home in London, before her wedding to the Duke of York at Westminster Abbey.
26th April, 1923

British music hall stars George Robey and Alma Adair at a radio rehearsal of the Covent Garden Review, *You'd be Surprised*.
18th January, 1923

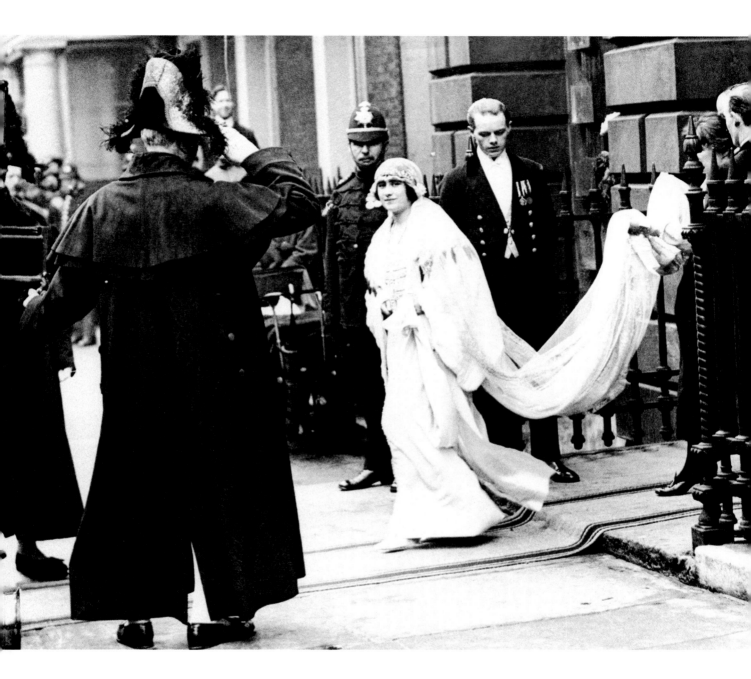

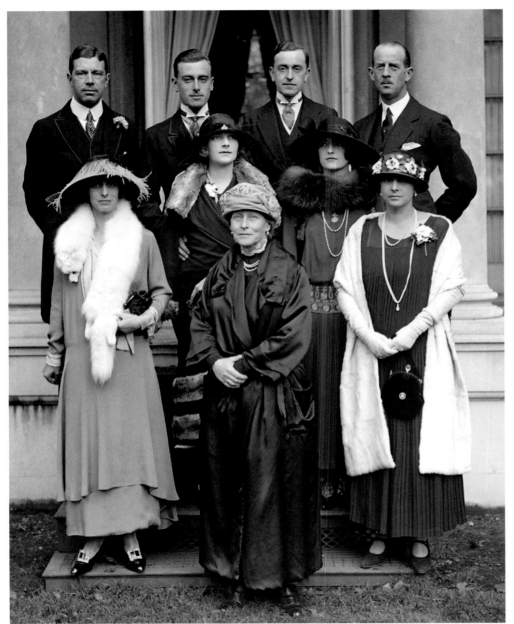

Facing page: Yelverton, a dog that collected £300 for charity, is presented to Queen Alexandra by Tessie Warren at Marlborough House.
13th June, 1923

Guests at the wedding of Lady Elizabeth Bowes-Lyon and the Duke of York. Front row: (L-R) Lady Louise Mountbatten, the Marchioness of Milford Haven and Princess Andrew of Greece. Middle row: unknown. Back row: (L-R) the Crown Prince of Sweden, Lord Louis Mountbatten, the Marquess of Milford Haven and Prince Andrew of Greece.
26th April, 1923

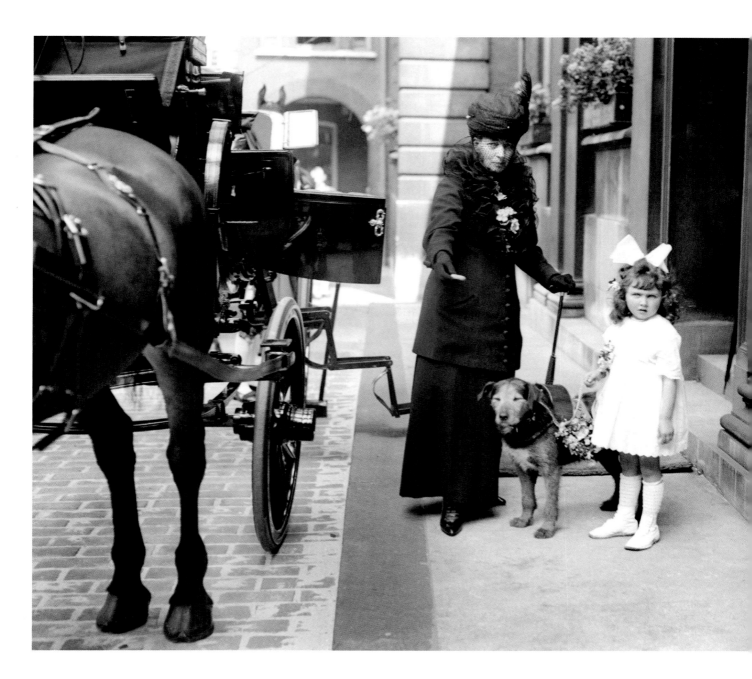

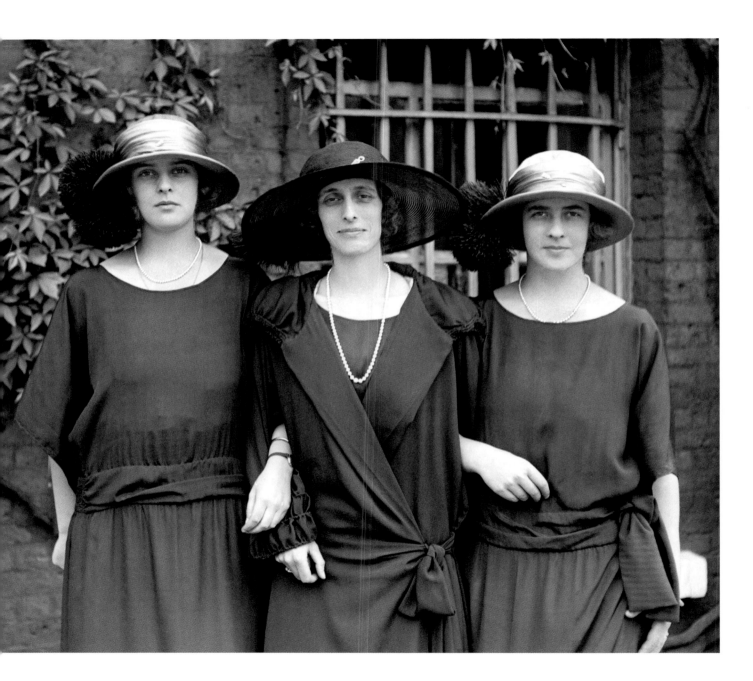

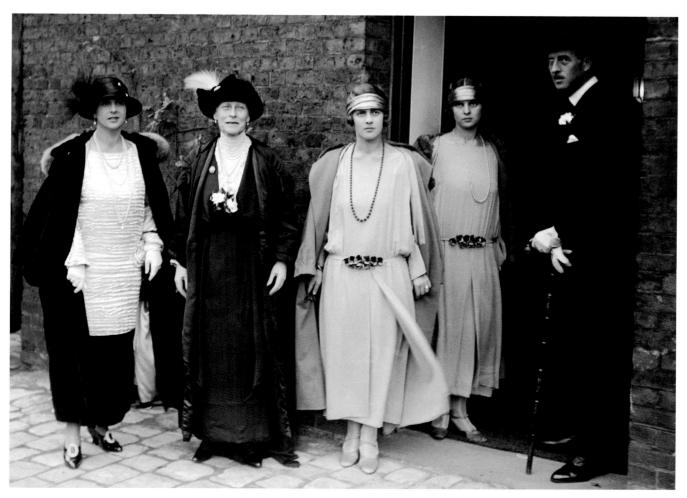

Facing page: Lady Louise Mountbatten (C) with Princess Theodora of Greece (L) and Princess Margarita of Greece (R), daughters of Prince Andrew of Greece and Denmark.
1st July, 1923

The Dowager Marchioness of Milford Haven (2nd L) at the wedding of Lady Louise Mountbatten and the Crown Prince of Sweden at the Chapel Royal, St. James' Palace. She is accompanied by two of the bridesmaids - Princess Margaret of Greece and Princess Theodora of Greece - and the Prince (R) and Princess (L) Andrew of Greece.
3rd November, 1923

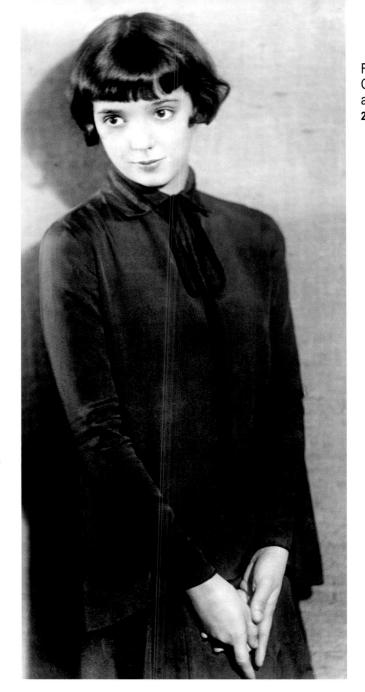

Facing page: Austen Chamberlain and his wife attending a wedding.
2nd June, 1924

Actress and singer Jessie Matthews, later dubbed *The Diva of Debauchery* by the popular press. Later still she played Mrs Dale in the BBC radio drama *Mrs Dale's Diary*.
1924

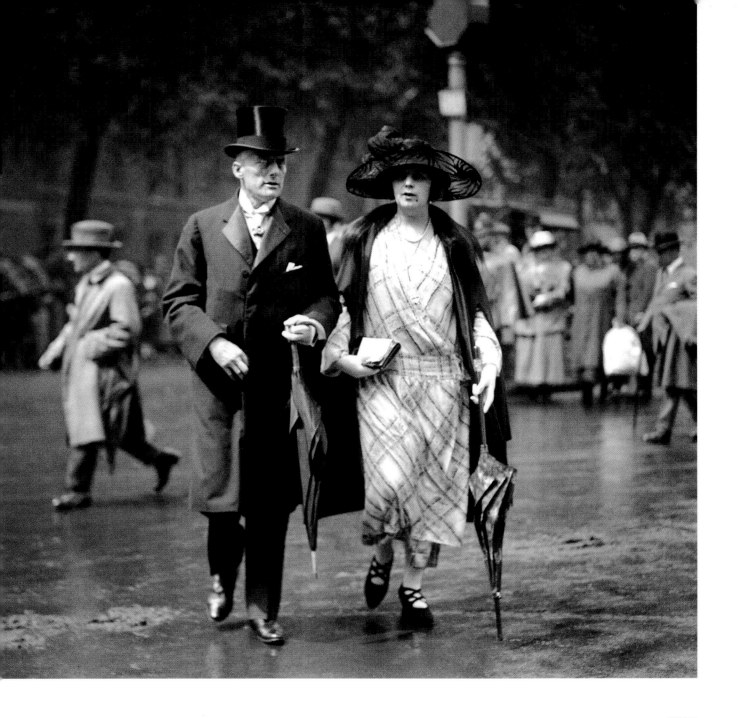

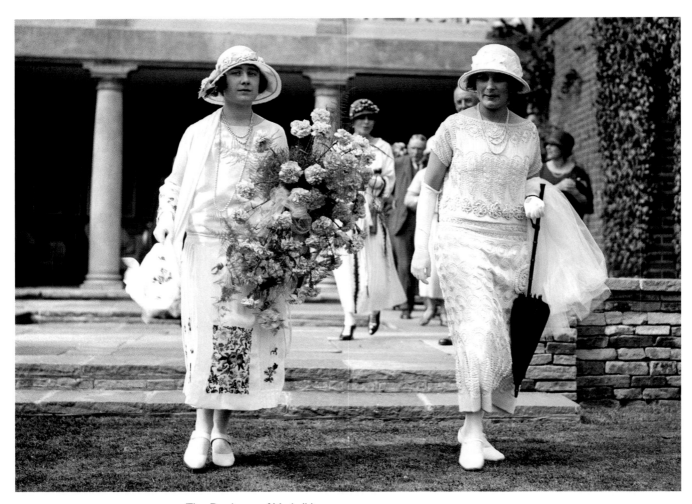

The Duchess of York (L)
visits the Molesey and
Hampton Court branch of the
Lest We Forget Association,
an organisation for disabled
ex-servicemen and women.
1924

Queen Mary in the rock
garden at Balmoral.
18th September, 1924

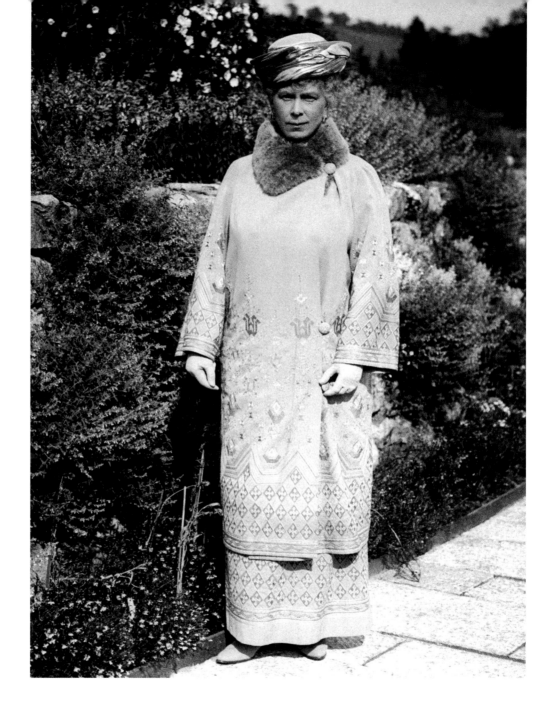

Rosie Dolly (L) looks through what appears to be a mirror at her twin sister, Jenny Dolly. The Dolly Sisters, as they were known, were well known stars of music hall and film.
16th December, 1924

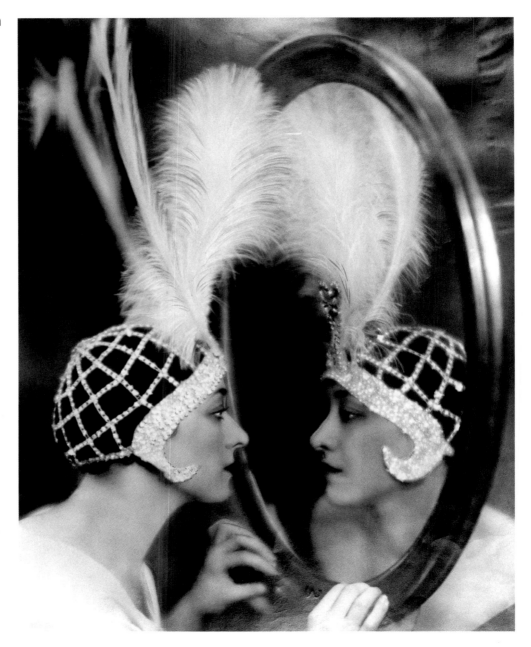

American actor John
Barrymore and British stage
star Fay Compton at the
Haymarket stage door in
London, where they were
playing in a production of
Hamlet.
12th February, 1925

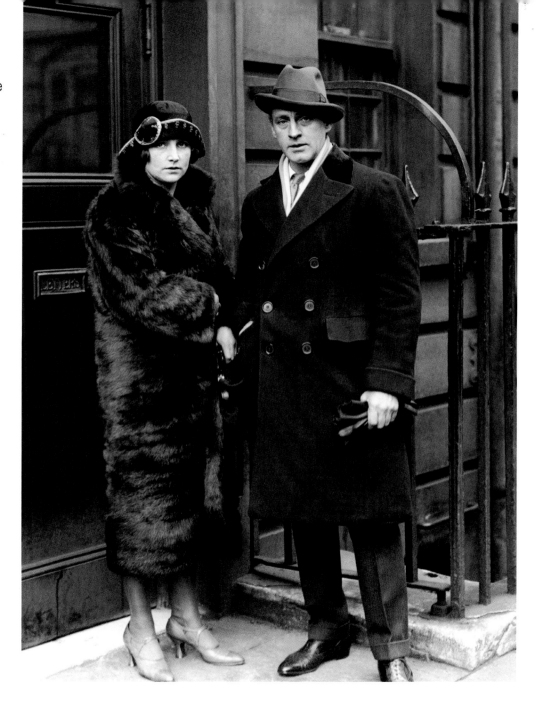

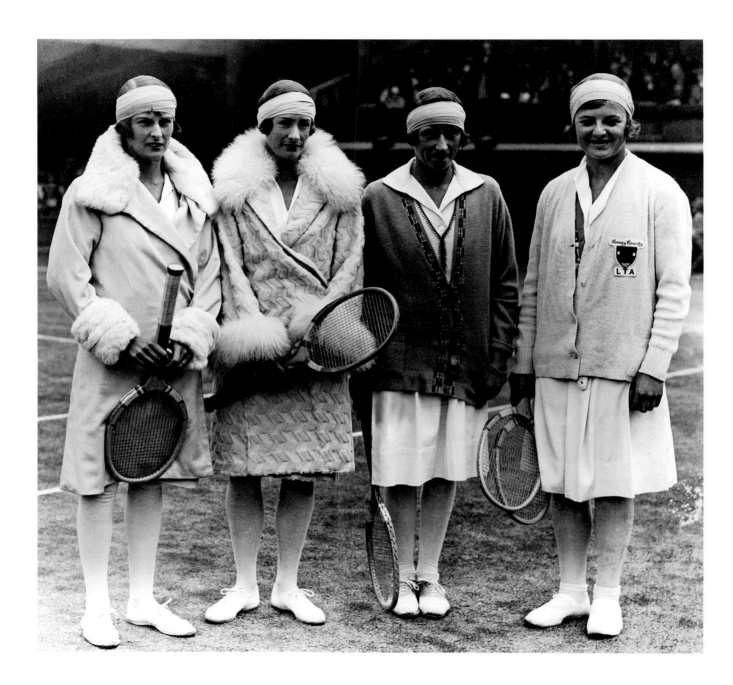

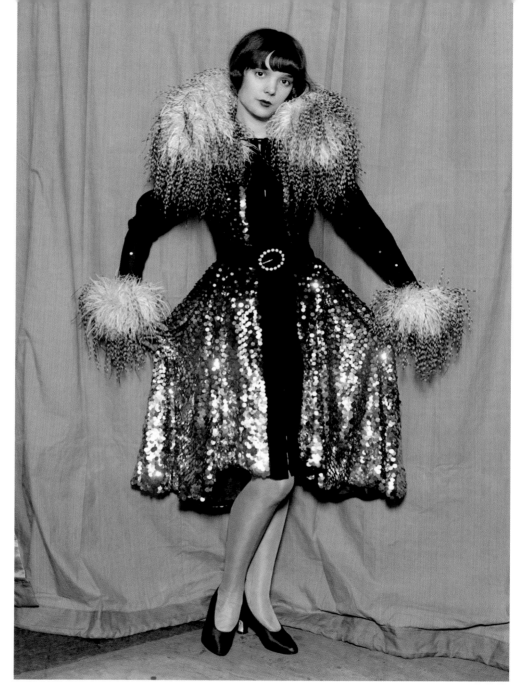

Facing page: Tennis players
(L-R) Joan Lycett, E Colyer,
Kathleen 'Kitty' Godfree and
Betty Nuthall.
25th June, 1927

British stage and screen star,
Jessie Matthews.
24th March, 1928

Facing page: Two debutantes leave the American Women's Club for a presentation party at Buckingham Palace, London. To the left is a disabled ex-serviceman with his tray, a familiar sight in the aftermath of the Great War.
9th May, 1929

Golfing champion, Joyce Wethered, who is regarded as the greatest British female player of all time.
10th March, 1929

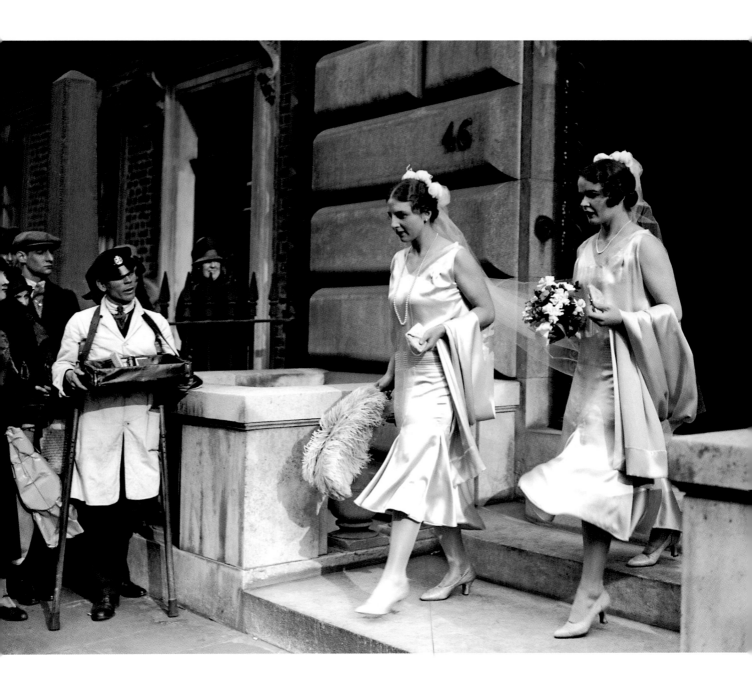

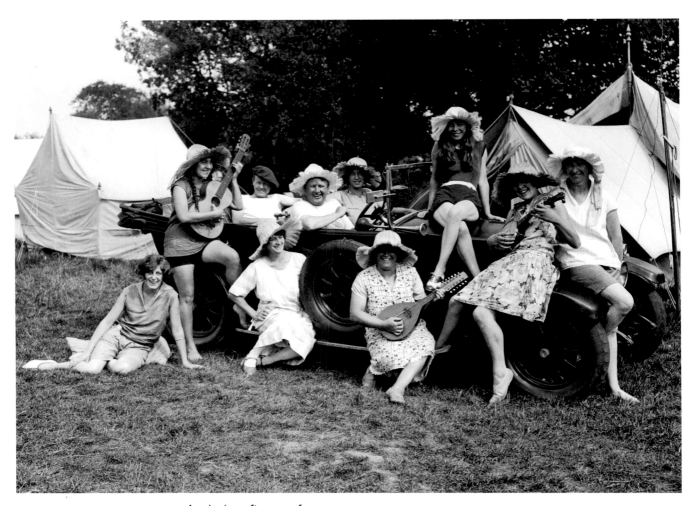

A relaxing afternoon for a
group of women at a Walton
on Thames holiday camp.
25th May, 1929

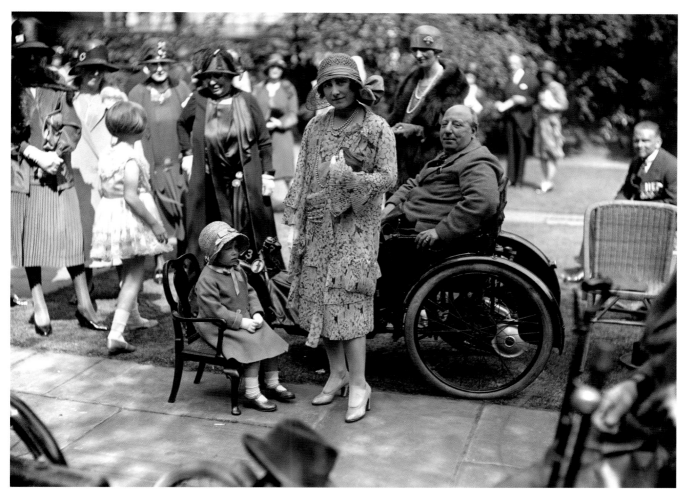

The Duchess of York
with her eldest daughter,
Elizabeth, at an exhibition
of disabled soldiers'
embroideries at Lowndes
Square, London.
12th June, 1929

Eve Tynegate Smith, well known dancing teacher to royalty, and her dancing partner.
5th August, 1929

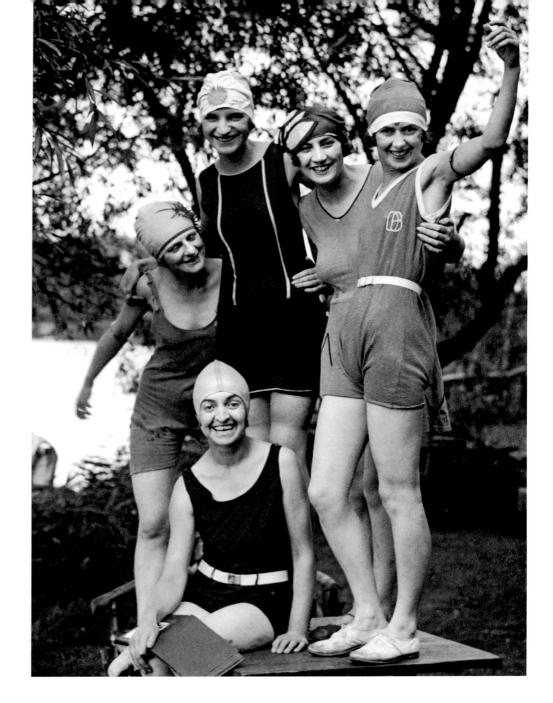

Young women in bathing suits enjoying the atmosphere of Dobb Weir Carnival in Hertfordshire.
6th August, 1929

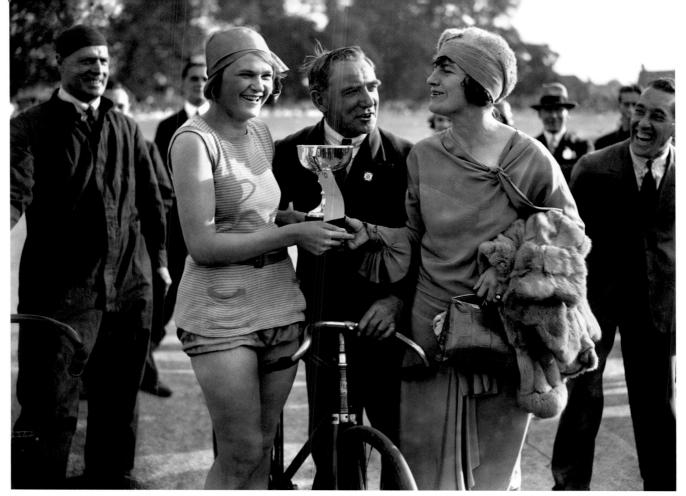

British actress and singer Gracie Fields presents a cup to the winner of the Cycle Championship for Young Ladies of *The Show's the Thing*, a West End production that ran at the Victoria Palace Theatre.
28th September, 1929

Facing page: A man wearing Oxford bags, so called because they were favoured by male students at Oxford University.
1930

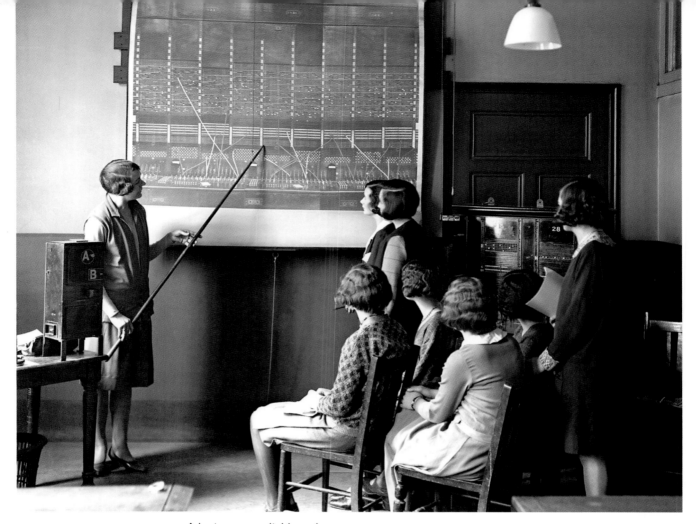

A lecture on switchboard
telephones at the Telephone
Training School.
June, 1930

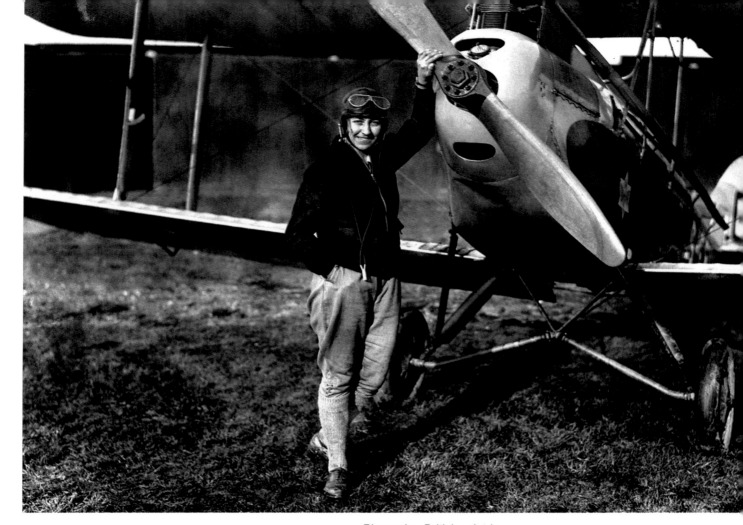

Pioneering British aviatrix
Amy Johnson at the London
Aeroplane Club. She set
numerous long-distance
records during the 1930s
and flew in the Second
World War as part of the Air
Transport Auxiliary. She died
during a ferry flight in 1941.
10th June, 1930

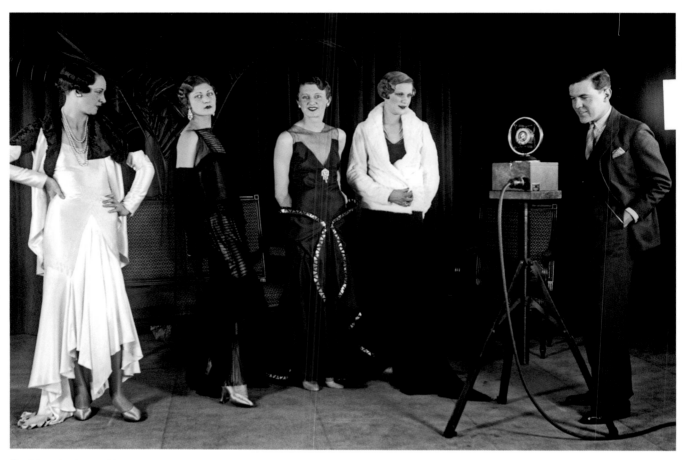

Fashion designer, Norman
Hartnell, being filmed for
Movitone News, with models
wearing the designs he was
to take to the Paris catwalks.
28th June, 1930

Facing page: Factory girls
in their overalls, with their
foreman – some of the girls
are wearing industrial clogs.
July, 1930

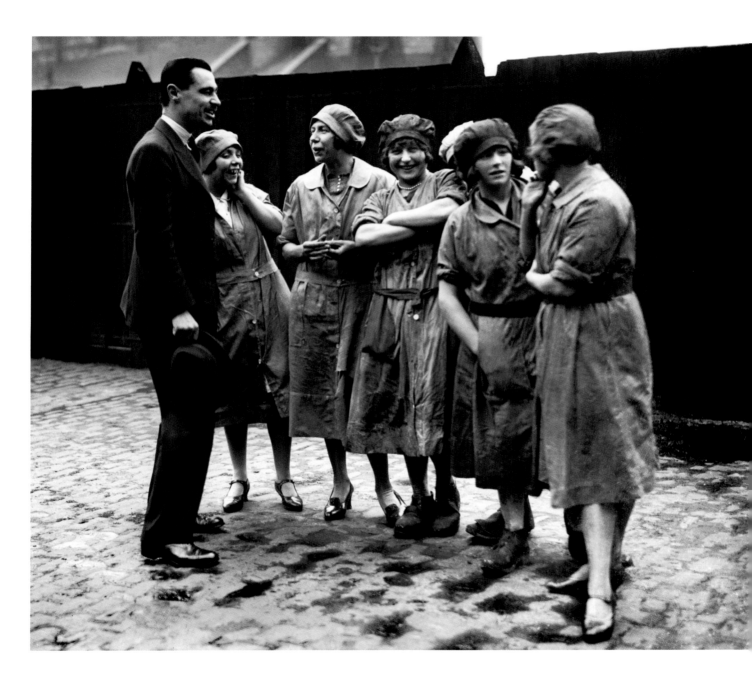

Facing page: A chance to dress up on the first day of Royal Ascot.
16th June, 1931

English novelist and biographer, Nancy Mitford.
1931

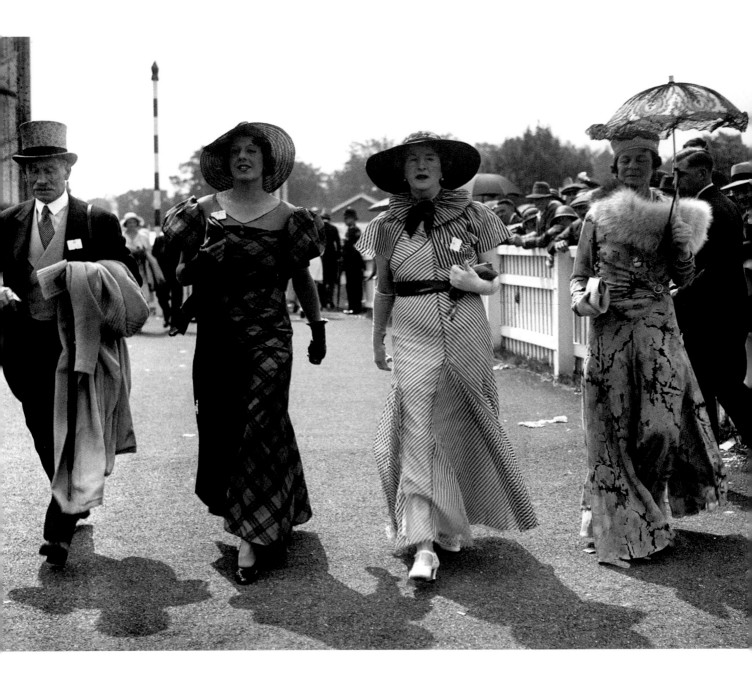

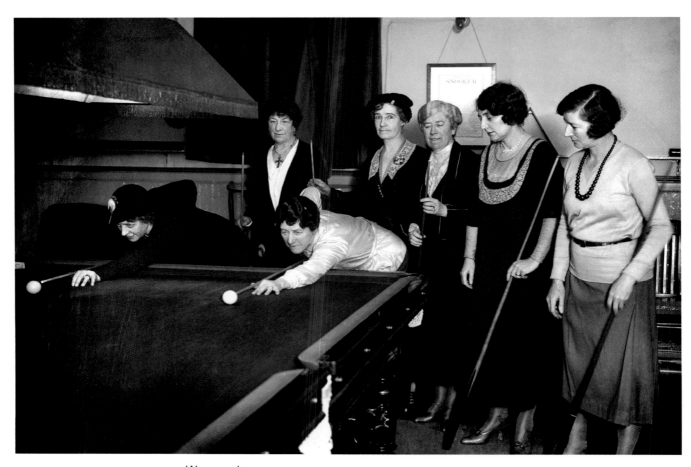

Women play a game
of billiards.
7th March, 1932

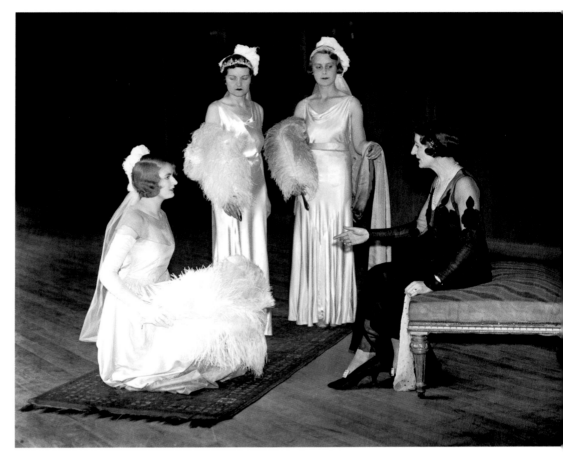

Debutantes being coached by Josephine Bradley, a dance and deportment teacher, for forthcoming presentations at Buckingham Palace. Of great importance is the correct use of the fan.
28th April, 1932

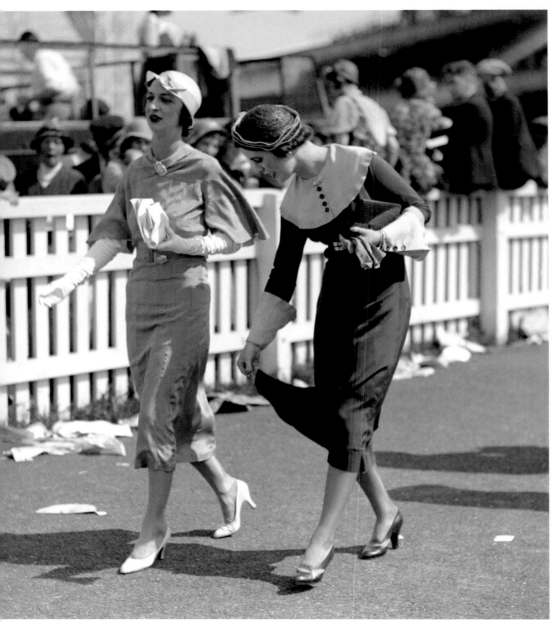

Facing page: Guests arrive at the Royal Garden Party at Buckingham Palace.
21st July, 1932

Margaret Whigham and her companion attend Ladies' Day at Ascot.
14th June, 1932

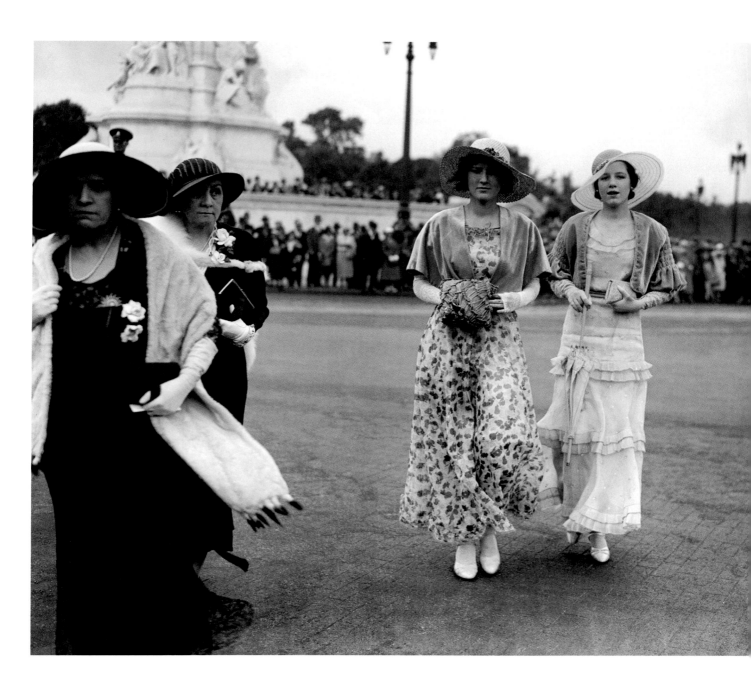

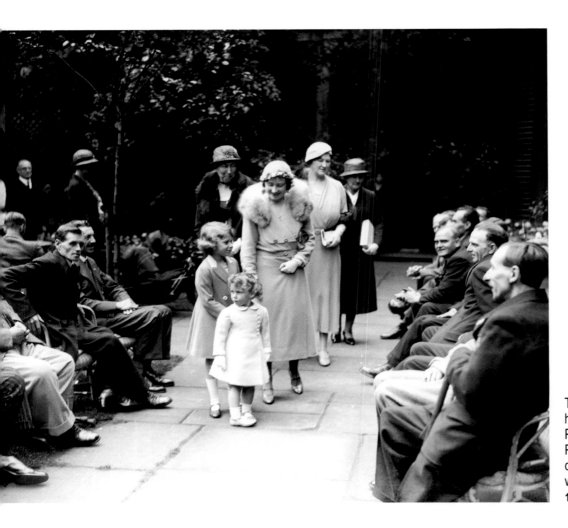

The Duchess of York with her two small daughters, Princess Elizabeth (L) and Princess Margaret, at a disabled ex-soldiers' sale of work.
16th May, 1933

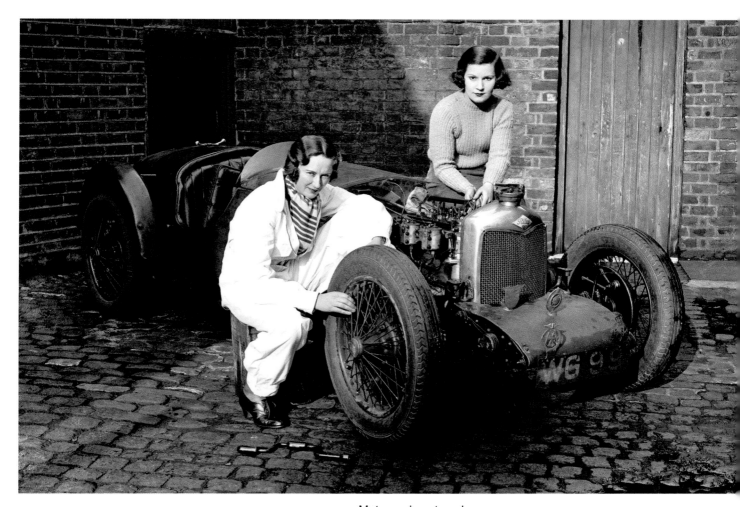

Motor racing stars Joan
Richmond (L) and Kay Petre (R).
15th June, 1933

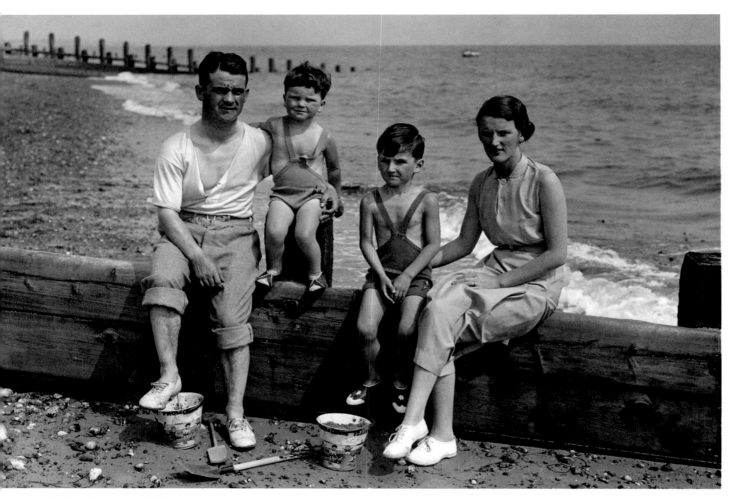

Champion British jockey
Gordon Richards relaxing
with his wife and two sons at
Shoreham-by-Sea.
24th July, 1933

Facing page: A modern
bathroom at the Ideal Home
Exhibition.
1st June, 1934

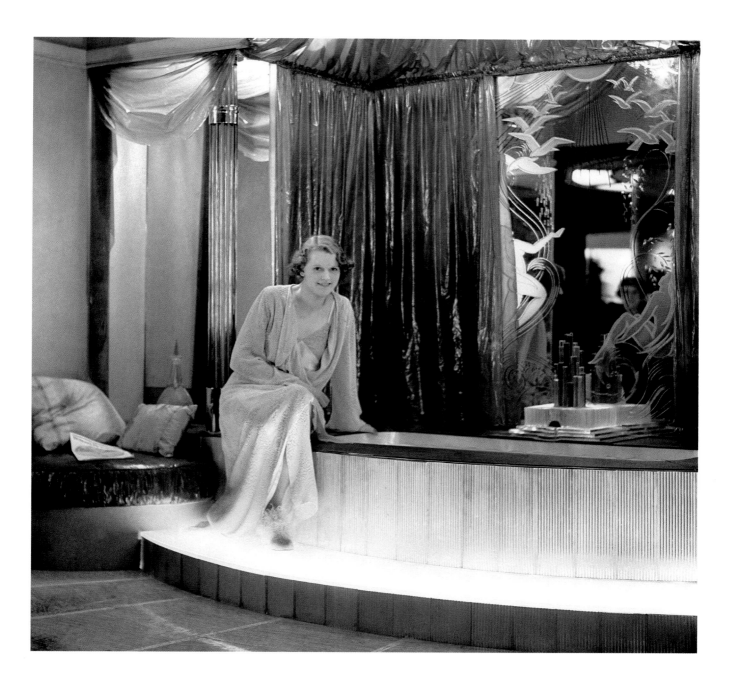

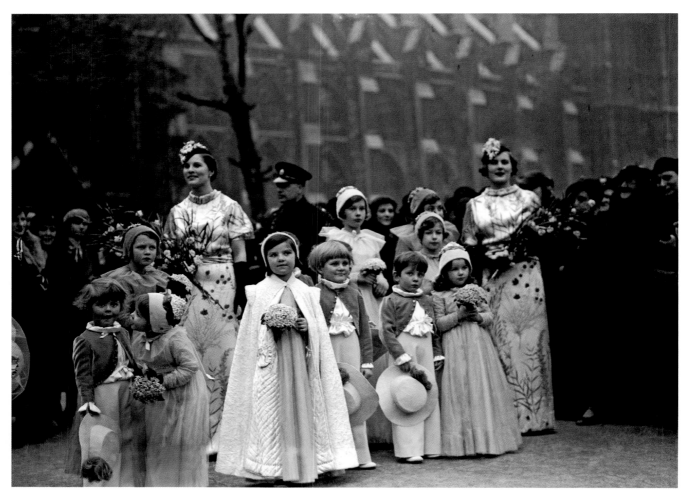

Bridesmaids and pageboys
at the wedding of society
figure Sir Michael Duff to
Joan Millicent Marjoribanks
at St Margaret's Church in
Westminster. The marriage
was annulled in 1937.
5th March, 1935

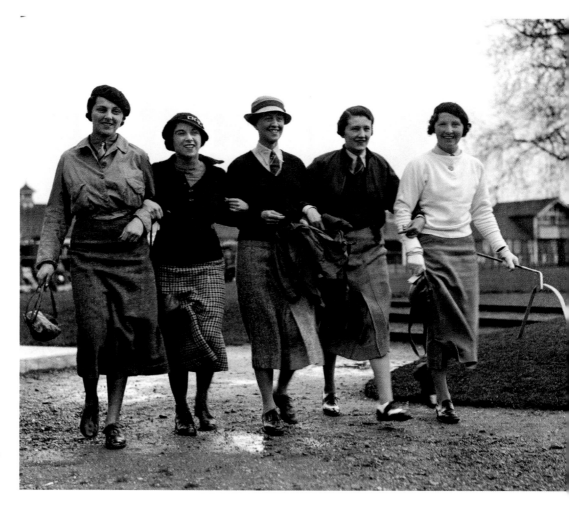

Champion golfers (L-R)
Isabella Rieben, Miss
Cradock-Hartopp, Lady
Alness, Mrs P Ceron and
England Captain Phyllis
Wade, at the Ranelagh Club
in Barnes.
10th March, 1935

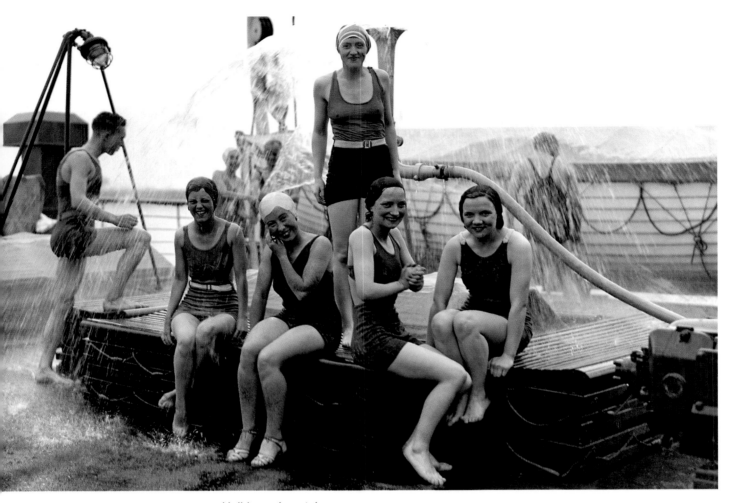

Holidaymakers take a
shower on the deck of the
ocean liner *SS Vienna*.
6th July, 1935

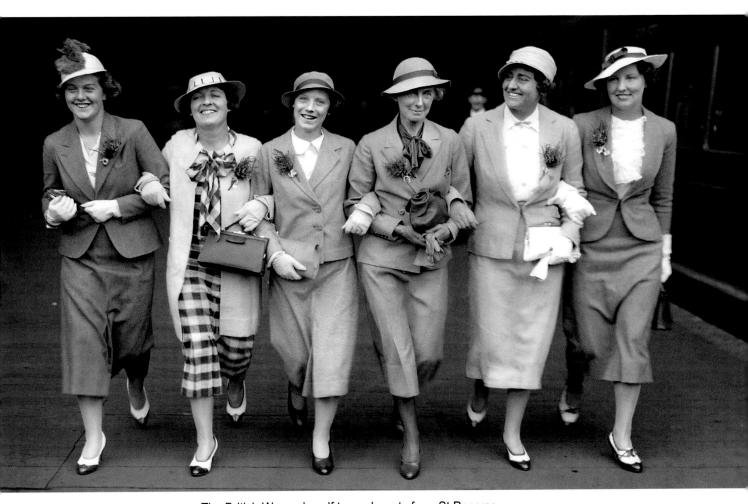

The British Women's golf team departs from St Pancras
Station on the *Strathaird* boat train for Australia where they
are to play several matches. (L-R) Pam Barton, Mrs Walker,
Mrs Anderson, Mrs Hodson, Mrs Greenlees and Phyllis Wade.
12th July, 1935

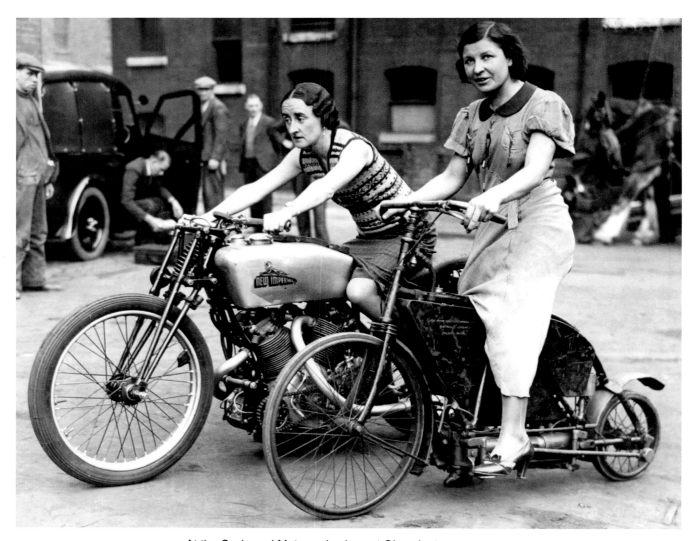

At the Cycle and Motorcycle show at Olympia, two women try out the 500cc New Imperial Twin (L) which reached 114mph at Brooklands race track, and an 1895 Crank Drive motorcycle (R).
29th November, 1935

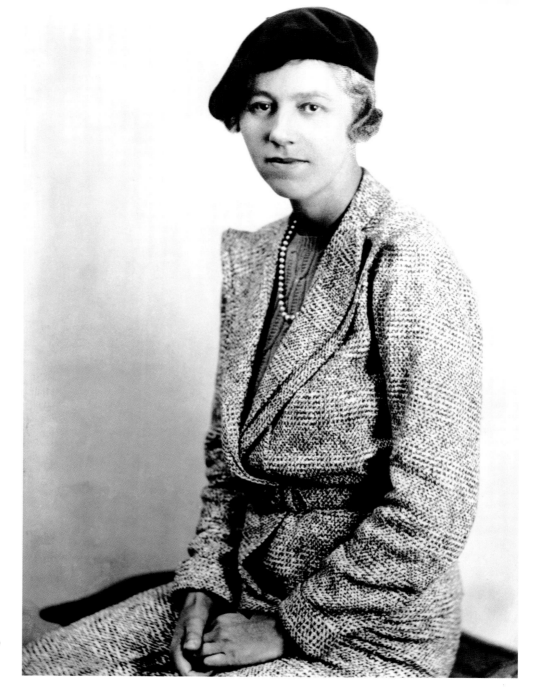

The great golfing champion,
Joyce Wethered.
25th January, 1936

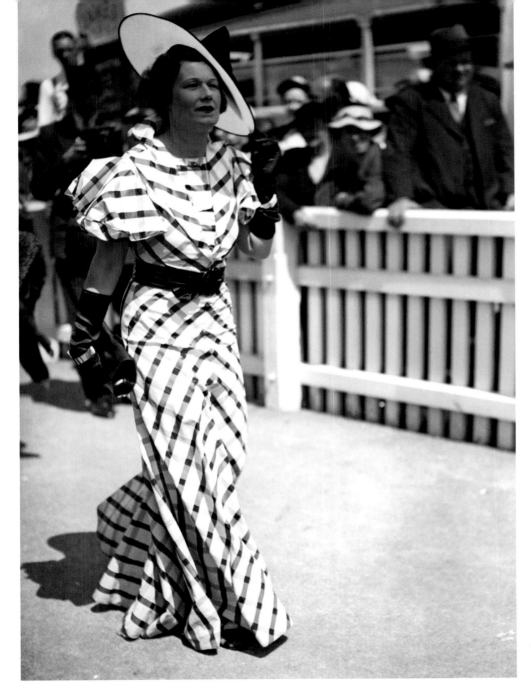

Ascot brings out the best
in fashion.
15th June, 1936

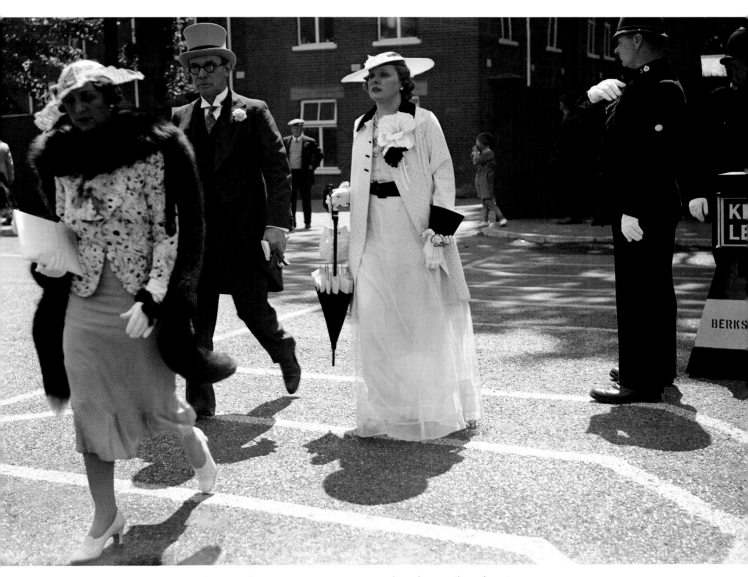

No occasion seems to attract more dressing up than Ascot.
19th June, 1936

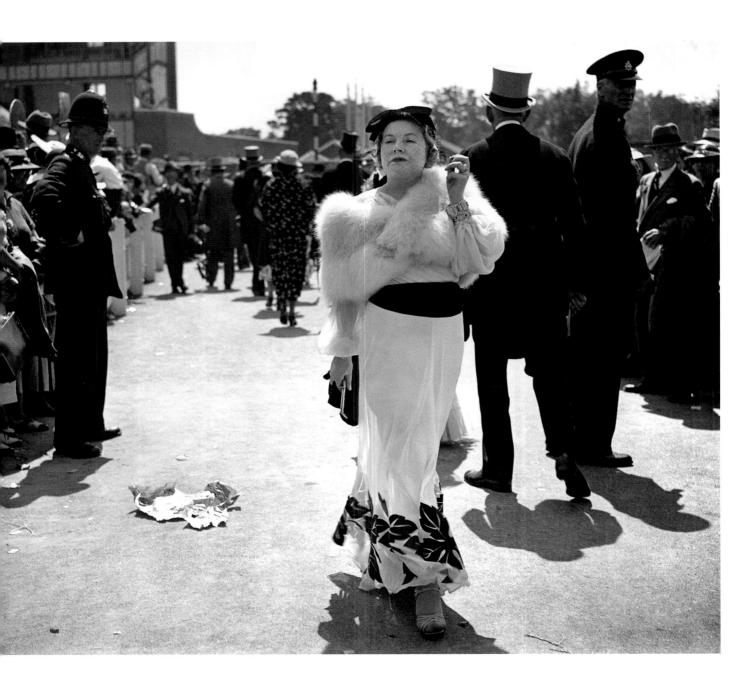

Facing page: Some turn
heads more than others
at Ascot.
19th June, 1936

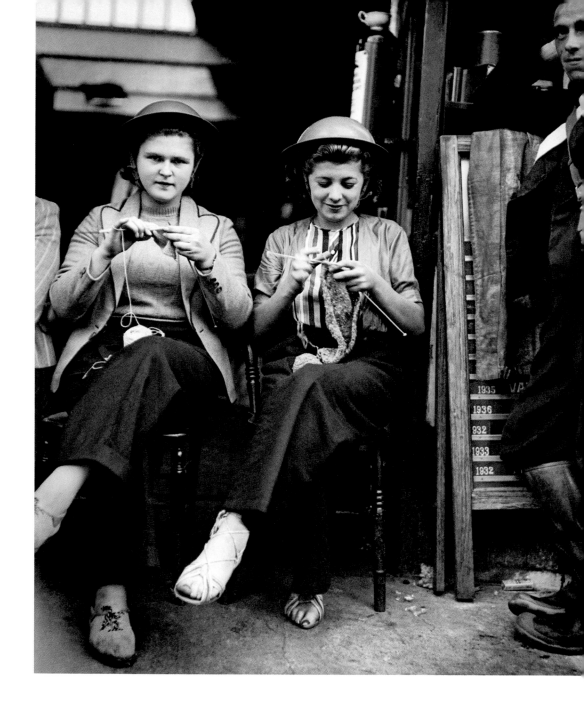

Two members of the
Auxiliary Fire Service
take a knitting break.
June, 1938

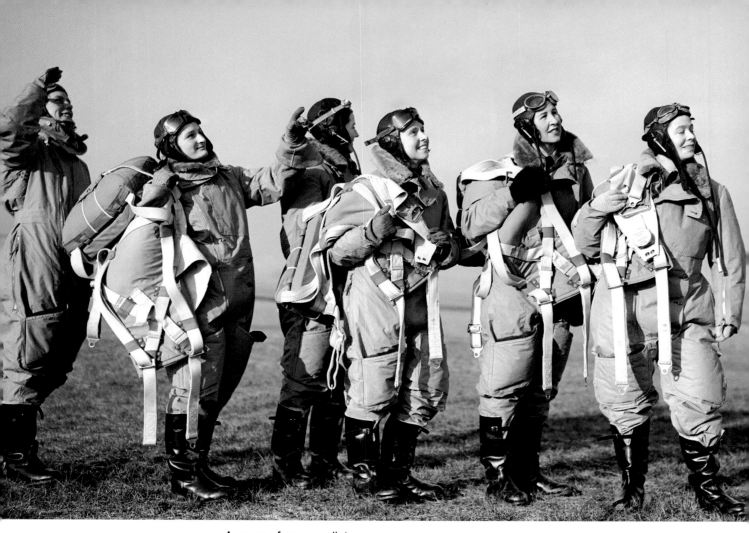

A group of women pilots
with their flying kit and
parachutes.
15th June, 1939

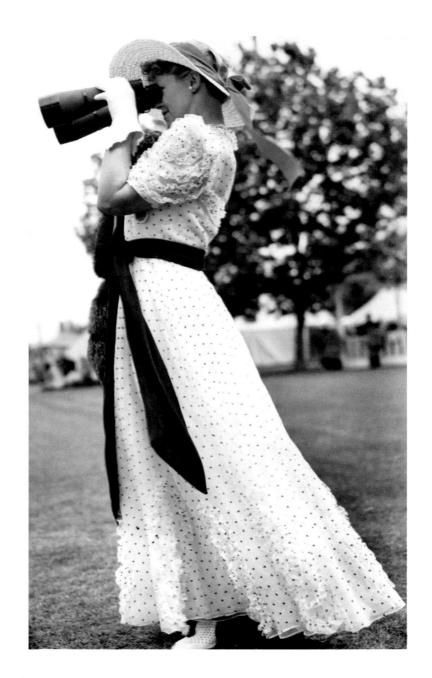

A young woman gets a close-up view of the race at Henley Royal Regatta.
8th July, 1939

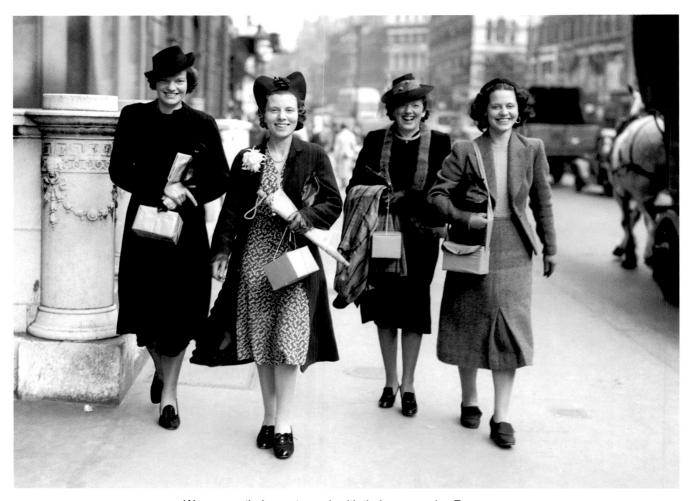

Women on their way to work with their gas masks. From the early part of 1939 London was preparing for war, with air raid, gas mask and evacuation drills becoming part of everyday life.
August, 1939

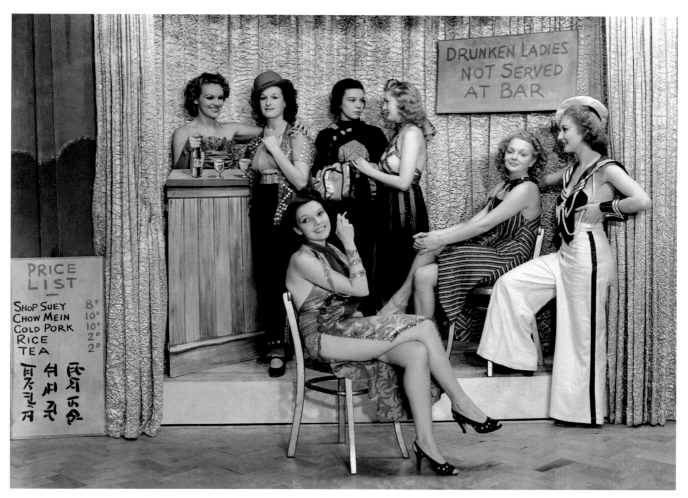

Cabaret girls at the Paradise Club.
16th December, 1939

The Wren (a member of the Women's Royal Naval Service) who was chosen as a model for a recruitment poster, with the finished design.
January, 1941

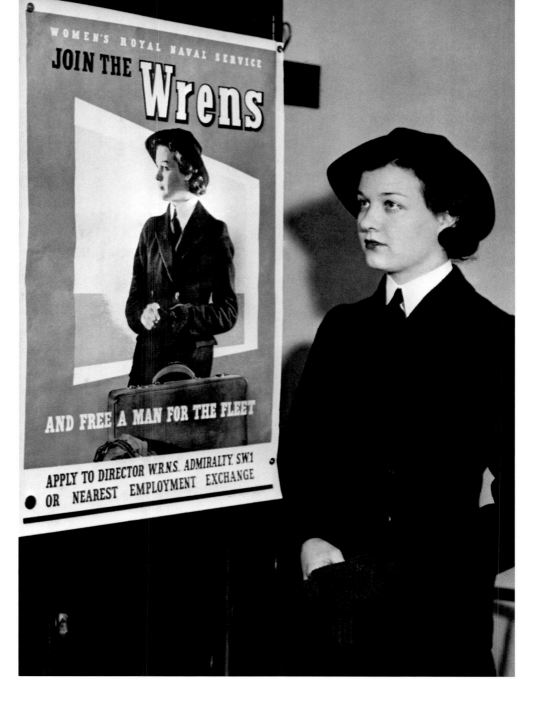

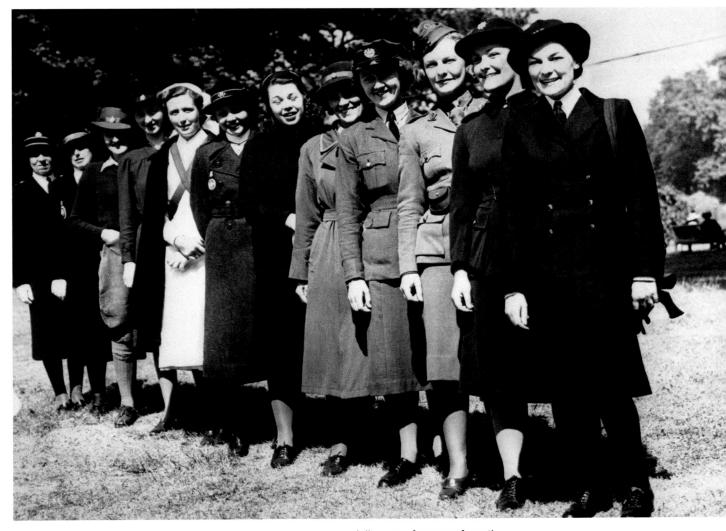

A line-up of women from the
Army, Navy and Air Force.
Their uniforms are made
from British wool.
January, 1941

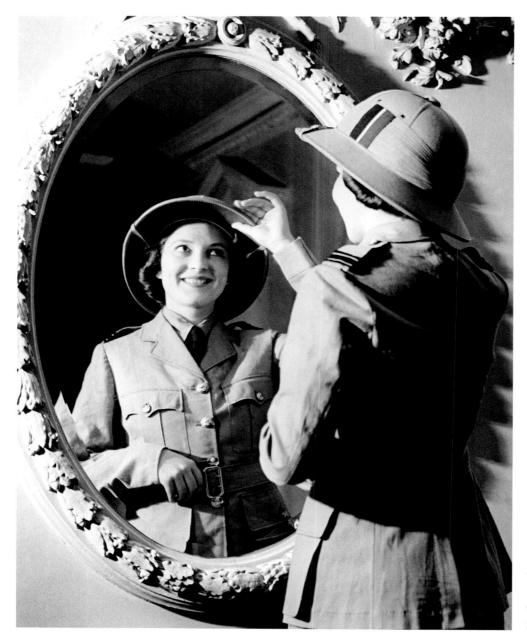

The Women's Auxiliary Air Force's tropical uniform for wear in the Middle East.
27th June, 1941

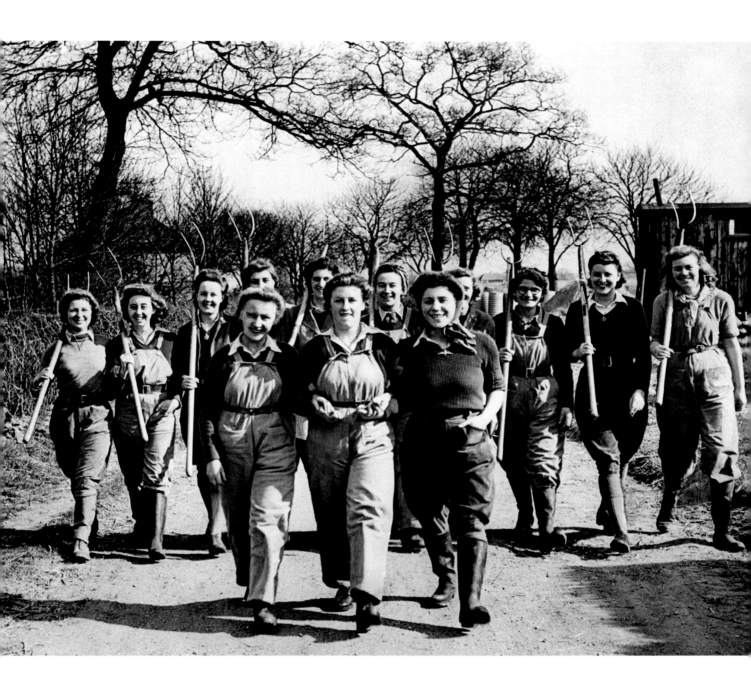

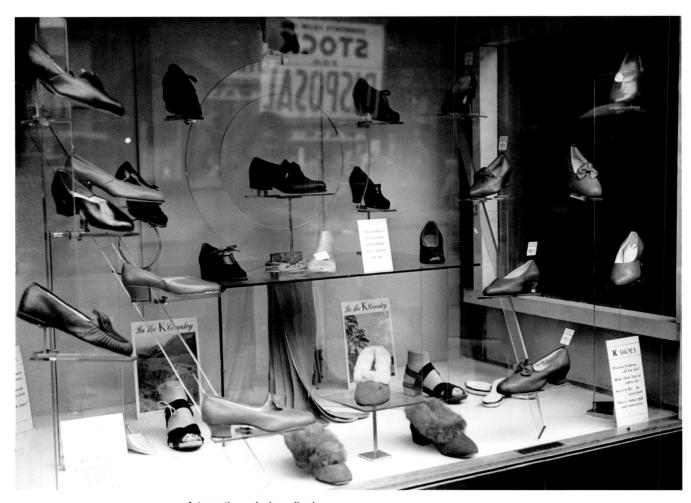

A tempting window display of shoes – unfortunately, the notice says that they are not for sale.
October, 1945

The biggest thing in post-war fashion, the *New Look*. This grey worsted coatdress is trimmed in navy and white spotted rayon, a semi-synthetic fibre, which had recently come into common use.

23rd January, 1946

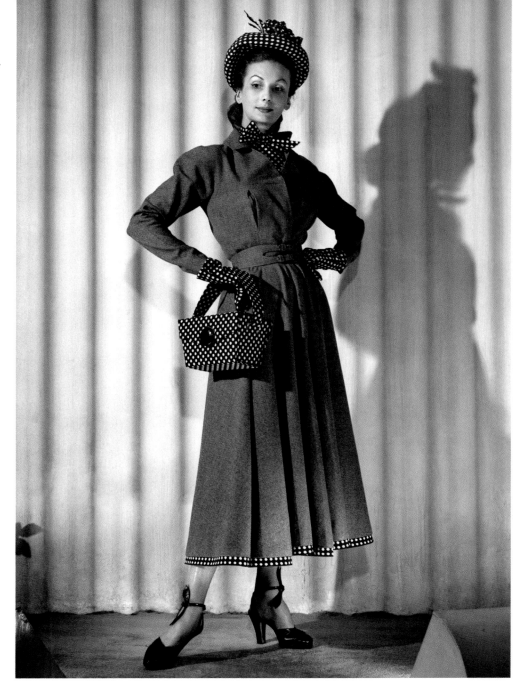

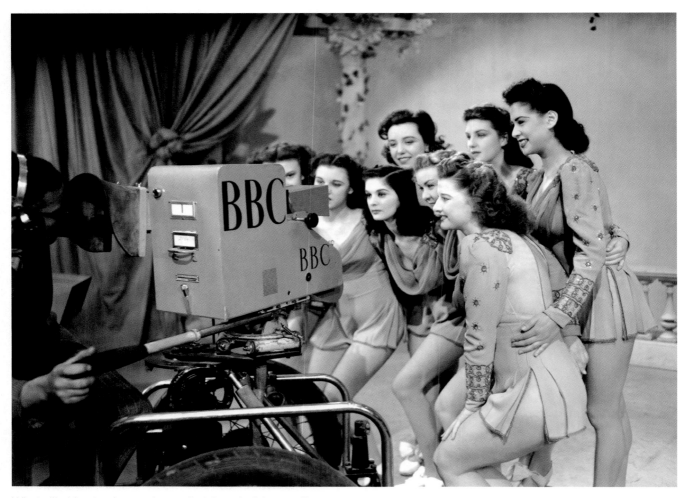

Windmill girls at a dress rehearsal at the television studios
at Alexandra Palace. The Windmill Theatre in London was
famous for its nude *tableaux vivants* in which the girls posed
naked but did not move. The popular phrase of the time that
referred to them was, "Nude not rude".
10th April, 1946

Facing page: An unusual
green felt hat with parrot
wing feathers.
5th May, 1946

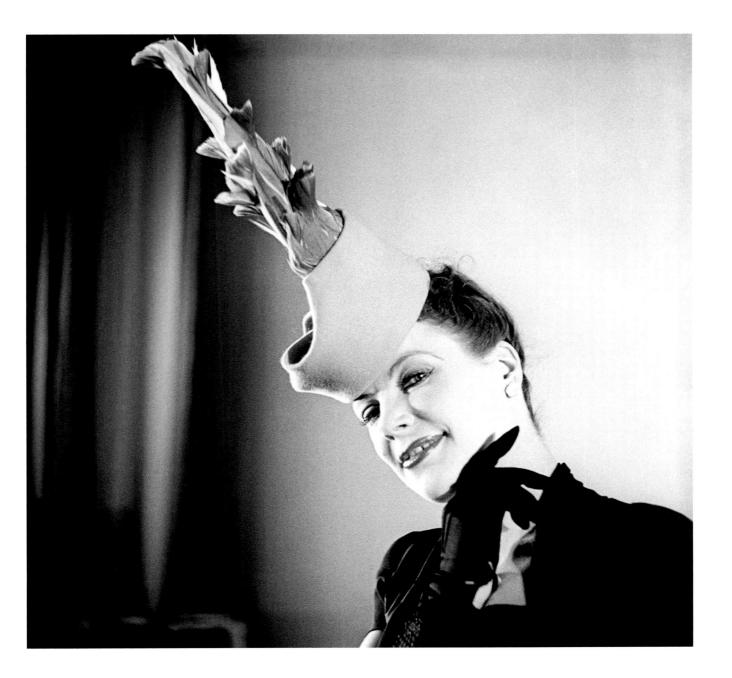

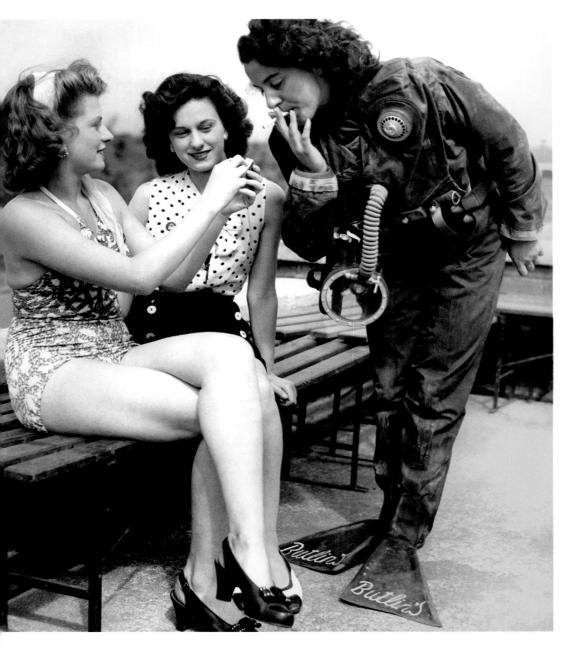

Facing page: The Duke and Duchess of Windsor aboard the *Queen Elizabeth* ocean liner.
5th November, 1946

A 'Frogwoman' gets a light for her cigarette from holidaymakers at the Butlins Holiday Camp in Filey, Yorkshire.
28th June, 1946

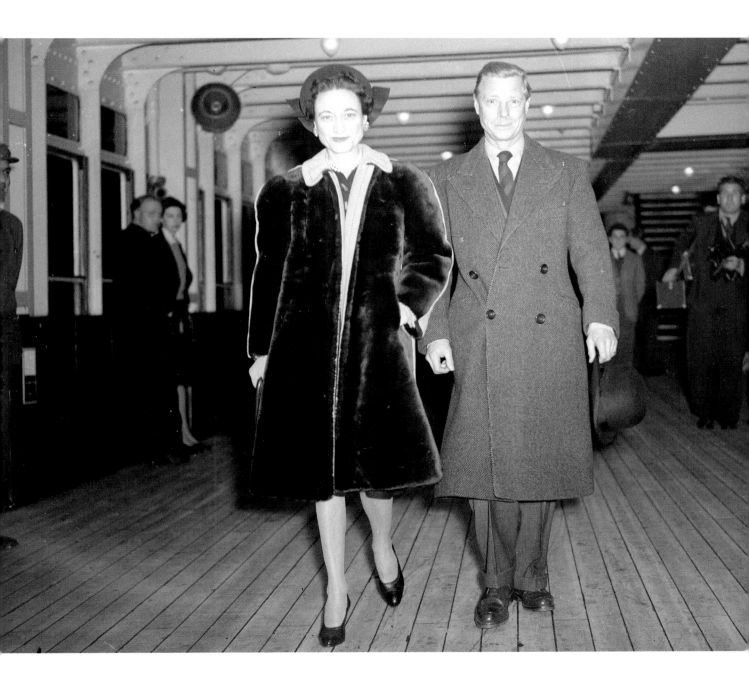

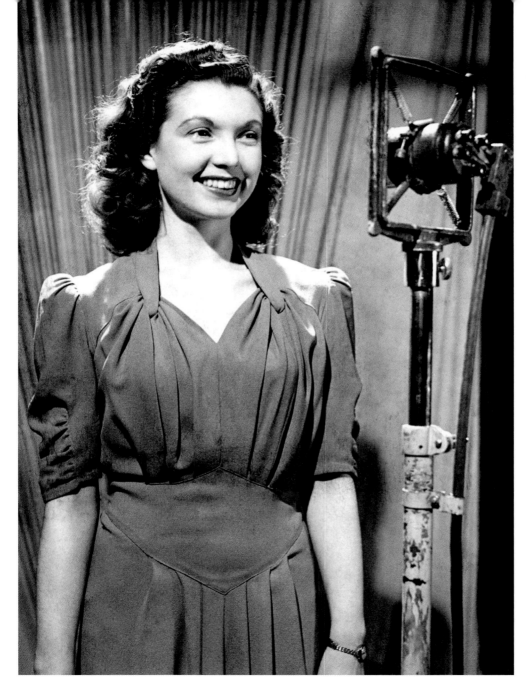

The winner of a competition for announcers, Sylvia Peters broadcasts from Alexandra Palace.
5th May, 1947

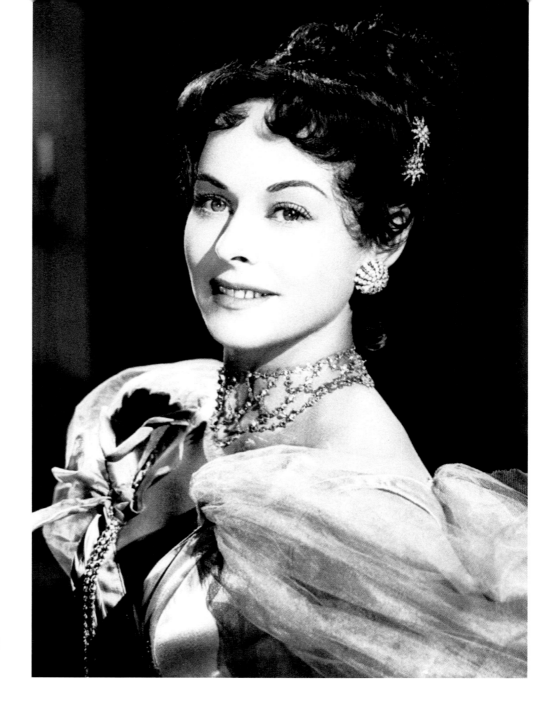

Actress Paulette Goddard
with a 'pin curl' hairstyle.
21st May, 1947

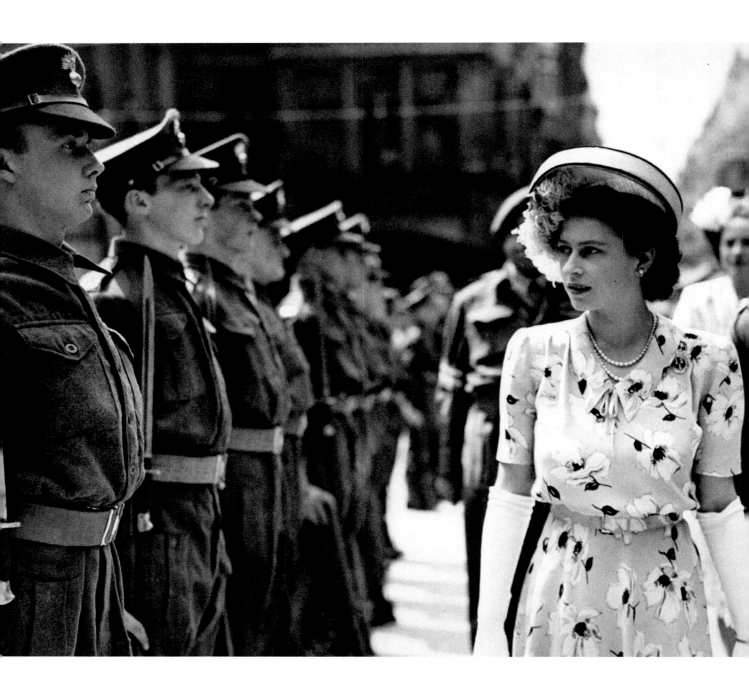

Facing page: The young Princess Elizabeth attends a ceremony of the Freedom of the City of London at Guildhall – the first significant ceremony that she undertook unaccompanied.
11th June, 1947

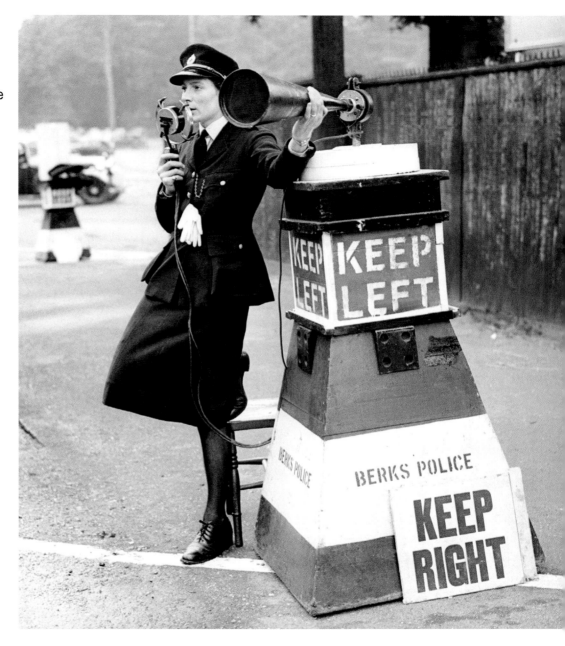

A woman police officer controls the traffic with loudspeaker and microphone.
18th June, 1947

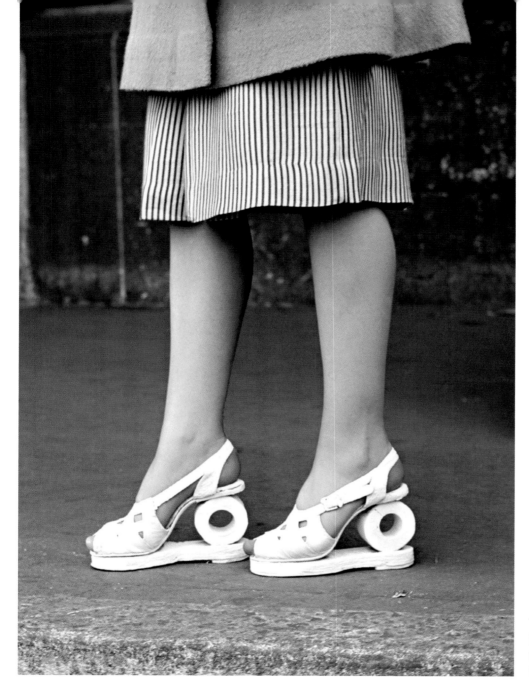

Facing page: Hats have long been the way to get noticed at Ascot.
19th June, 1947

This pair of shoes, worn by Irene Clifford at Ascot, was made by her father.
19th June, 1947

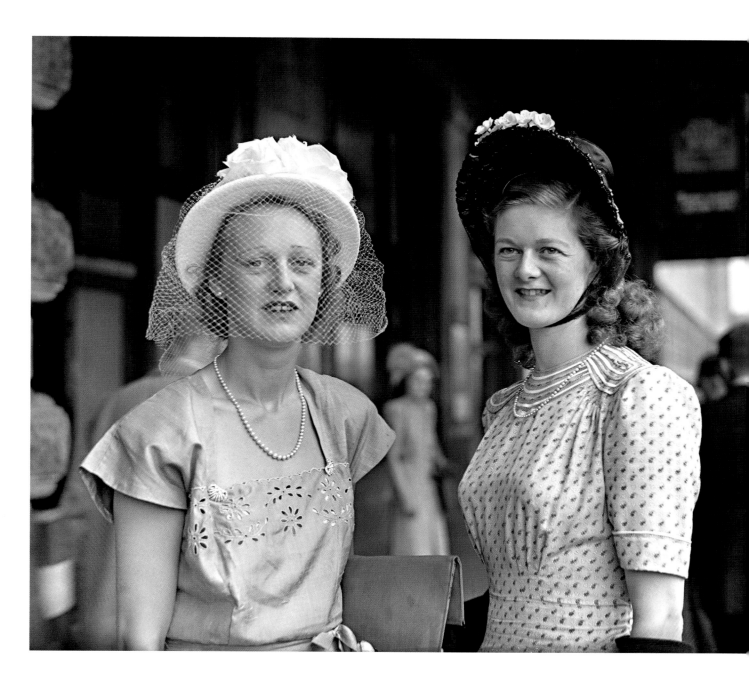

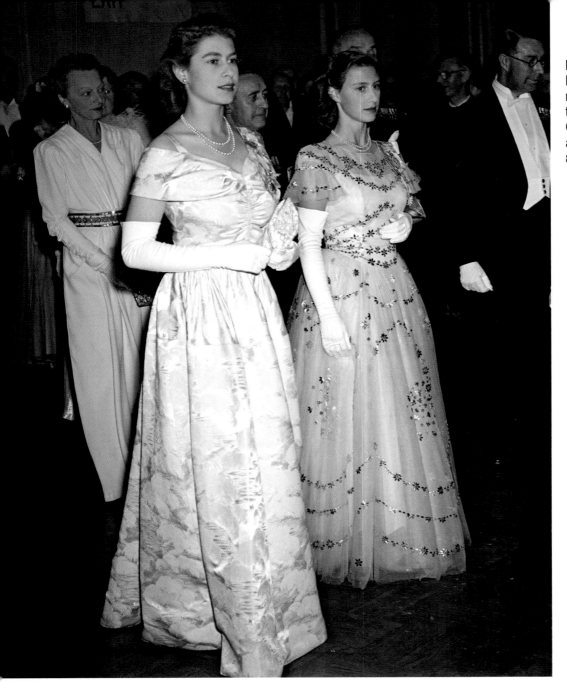

Princess Elizabeth (C) and Princess Margaret (R) at a reception in London held by the Chairman of the London County Council for the King and Queen.
8th July, 1947

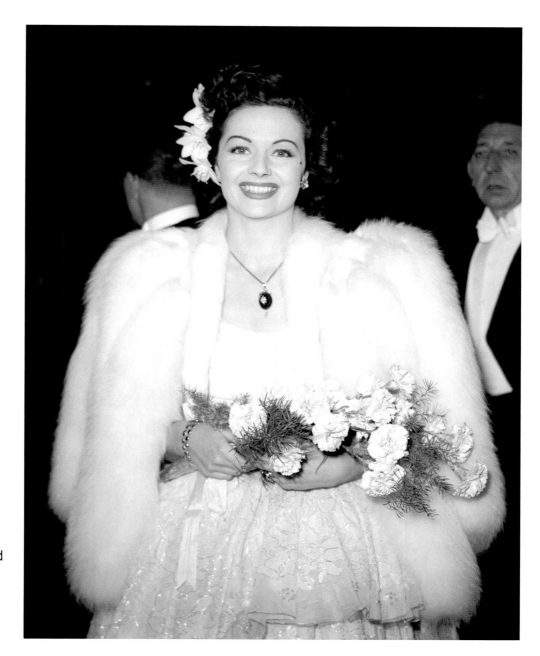

Actress Margaret Lockwood
arrives for the premiere of
the film *White Unicorn* at
the New Gallery cinema in
Regent Street.
20th October, 1947

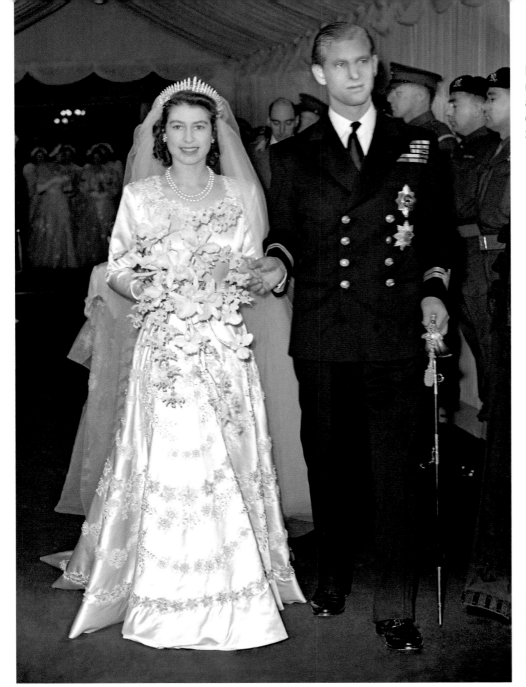

Facing page: Instead of the usual wax dummies, there are live models in a window display in Regent Street.
22nd January, 1948

Princess Elizabeth and the Duke of Edinburgh as they leave Westminster Abbey after their marriage ceremony.
20th November, 1947

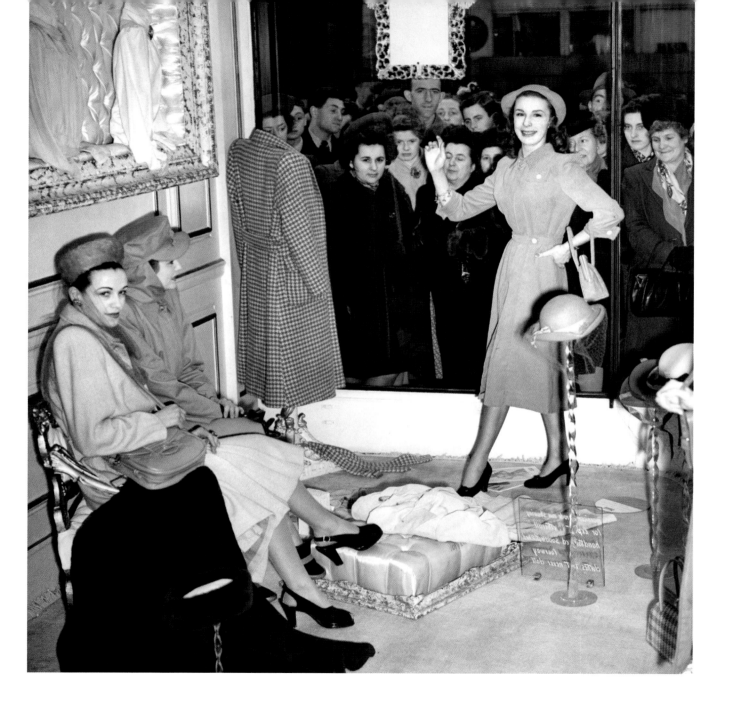

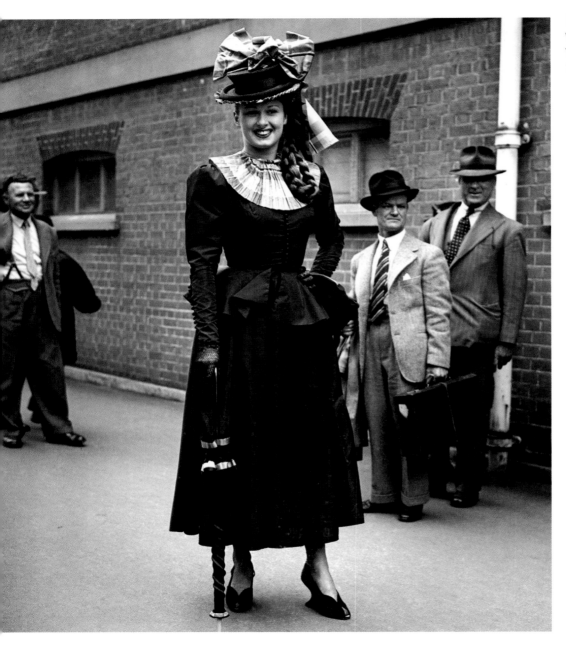

It's Royal Ascot time again with Elizabeth Shelley posing for the camera.
15th June, 1948

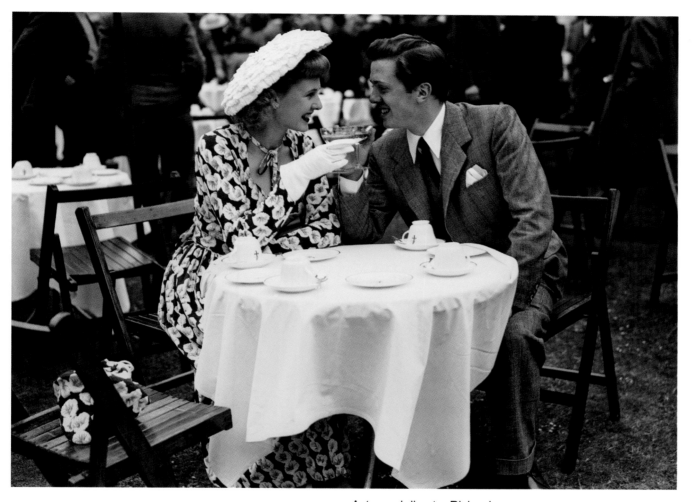

Actor and director Richard
Attenborough and his wife
Sheila Sim at a film garden
party at Morden Hall Park.
10th July, 1948

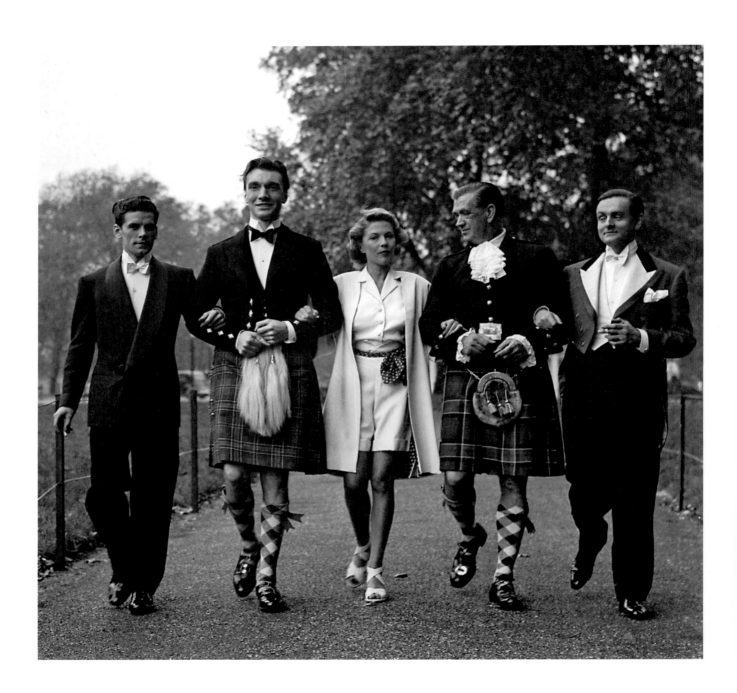

Facing page; The cast of the play *Gentleman's Relish* model (L-R) a smoking jacket in midnight blue with shawl collar, two highland evening dress jackets with kilts and an evening dress hunting coat.
14th September, 1948

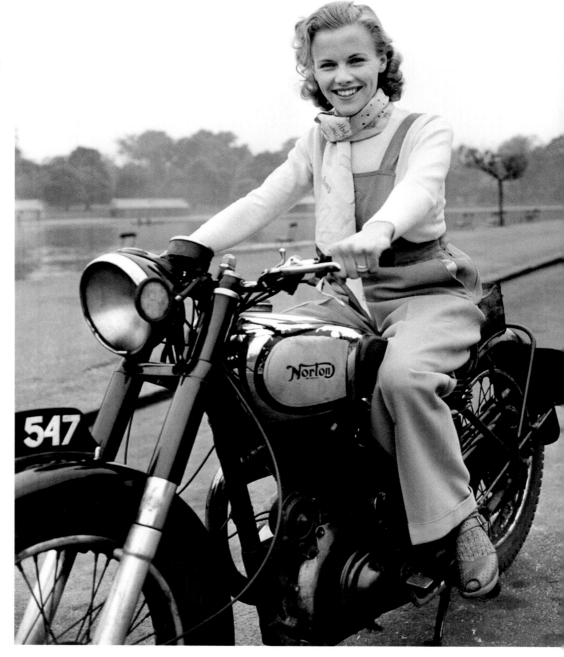

The 23 year old film actress Honor Blackman rides a motorcycle through Hyde Park.
9th May, 1949

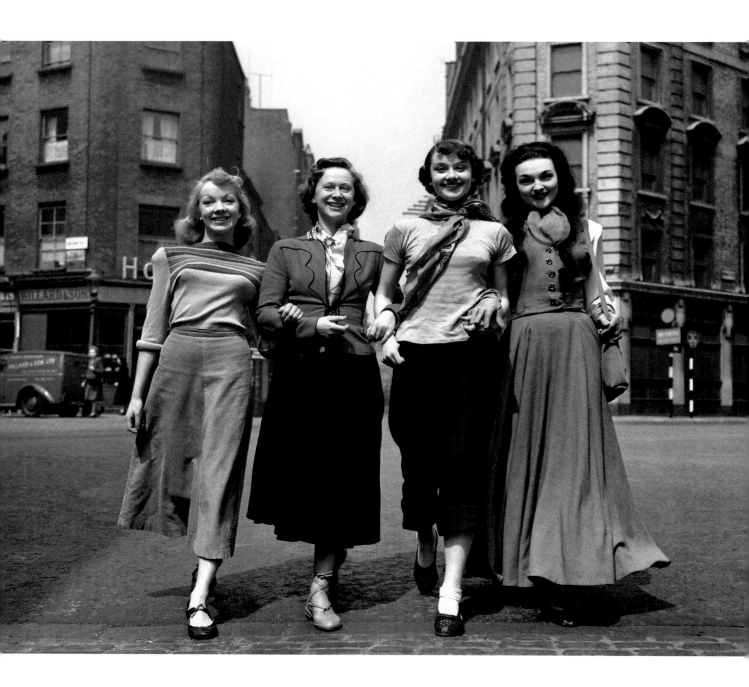

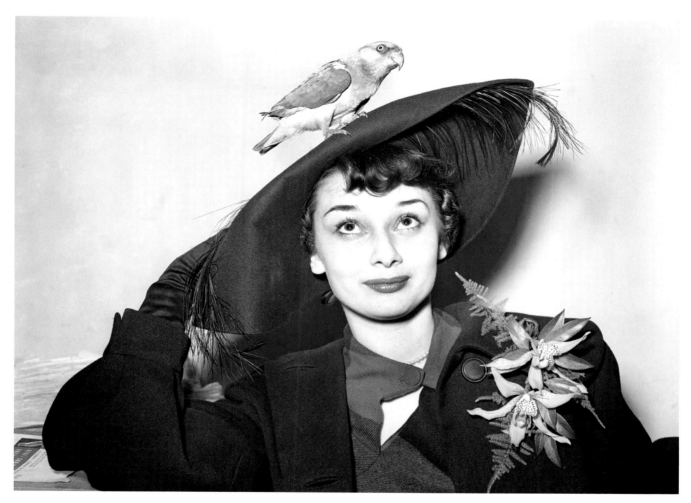

Facing page: Members
of the cast of *Sauce
Tartare* at the Cambridge
Theatre in London. (L-R)
Aud Johannsen, Nina
Tarakanova, Audrey
Hepburn and Marlana.
13th May, 1949

Audrey Hepburn makes
friends with a Hyacinth
Macaw.
1st December, 1949

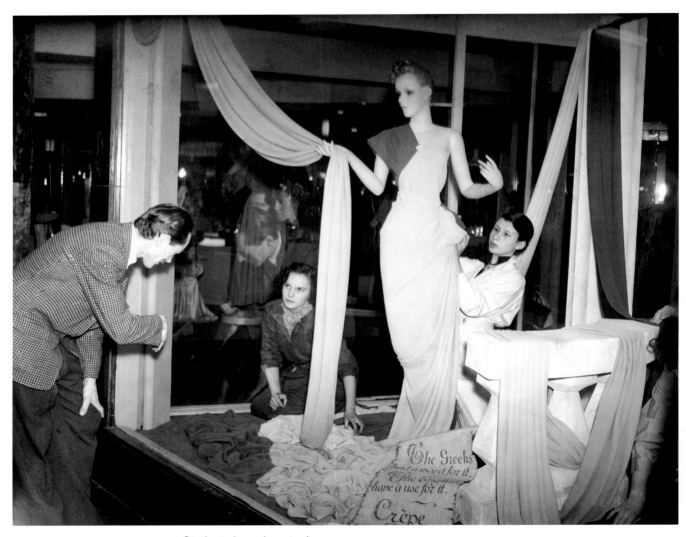

Students learn how to dress a
shop window in Regent Street.
18th February, 1950

Swimwear modelled by film actress Zena Marshall. The suit was designed by ex-engineer Major H Du Cros.
12th May, 1950

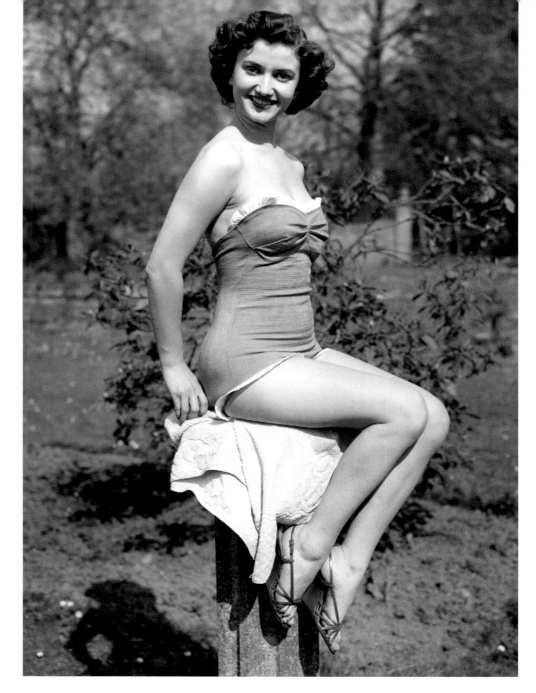

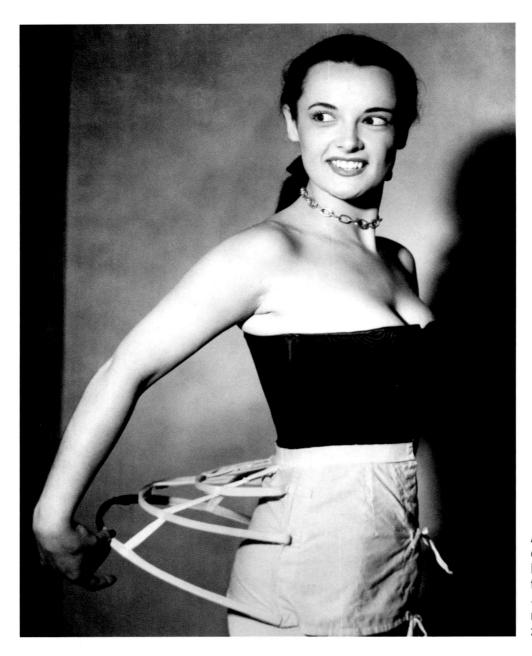

An 1880s bustle cage corset modelled by Mercy Haystead, the starlet of the film *What the Butler Saw*, a soft-core erotic film made in 1950.
23rd June, 1950

Designs by Christian Dior
being shown at the Savoy
Hotel in London.
25th August, 1950

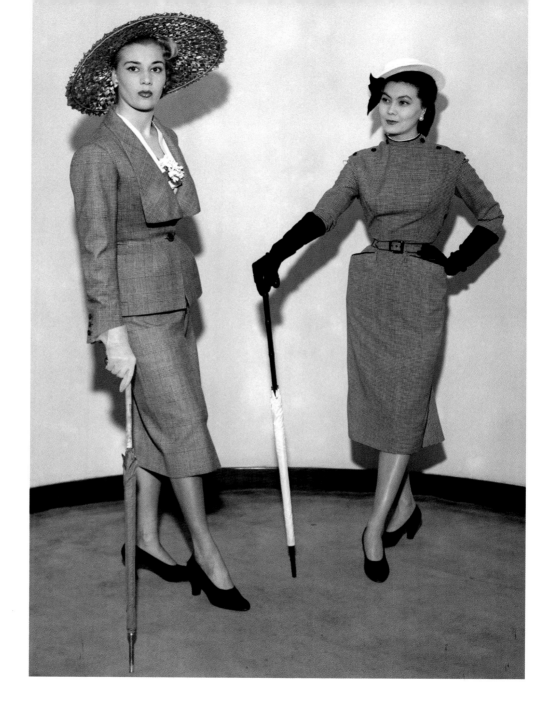

Model Barbara Goalen
wearing an Ian Meredith
two-piece.
19th March, 1951

Facing page: A beach suit
designed in the School of
Fashion and shown at the
Royal College of Art annual
fashion show.
2nd July, 1951

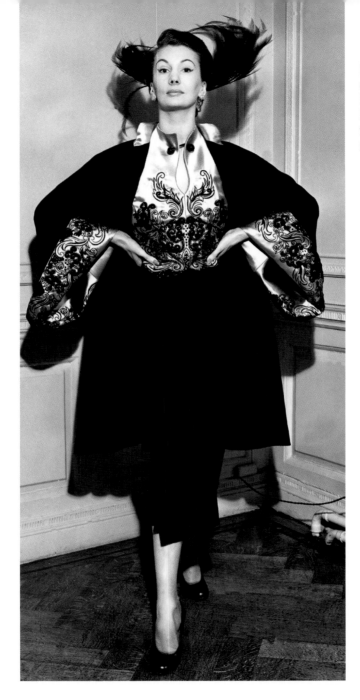

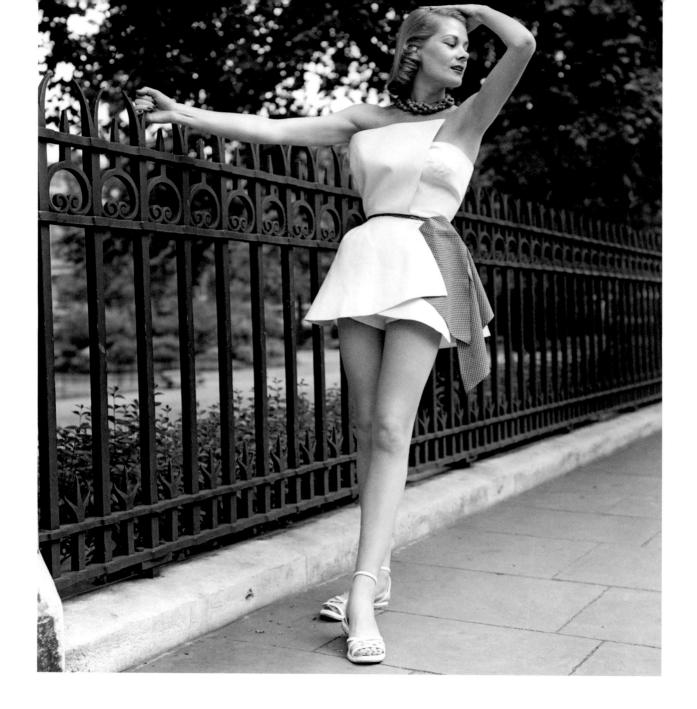

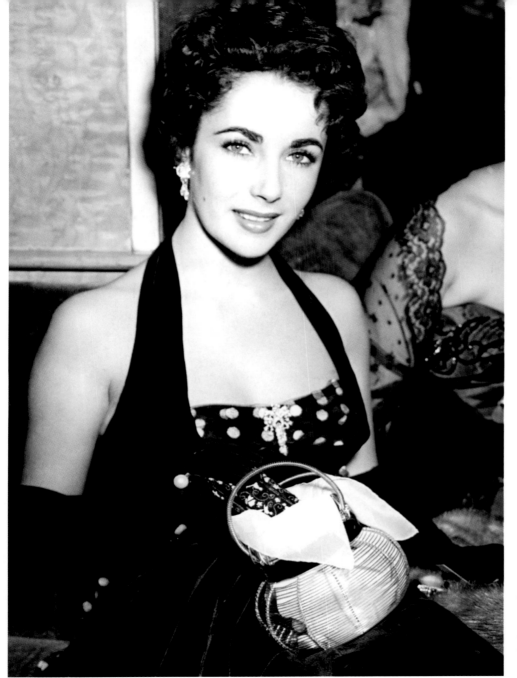

Facing page: Actress Audrey Hepburn arrives at London Airport.
21st May, 1953

Actress Elizabeth Taylor arrives at the premiere of *The Lady With The Lamp* in which her husband, Michael Wilding, starred.
22nd September, 1951

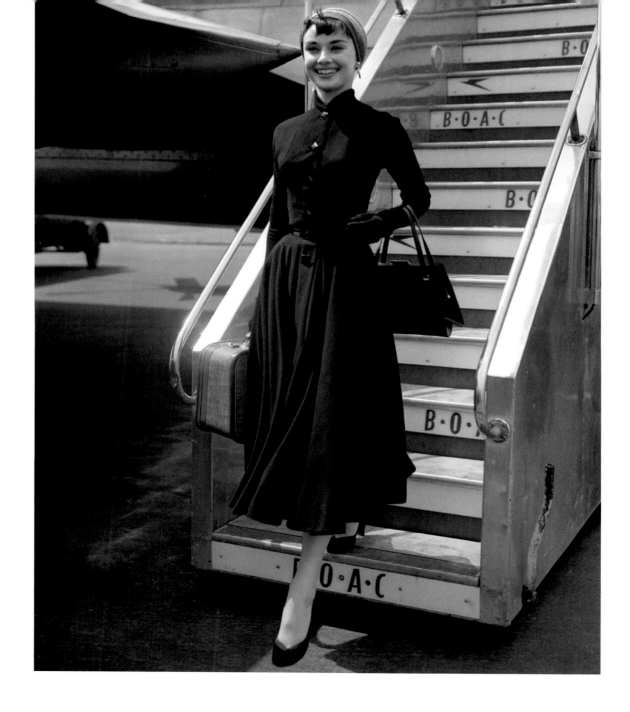

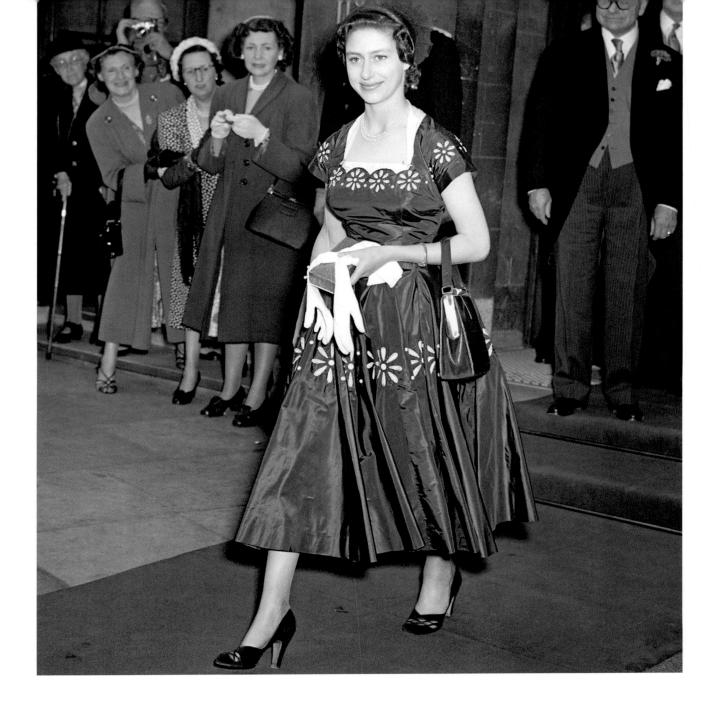

Facing page; Princess Margaret leaving Grosvenor House in London.
10th June, 1953

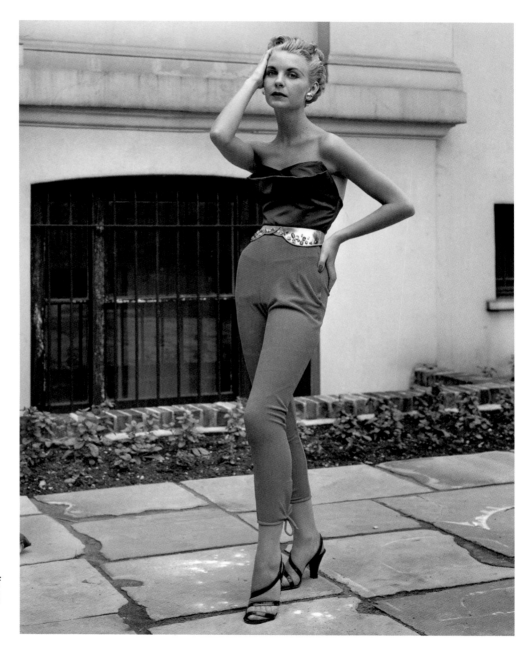

Red pantaloons and green satin top, designed by Mary Lenanton from the School of Fashion, shown at the Royal College of Art show.
1st July, 1953

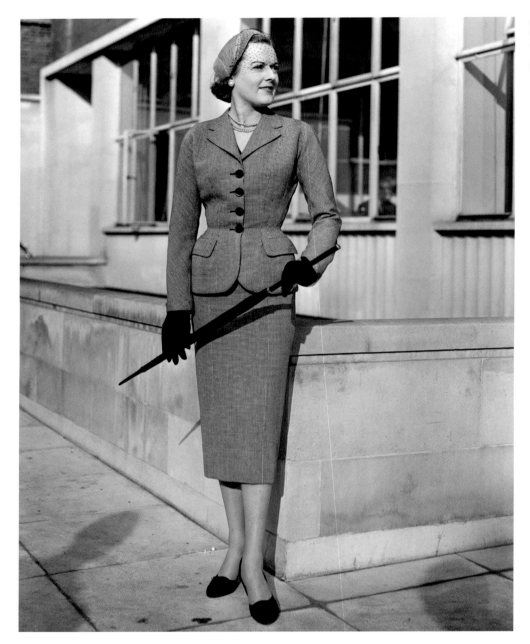

A suit from the spring fashion collection of Top Twelve Designers.
8th February, 1954

An evening dress by Mattli
from the spring collection of
Top Twelve Designers.
8th February, 1954

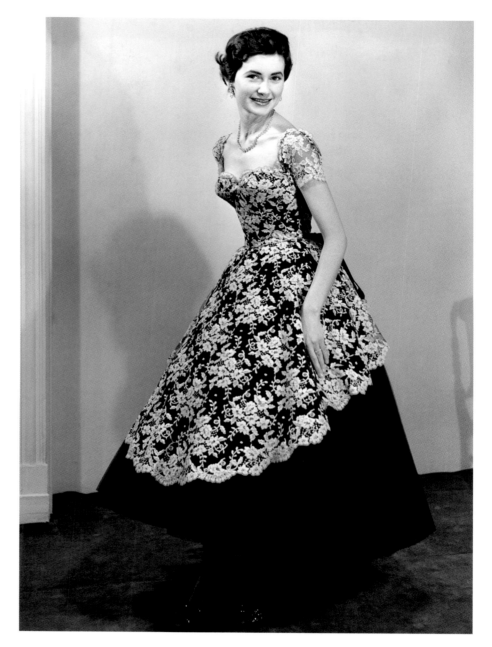

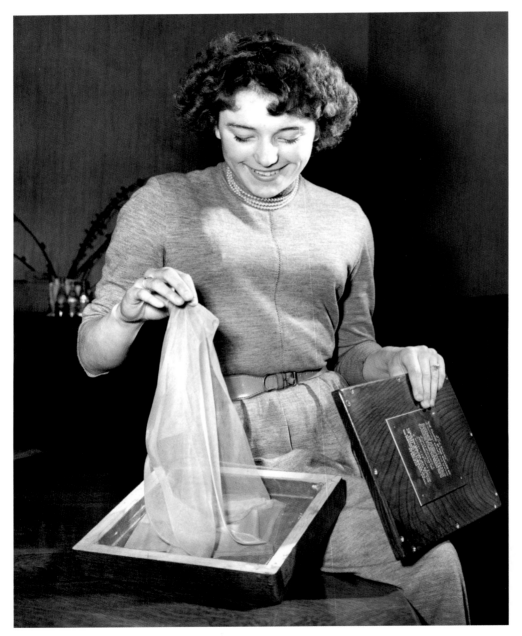

Facing page: Evening dresses shown at a Jacques Faith fashion show in London.
29th September, 1954

A pair of nylon stockings which are to be buried in a lead-lined wooden casket at the opening of the new Klinger factory in Margate where the stockings were manufactured.
7th April, 1954

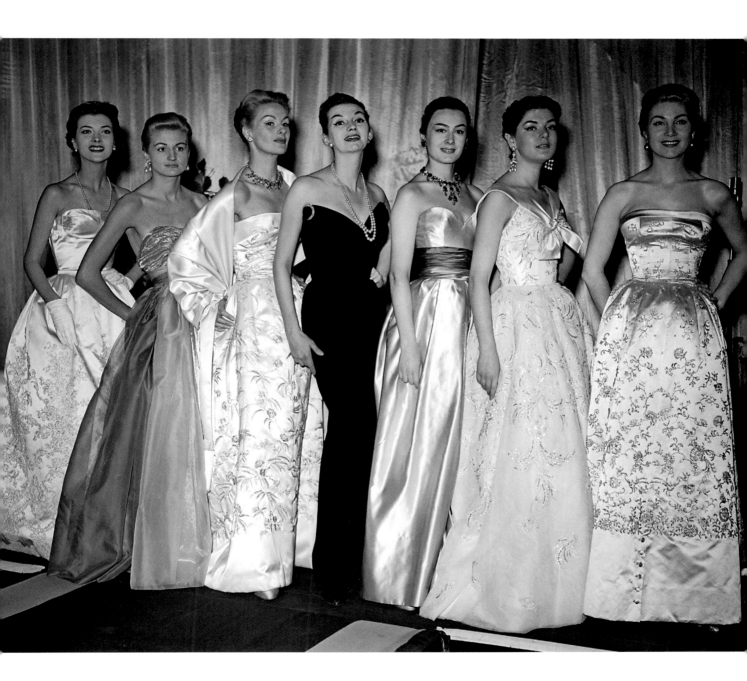

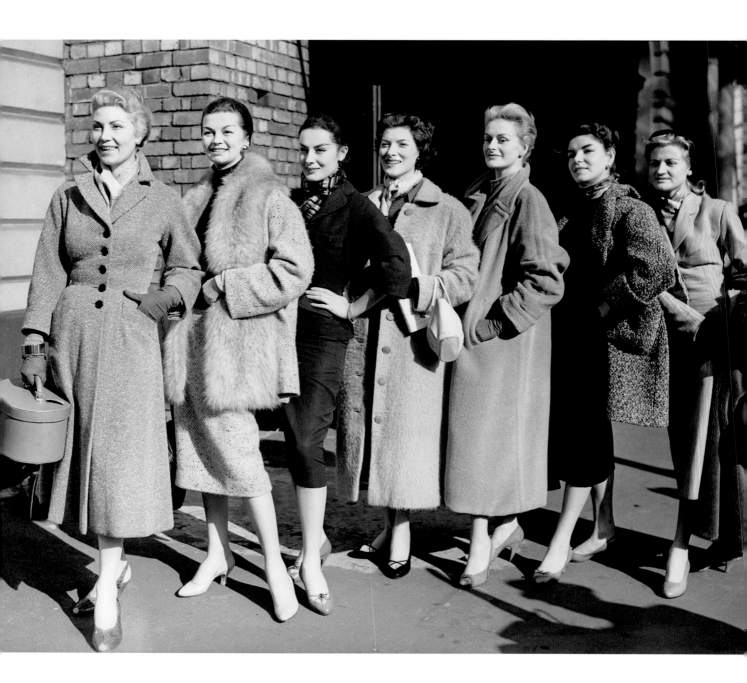

Facing page: Jacques Faith winter wear.
29th September, 1954

A yellow Jaguar cotton suit by Peter Rotas from his spring collection.
3rd December, 1954

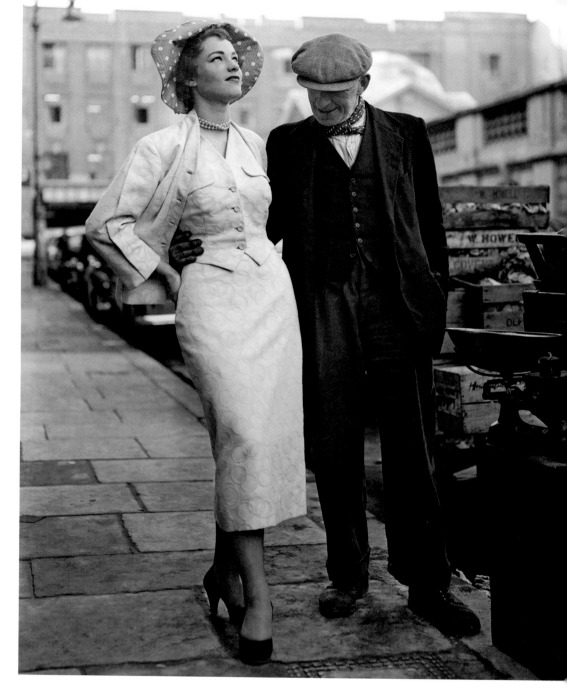

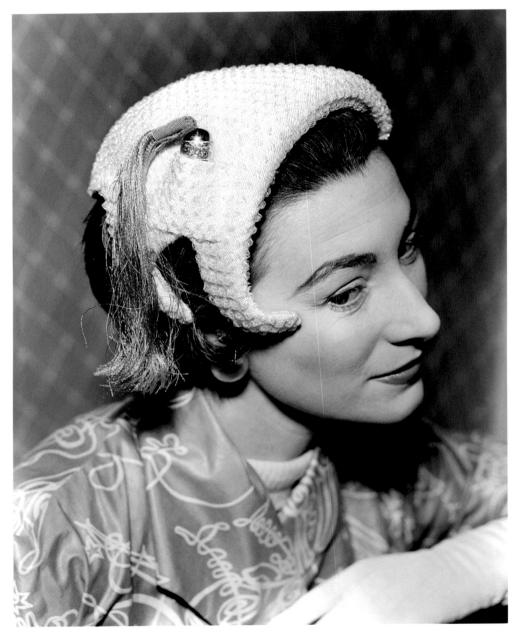

Combining humour with practicality – a hat with a sewing set in the side pocket, designed by Madge Chard.
3rd December, 1954

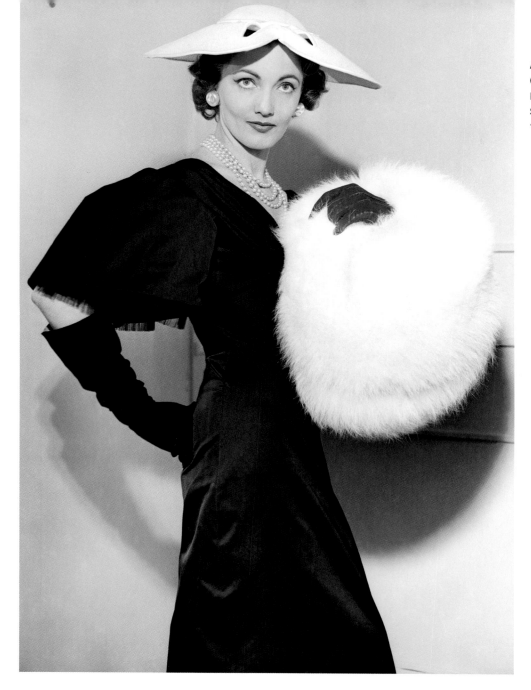

A dress, from the spring collection by Maggy Roff, made of radzimir, a woven silk fabric.
15th December, 1954

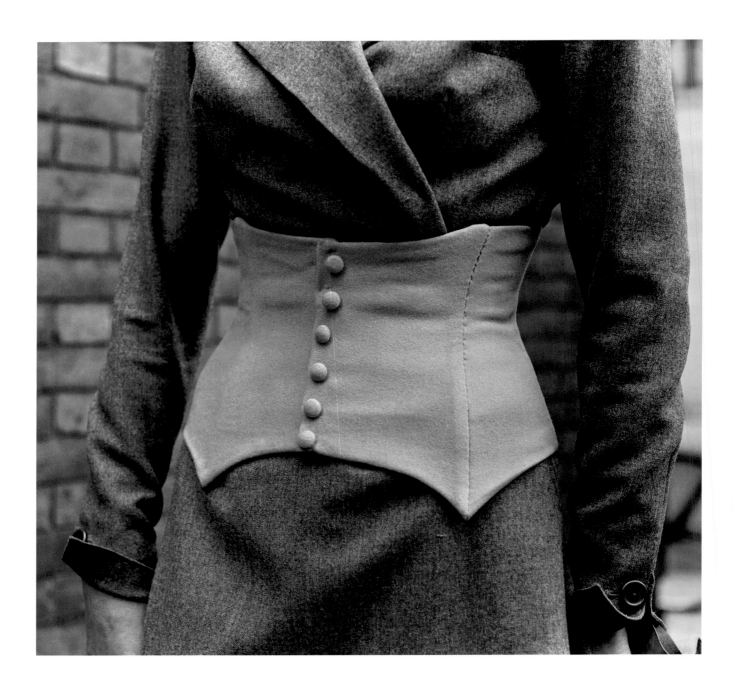

Facing page: A corselet of yellow wool, worn over a suit, by Charles Creed.
27th January, 1955

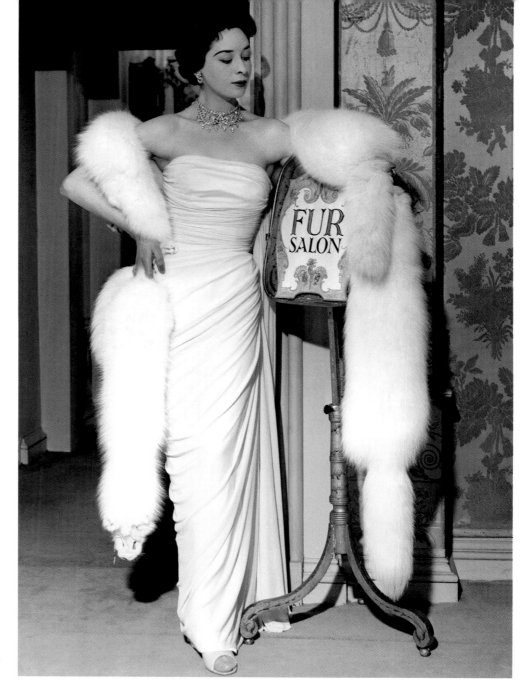

White fox fur and silk jersey evening dress by Neil Roger.
7th February, 1955

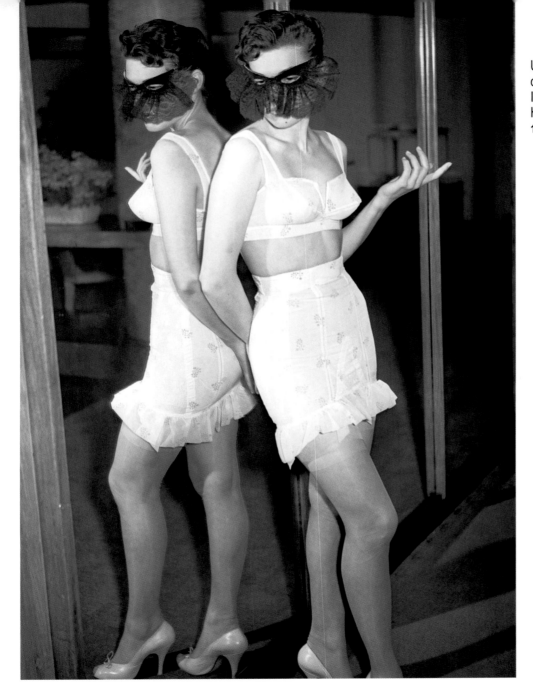

Underwear in white nylon chiffon by the French Corset Industry, shown at the Savoy Hotel in London.
10th February, 1955

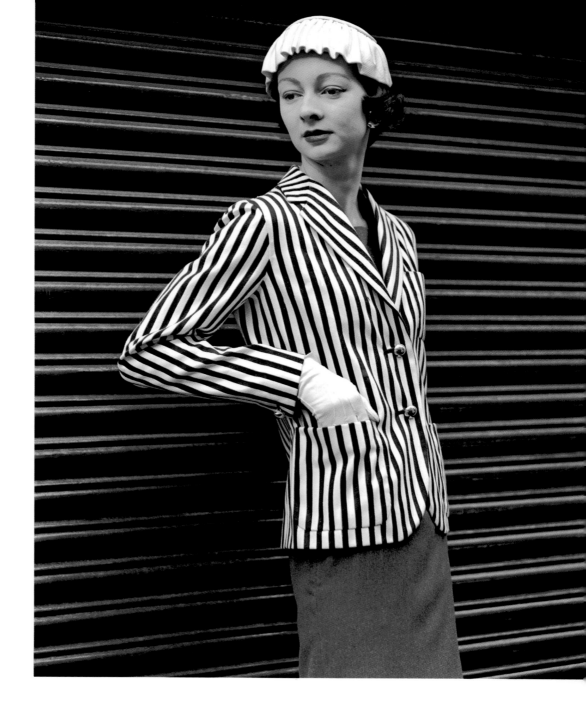

Blazer by Digby Morton.
10th February, 1955

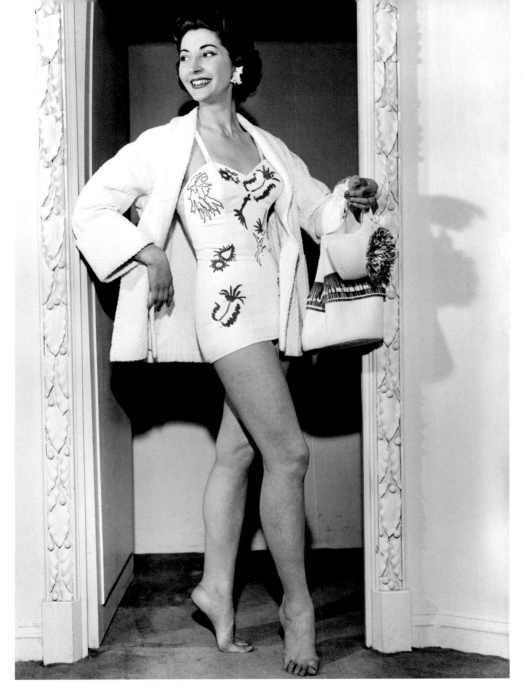

Swimsuit with short coat
from Pierre Balmain's
beachwear collection.
10th March, 1955

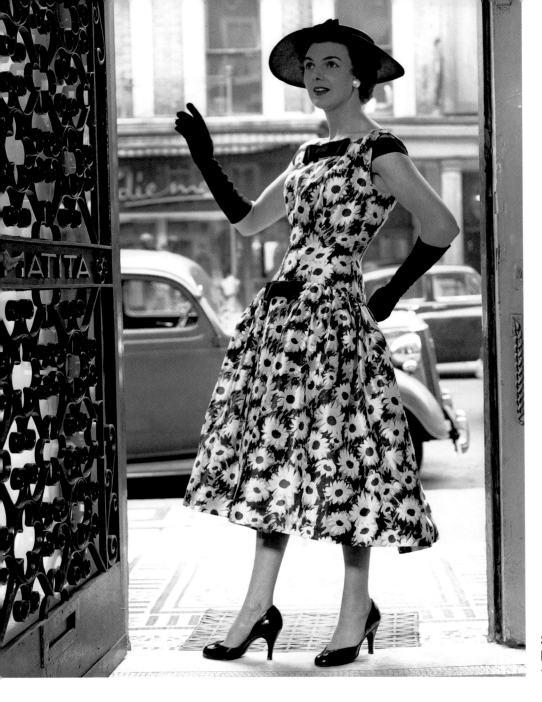

Silk shantung organza dress
by Matita.
11th March, 1955

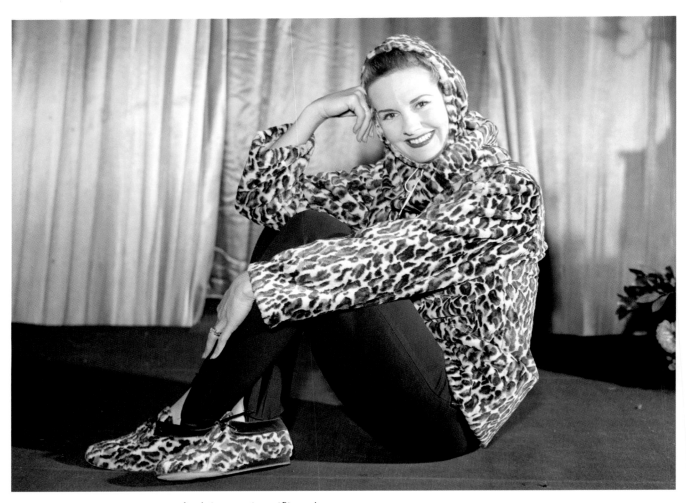

A winter sports outfit made from the new material Dry-Sil which is coated in silicone, making it water resistant. It is being shown at the Dry-Sil Fashion on Parade show in Park Lane.
21st November, 1955

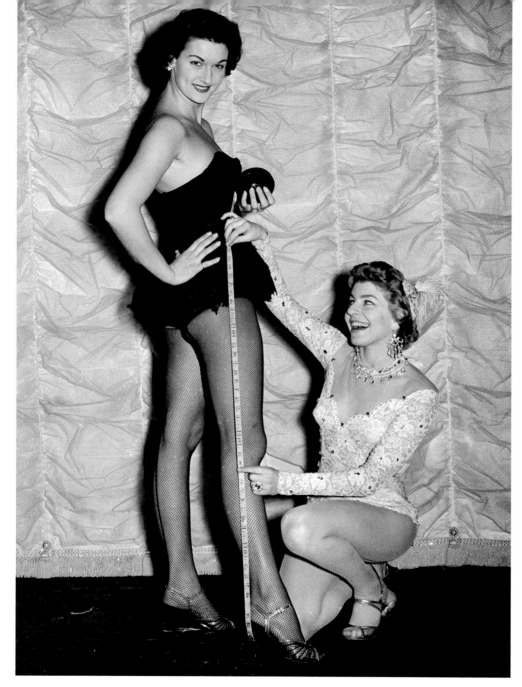

Actress Helen Brown has her legs measured for *The Longest Legs in Show Business 1956* competition.
25th February, 1956

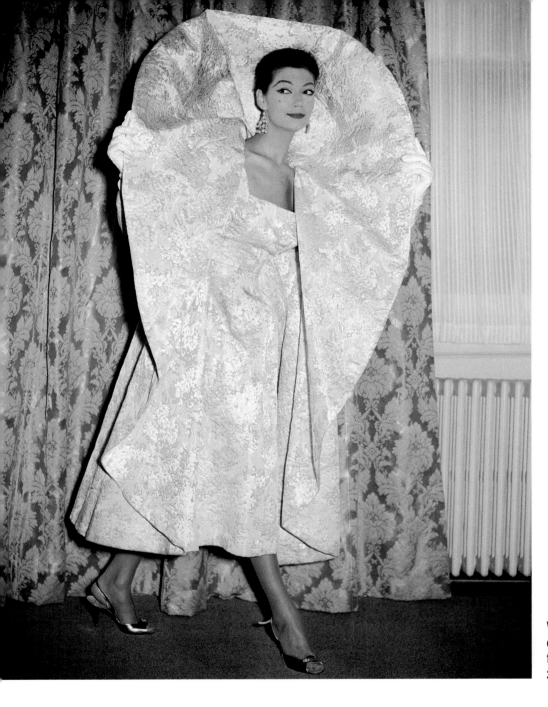

White and gold brocade
ensemble by Jacques Faith
from Lurex House.
26th September, 1956

Model Barbara Mendoza
wears a dress and jacket by
Charles Creed who at the
time had his own couture
house in London.
24th January, 1957

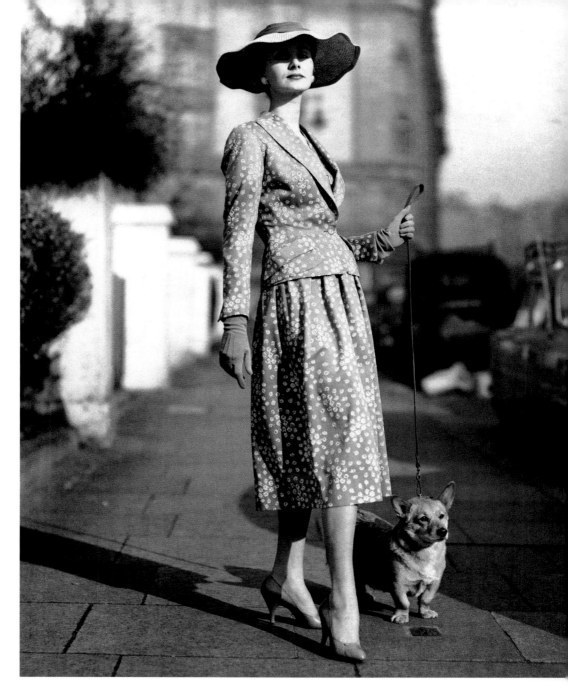

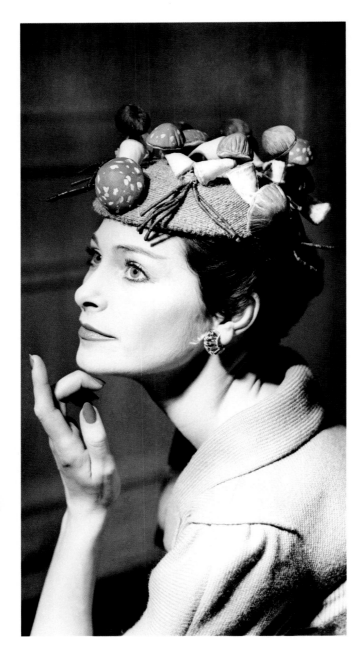

Facing page: A young woman sits in a Kentish orchard.
1st April, 1957

Hat with mushrooms and toadstools by millinery designer, Simone Mirman.
24th January, 1957

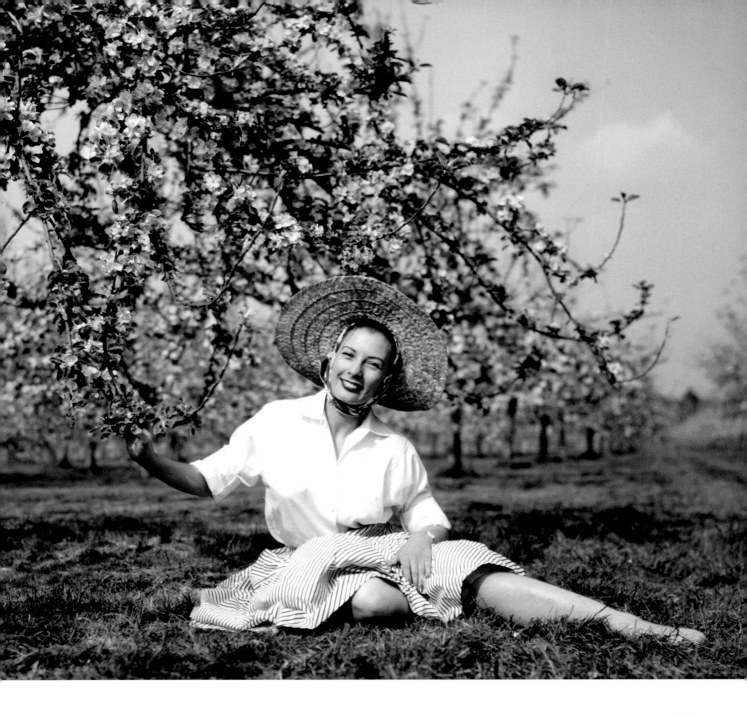

Facing page; Autumn hats for men at Londonderry House.
31st October, 1957

Jersey knit t-shirt and jeans, part of the Tommy Steele Jive Fashions by Teddy Tinling.
14th May, 1957

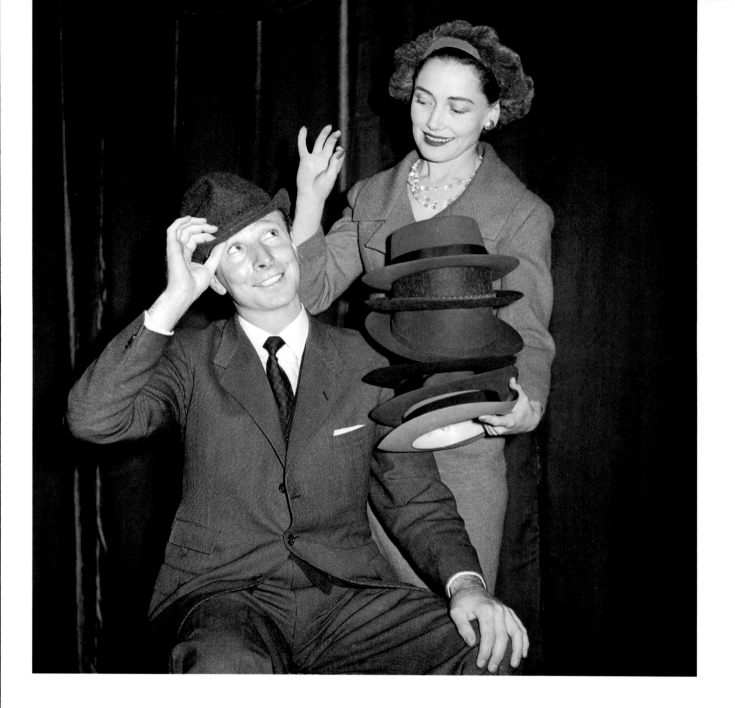

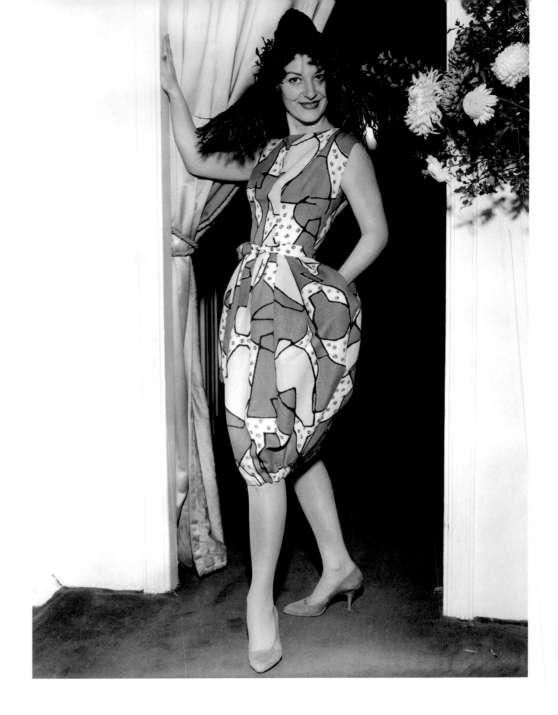

'Balloon' beach outfit
in printed linen by
Selincourt & Sons.
7th November, 1957

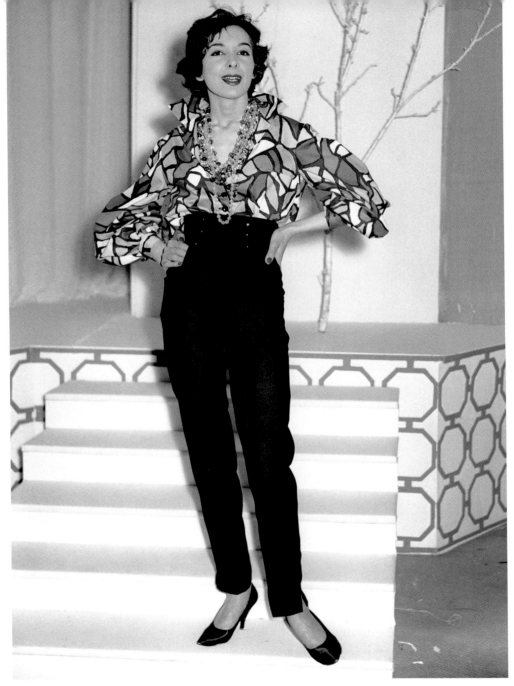

Black piqué high waisted trousers with harlequin printed shirt by Horrockses.
26th February, 1958

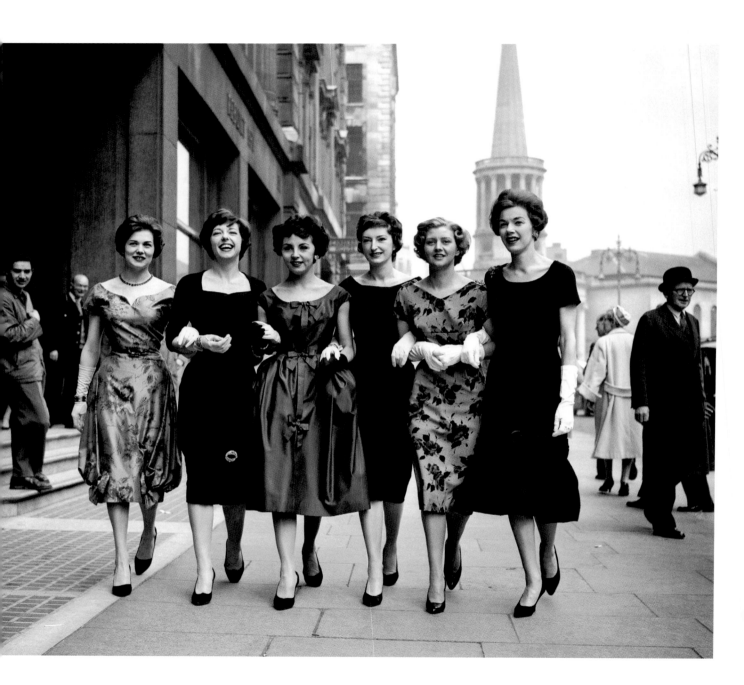

Facing page: The Marcusa
autumn range of dresses.
30th April, 1958

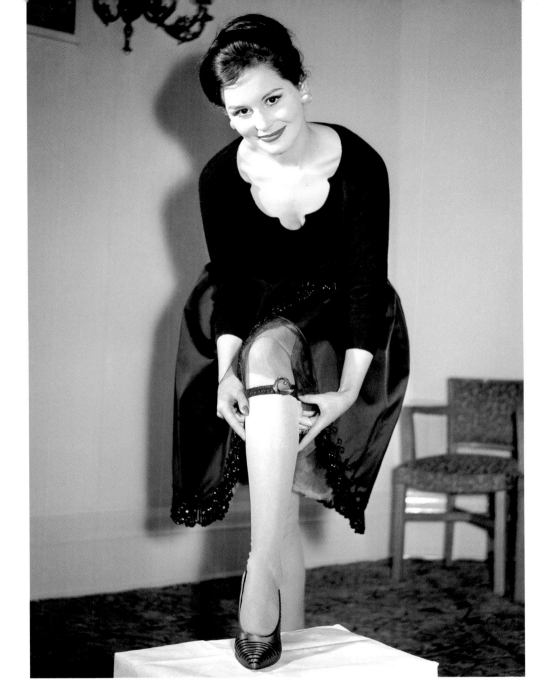

Black satin cocktail skirt
and rose garter.
2nd February, 1959

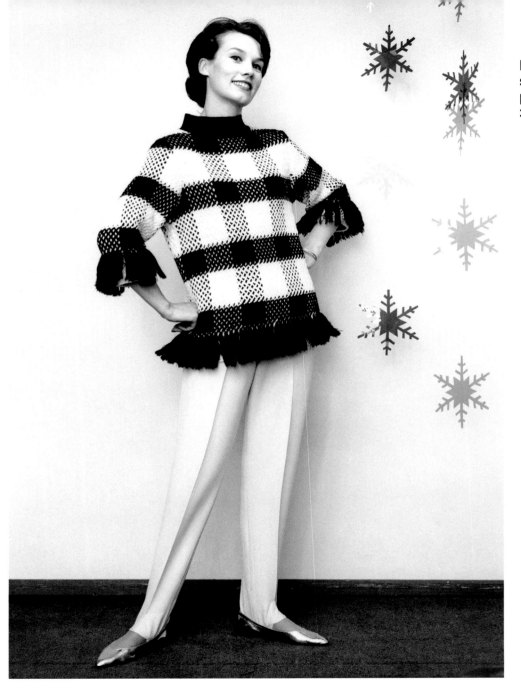

Pink and mulberry check ski sweater with pale pink ski pants by Lilywhites.
3rd October, 1961

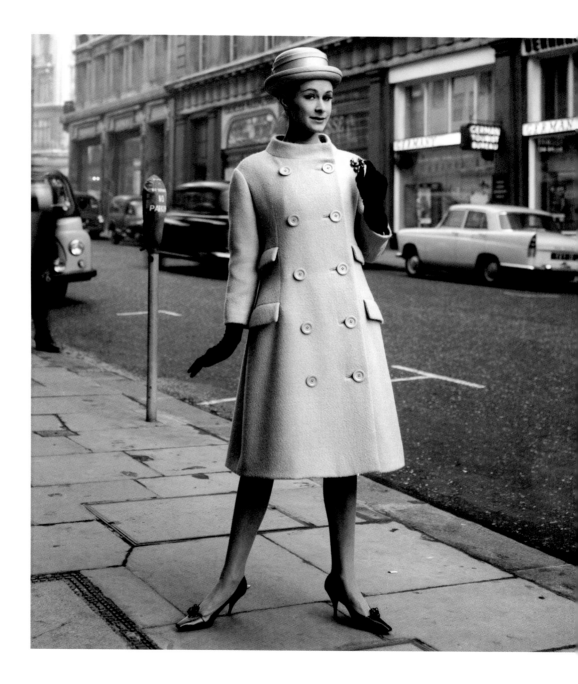

A green tweed coat by Christian Dior from his London spring collection for 1962.

22nd November, 1961

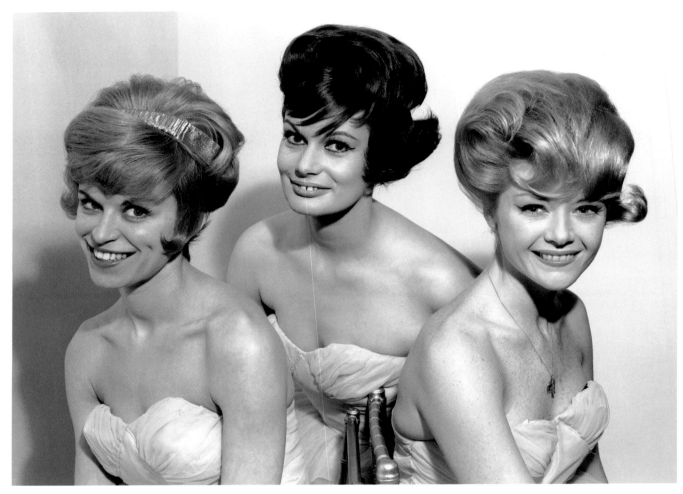

L'Oreal of Paris shows the latest hairstyles at its new London showrooms in Berkeley Square.
9th January, 1962

Facing page: Actress Francesca Annis in London to audition for a part in Noel Coward's West End play, *Sail Away*.
25th January, 1962

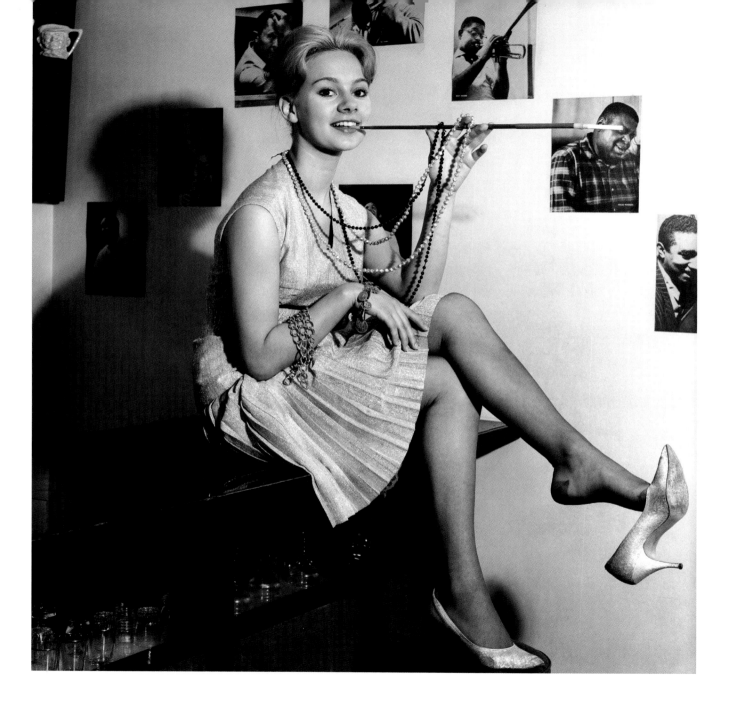

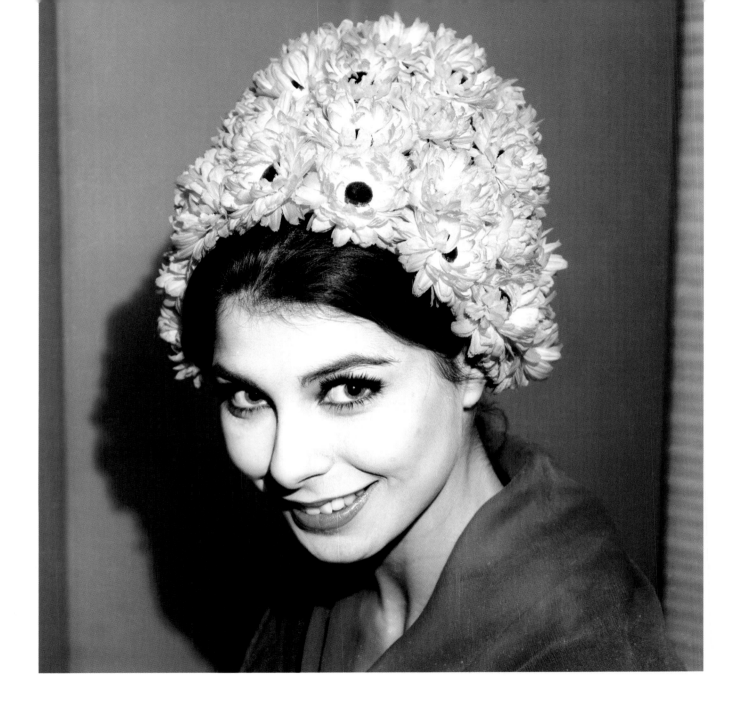

Facing page: Orange marigold turban by Simone Mirman from the spring collections of the Incorporated Society of London Fashion Designers.
29th January, 1962

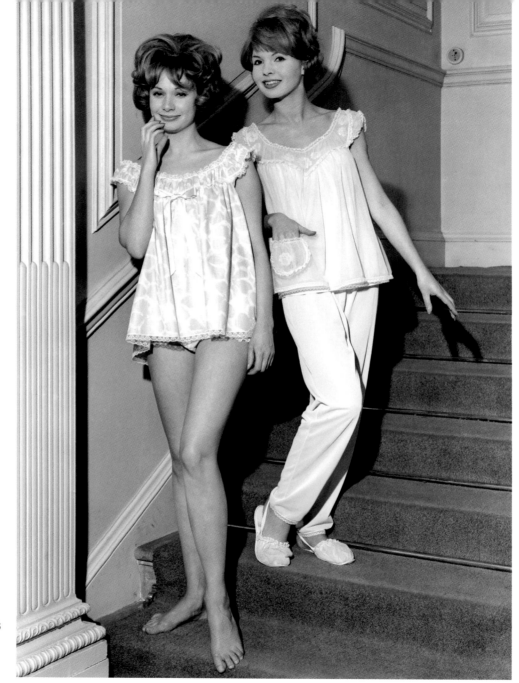

'Baby Doll' pyjamas in printed cotton cambric (L) and full length nylon pyjamas from the Kayser spring collection.
31st January, 1962

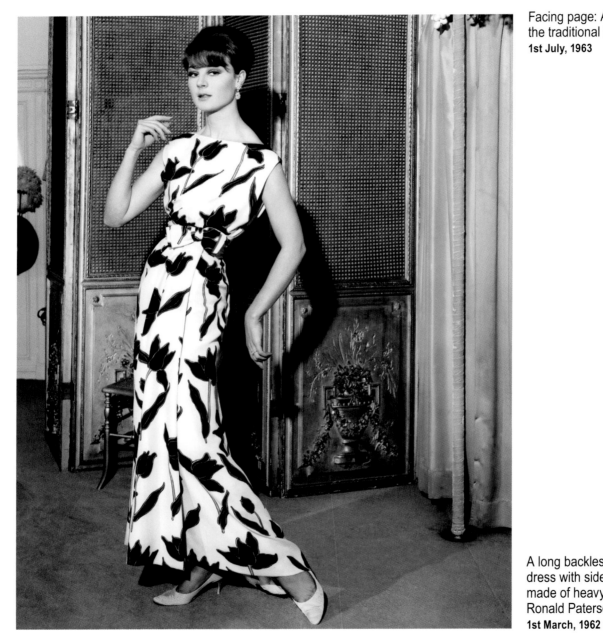

Facing page: A new look for the traditional bowler hat.
1st July, 1963

A long backless evening dress with side draped skirt, made of heavy silk crepe, by Ronald Paterson.
1st March, 1962

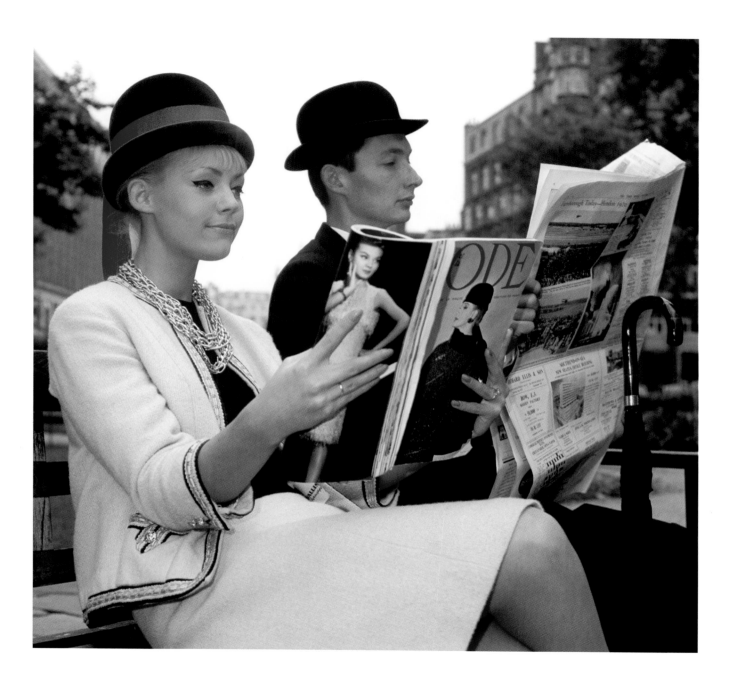

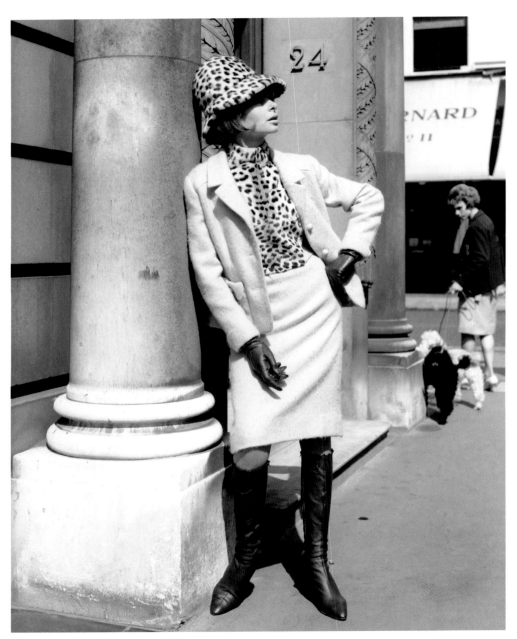

A safari suit by Ronald Paterson in yellow wool, worn with 'leopard-skin' polo-neck sleeveless sweater and matching hat. The knee-high brown leather boots are by Holmes of Norwich.
19th August, 1963

PVC coat with zip front and detachable throat tab, lined with tartan cotton, worn with high black leather boots.
20th November, 1963

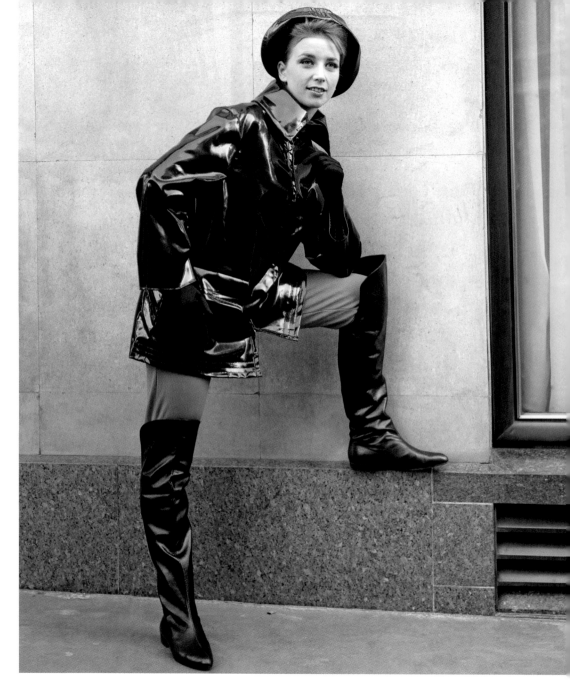

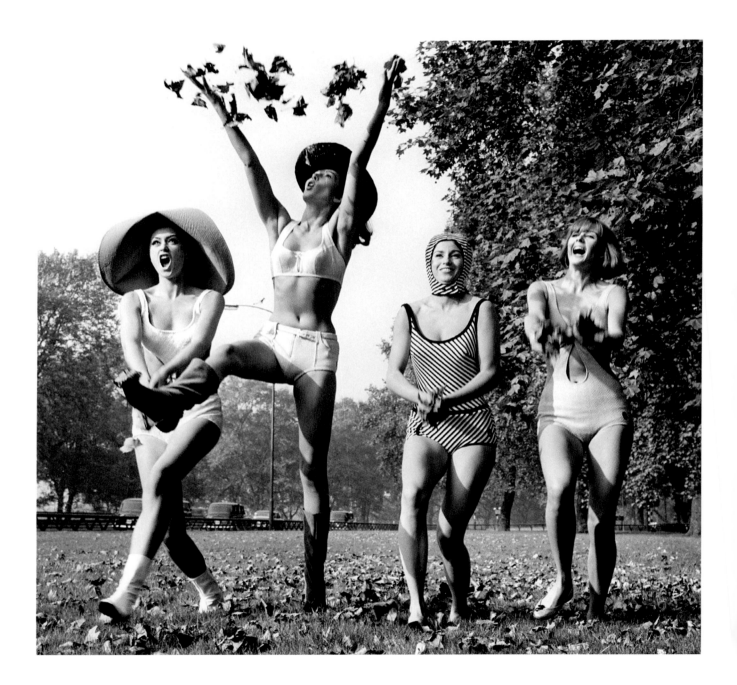

Facing page: Beachwear
from the Triumph
International spring/summer
fashion show for 1966.
20th October, 1965

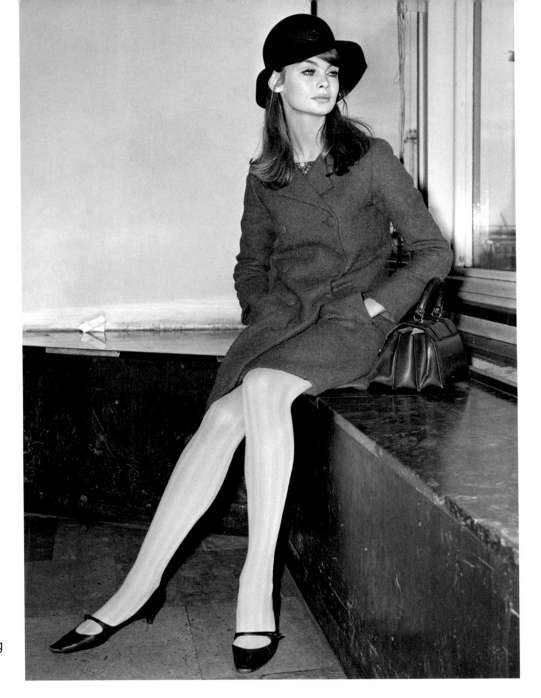

Top model Jean Shrimpton
at Heathrow Airport, waiting
for a flight to Rome.
23rd February, 1966

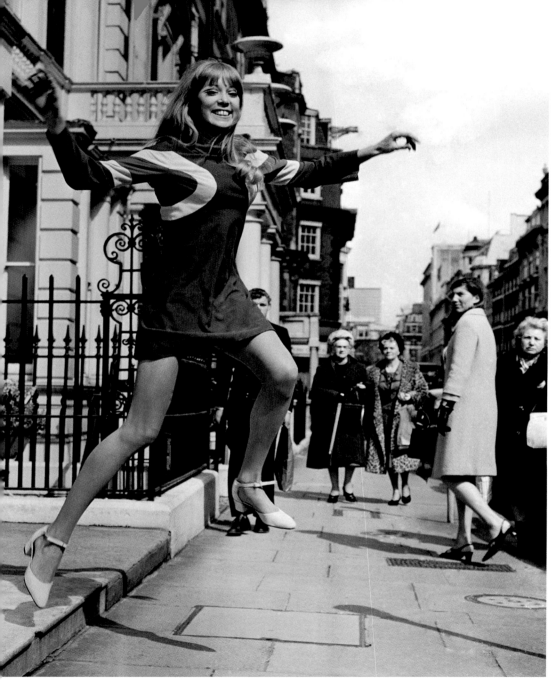

Facing page: Calling themselves The British Society for the Advancement of the Mini-Skirt these young women are protesting outside Christian Dior's fashion house about his new below-the-knee creations.
6th September, 1966

Patti Boyd, top model and first wife of George Harrison, wears a dress designed by Ossie Clark.
21st March, 1966

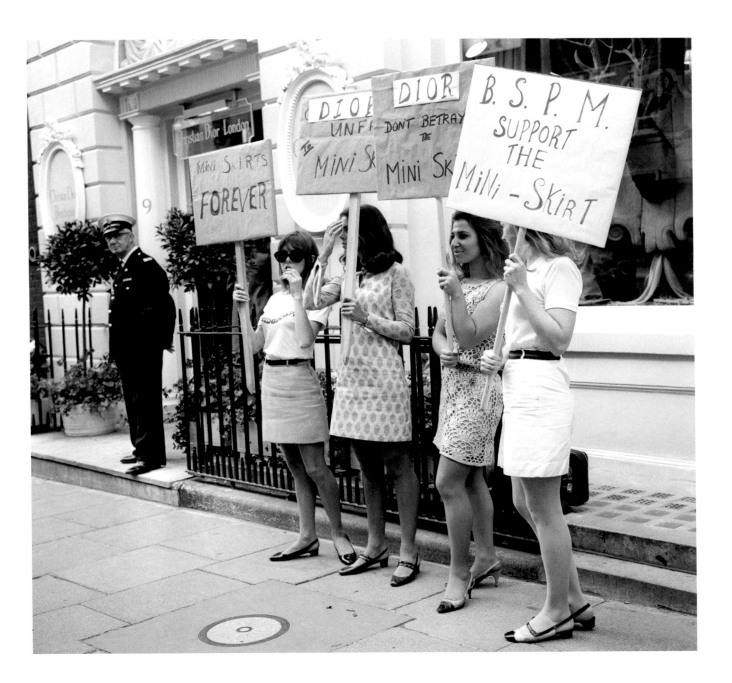

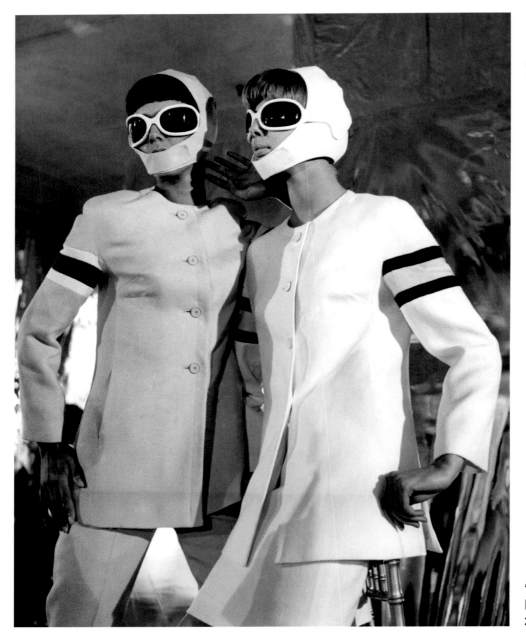

Facing page: Bridal underwear and housecoat modelled at the Kayser spring collection fashion show.
10th January, 1967

'Hotting-Up Suits' by the Reldan-Digby Morton Group.
21st September, 1966

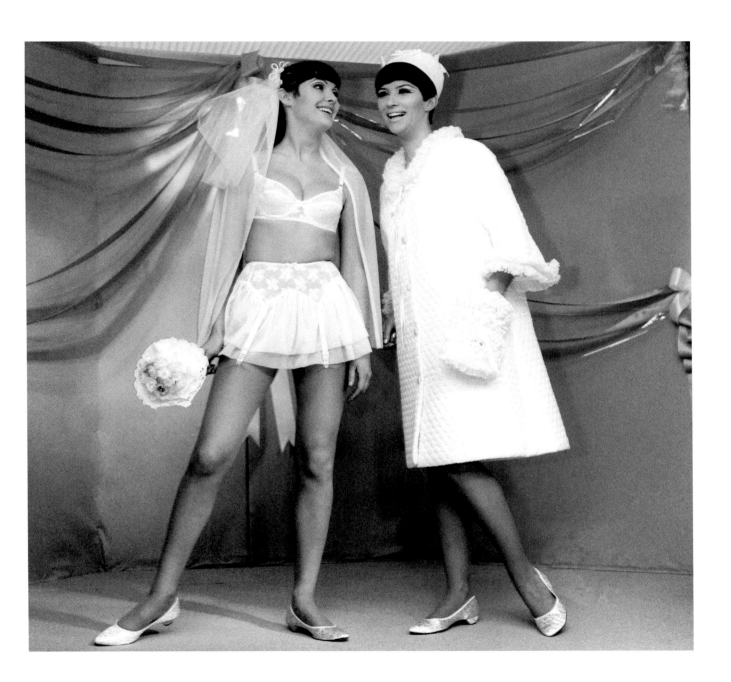

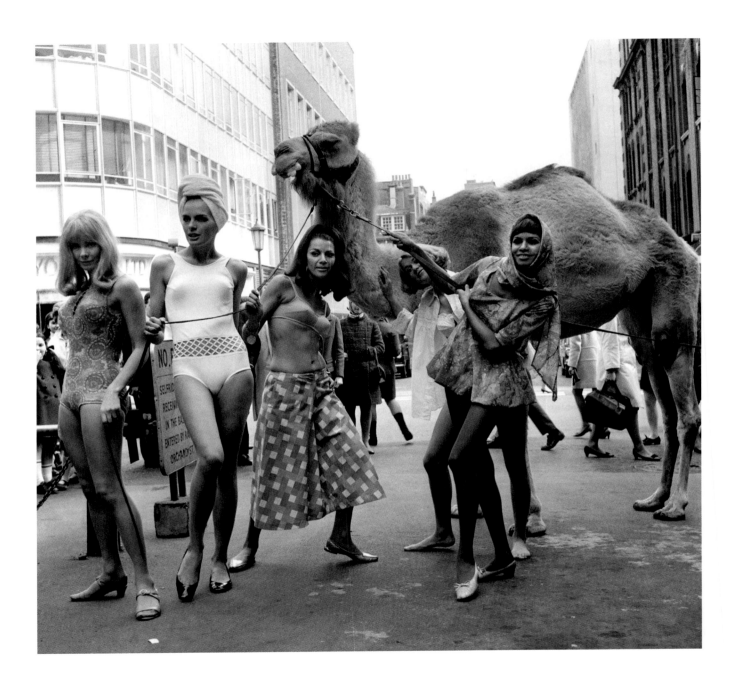

Facing page: Fashion from the Jantzen Maroc 7 collection for Miss Selfridge, worn by models who appeared in the film *Maroc 7*, which was made on location in Morocco.
30th March, 1967

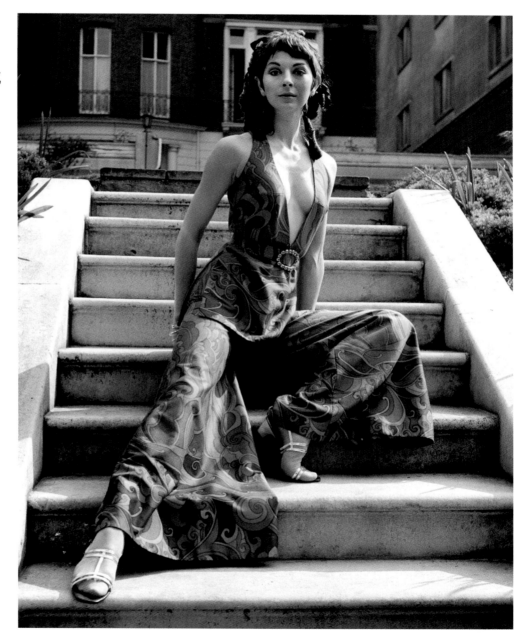

A playsuit in cotton gabardine from Fergusons.
11th May, 1967

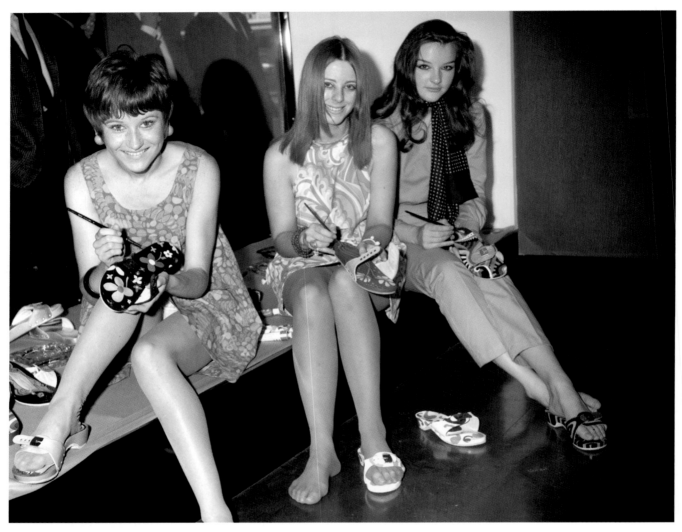

Three students from the London College of Fashion hold a 'Beat the Clock' marathon of psychedelic painting in the window of a Knightsbridge store. The op and pop art designs are being painted on Dr Scholl's sandals. The students are (L-R) Sally Mathias, Serena French, and Angela Collins.
26th July, 1967

Facing page: Mary Quant (R) shows her new shoe designs in London.
1st August, 1967

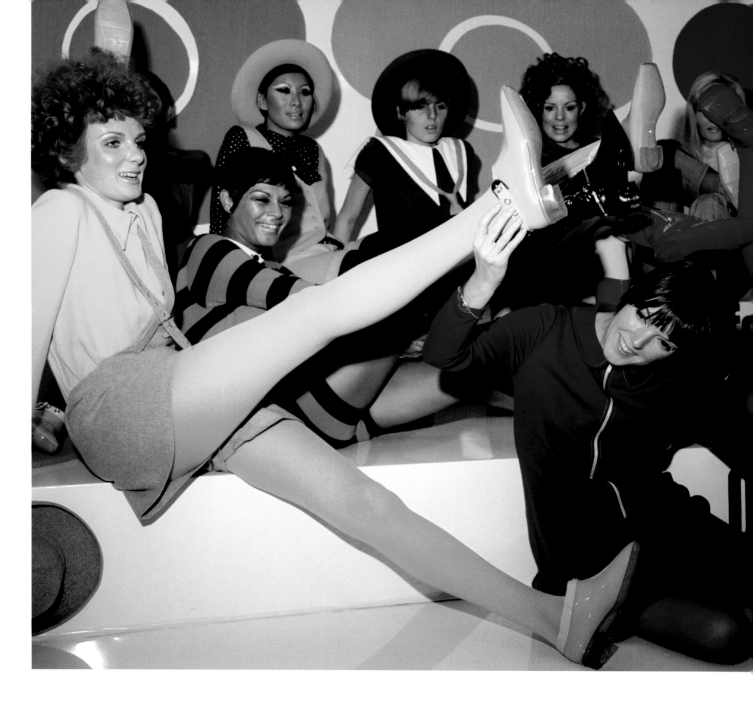

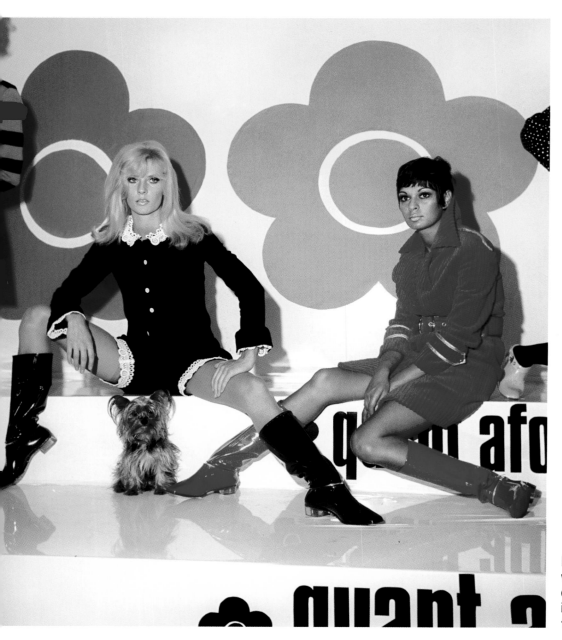

Facing page: British models at Heathrow Airport, prior to their departure for Moscow. They were working for the British Clothing Export Council, taking part in the Soviet Union's International Festival of Fashion.
1st September, 1967

Designs by Mary Quant who was known for her pop art designs, and was one of the instigators of the mini-skirt.
1st August, 1967

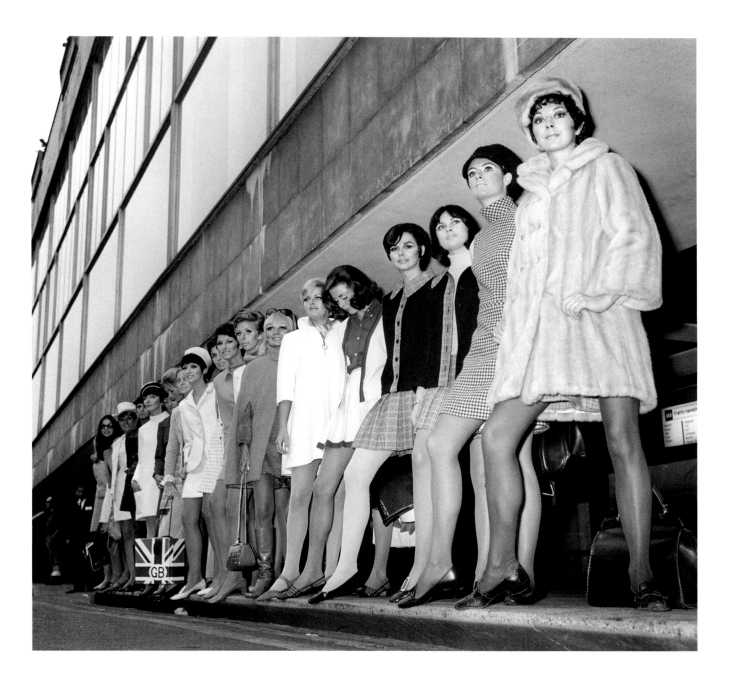

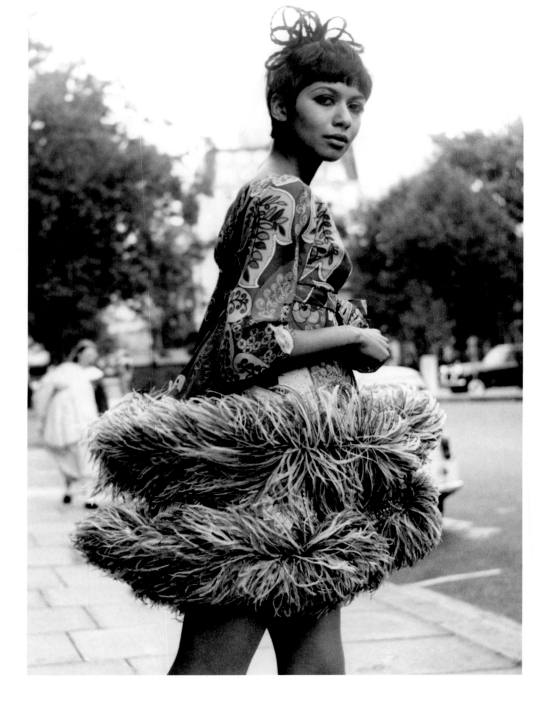

Dress in printed chiffon
with a double hem of
ostrich feathers.
5th September, 1967

Man's three-piece suit in green/blue check made from 100% Evlan, a toughened fabric that has a crease resistant finish.
26th February, 1968

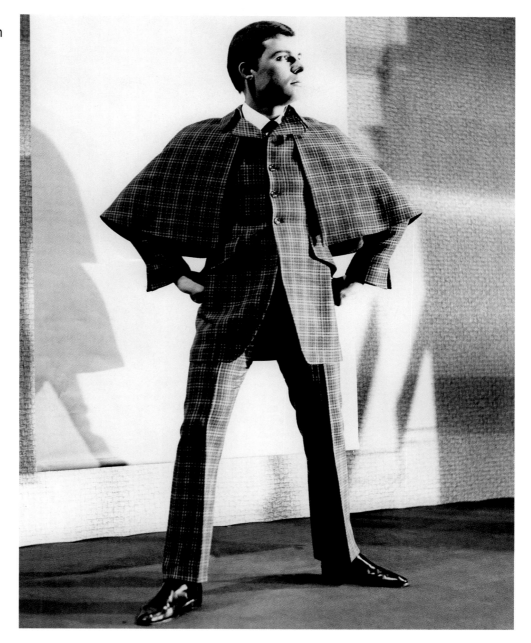

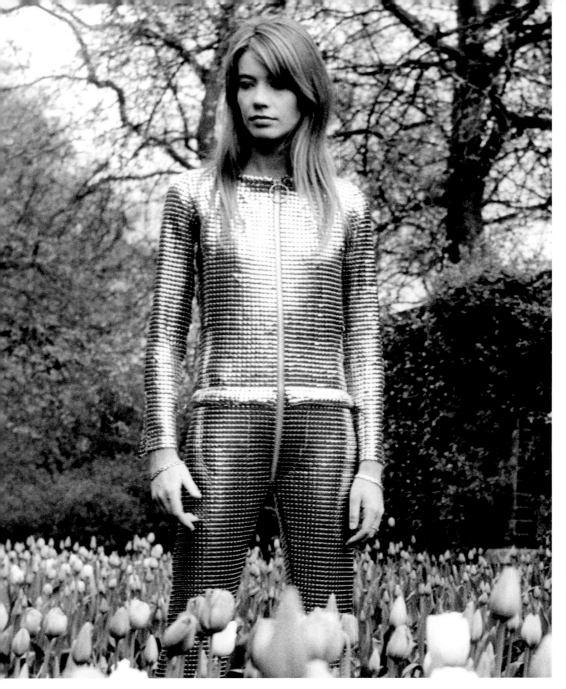

Facing page: Marlene McDonald, a saleswoman in the Lady Jane Boutique in Carnaby Street, models what appears to be the latest craze, a mini-skirt embellished with a coat of arms individually designed for the wearer.
9th December, 1968

French singer, Francoise Hardy, wears an all-metal trouser suit at the Embankment Gardens in London. The suit has 2,000 links and takes over an hour to get on.
23rd April, 1968

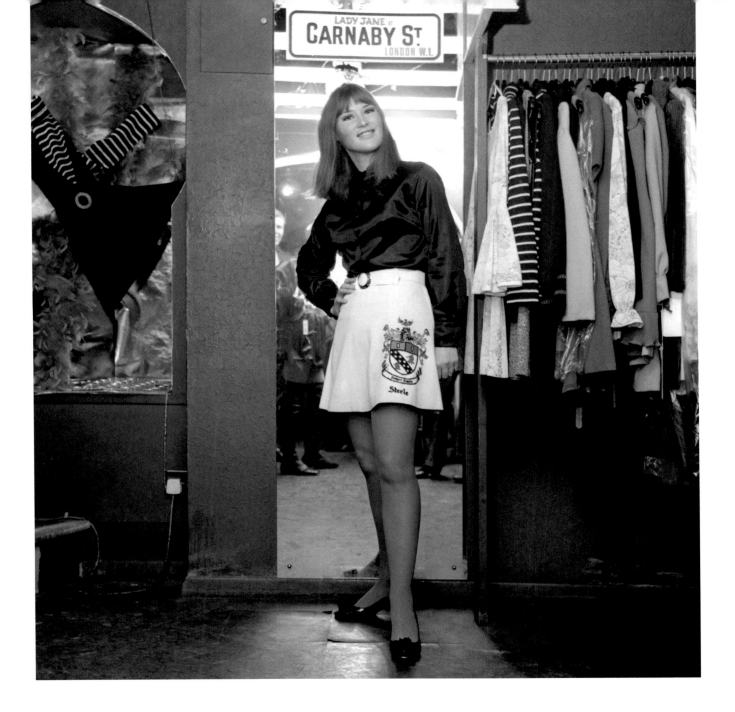

Facing page: This hairstyle is entitled the 'Fra Angelico' and is inspired by the Italian painter of religious frescoes.
26th July, 1969

Breaking away from convention, with tights that have contrasting coloured legs.
18th April, 1969

A model wears a maxi-dress
from the winter collections.
1st September, 1969

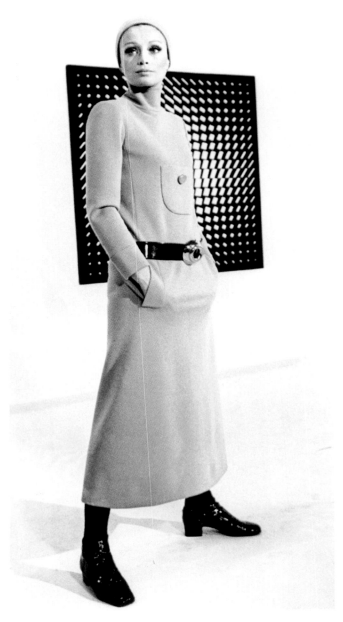

Facing page: An outfit from
the Christian Dior autumn
collection.
9th September, 1969

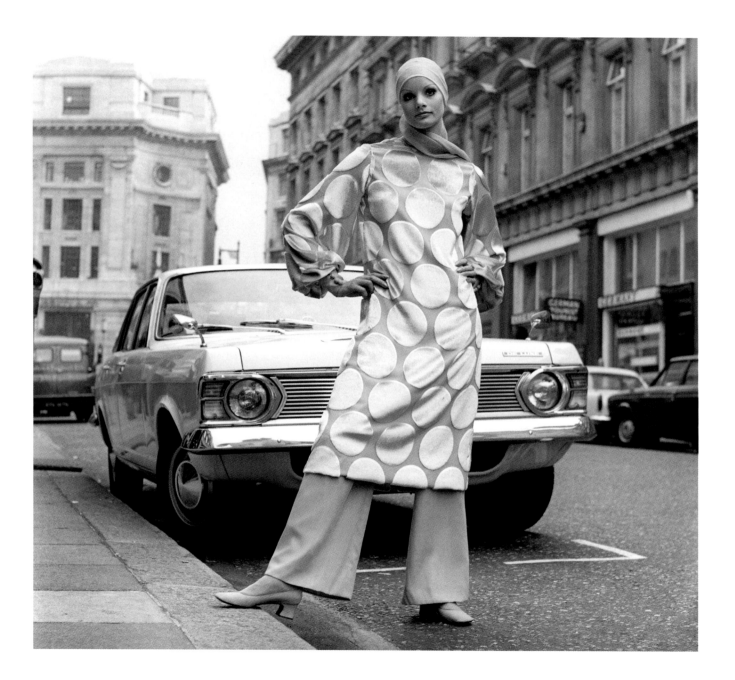

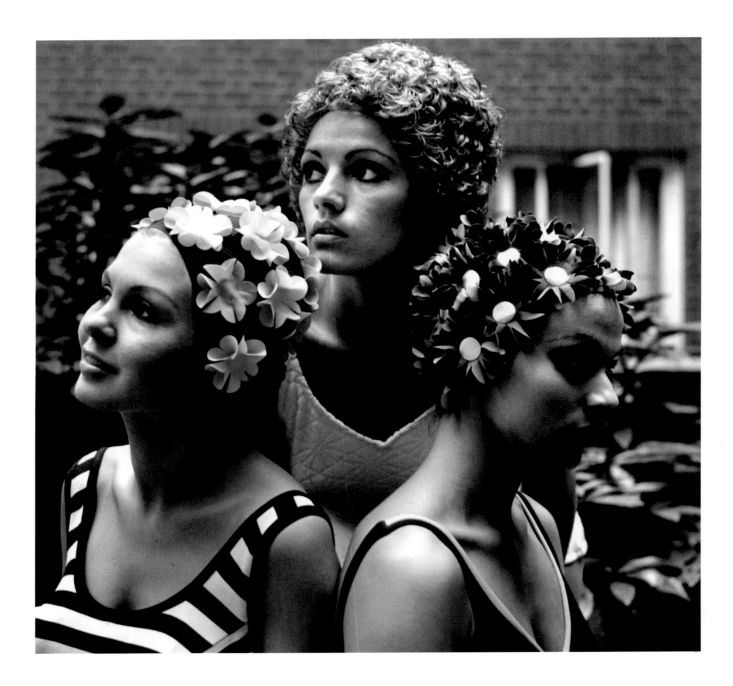

Facing page: A selection of swimming caps by Kleinet.
18th September, 1969

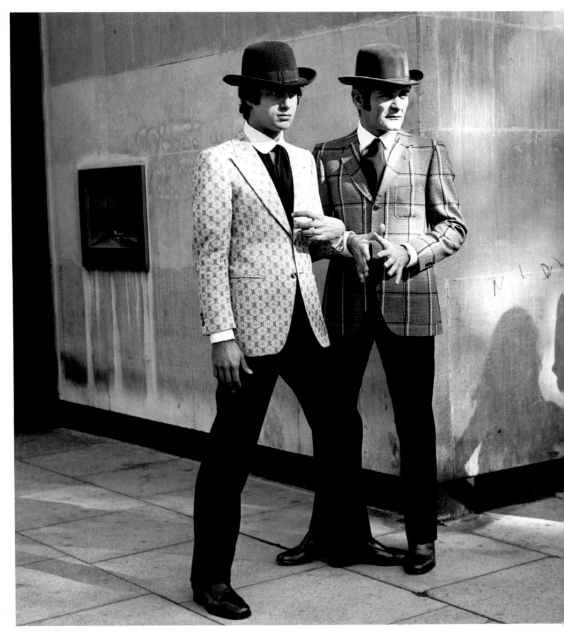

The latest menswear from Italy, being shown in London.
30th September, 1969

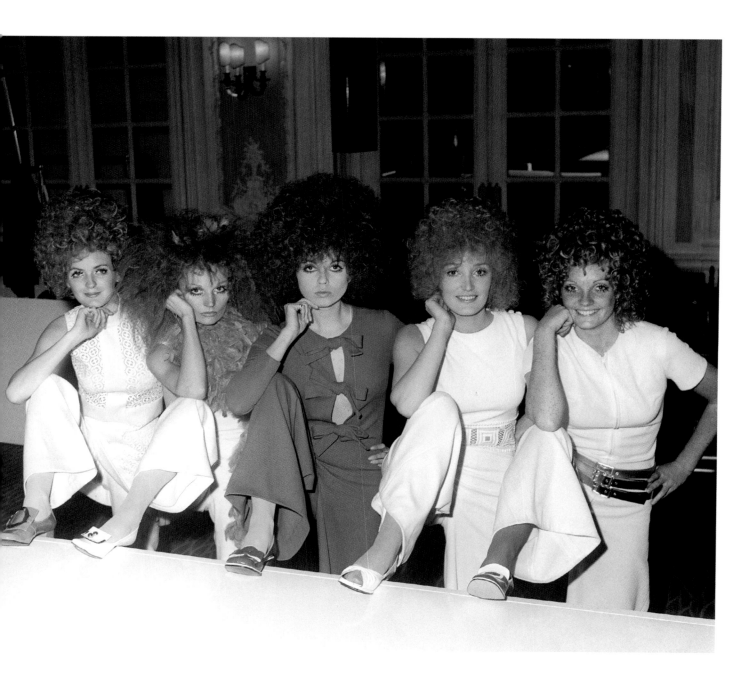

Facing page: The 1970s scene in shoes – or is it hair? Shoes (L-R) 'Etna' and 'Couture' by Lotus, 'Heide' by George W Ward, 'Elstree' by Rayne and 'Astral' by Saxone.
12th January, 1970

'His and Hers' designs by Yves St Laurent, shown at the opening of his new menswear shop Rive Gauche in Brompton Road, London.
7th December, 1970

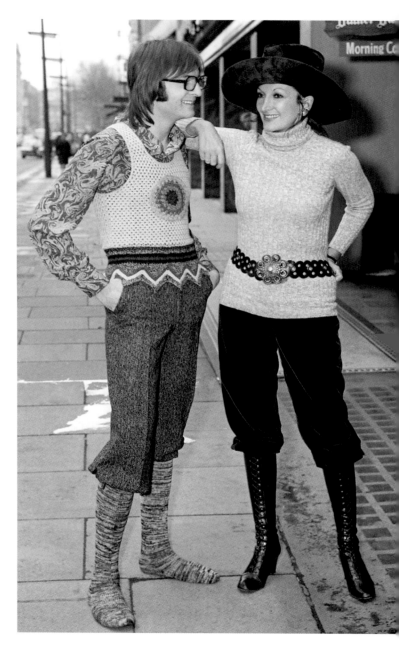

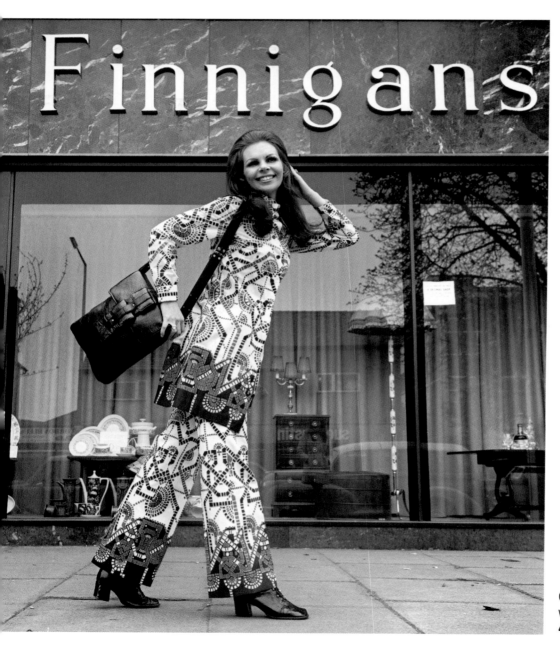

Facing page: Marilyn Ward, the reigning Miss England, outside her shop, The Little Bo-tique, in Hampshire.
8th May, 1971

Cotton cat suit by Elgor in white, navy, red and tan.
4th May, 1971

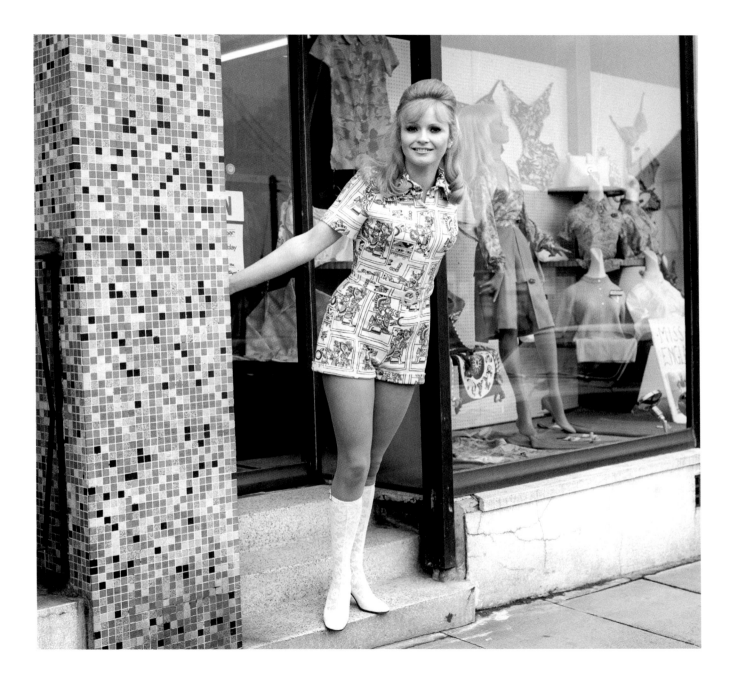

Jaeger fashion for 1971: (L)
brown print dress with green
suede belt, (R) mauve print
dress, also with suede belt.
2nd June, 1971

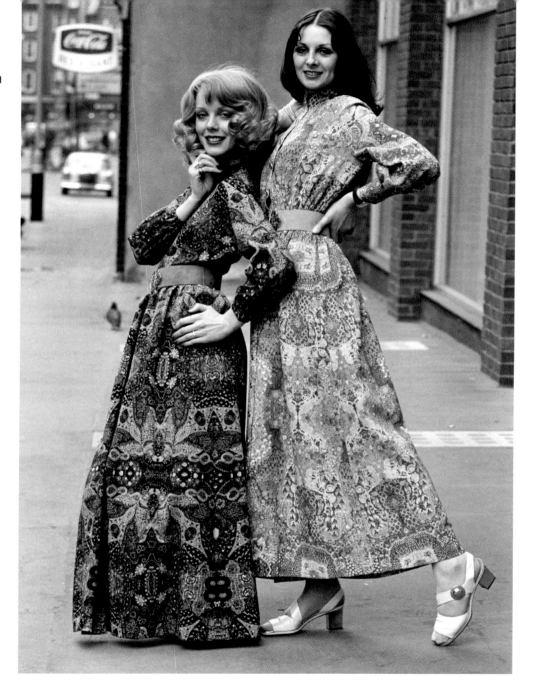

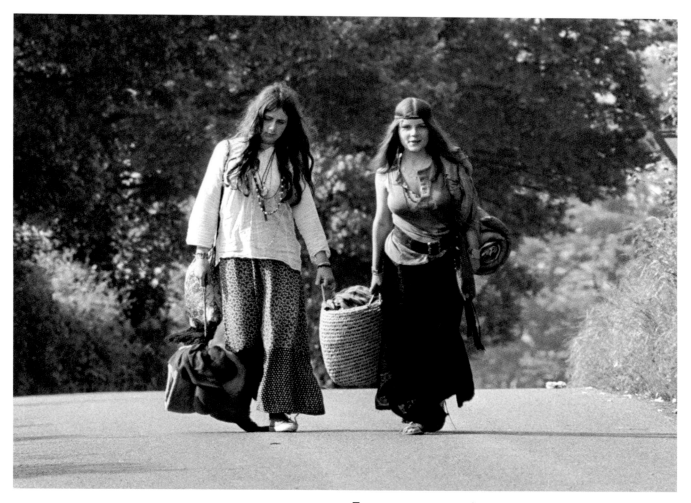

Two young women at the
Glastonbury Festival.
23rd June, 1971

A knee length dress made with discs, from the Clive Couture collection.
13th July, 1971

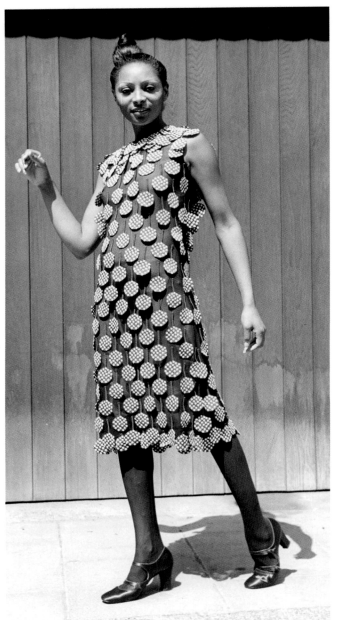

Facing page: Models wearing 'His and Hers' creations by Yves St Laurent at the rehearsal for a charity fashion show to be shown to Princess Margaret at London Planetarium. They have jersey trousers, suede shoes, printed shirts, knitted vests and showerproof jackets.
27th September, 1971

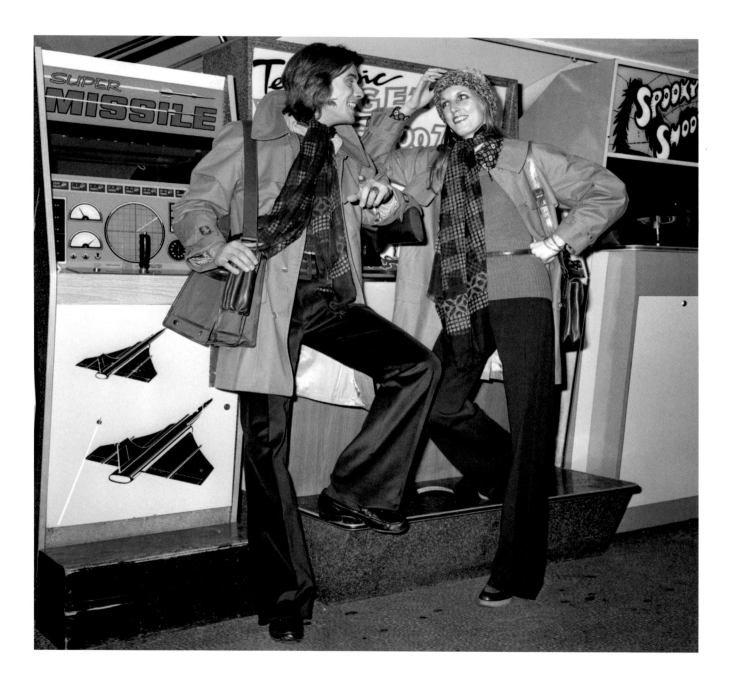

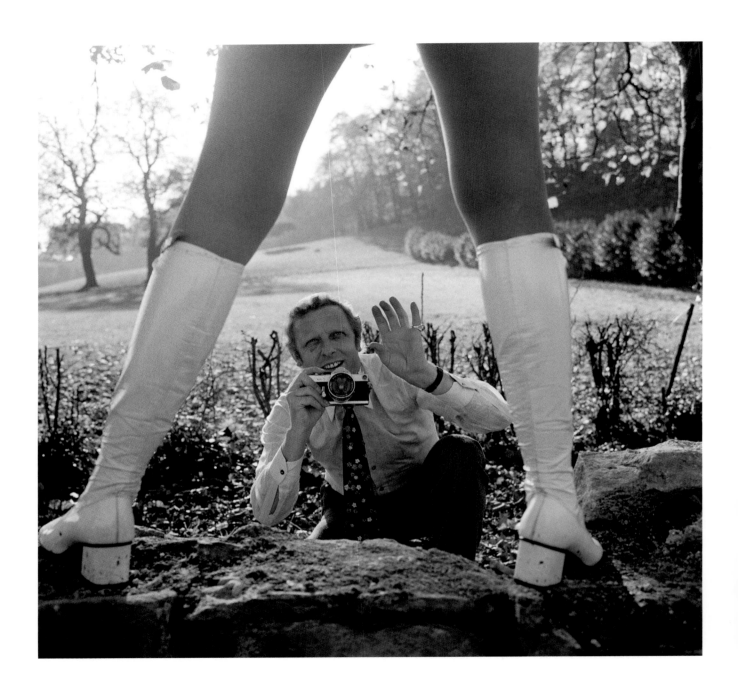

Facing page: Former Radio Luxembourg disc jockey, Don Moss, photographs a model wearing white PVC boots.
15th November, 1971

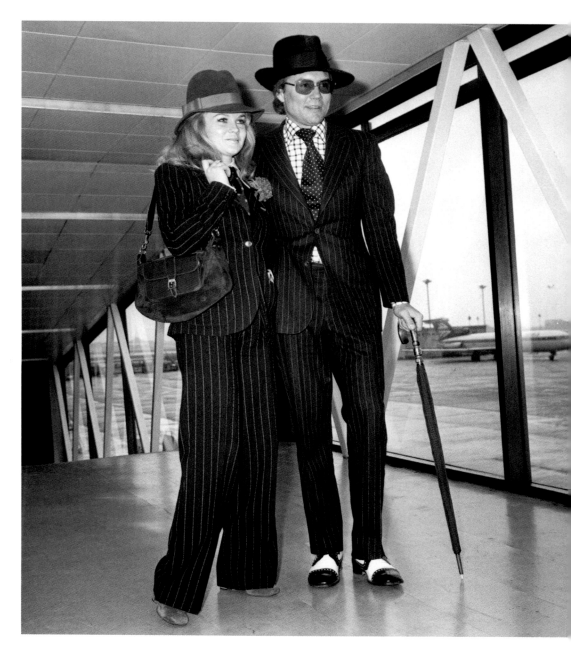

Actress Ann-Margret at Heathrow Airport in a man's style suit and trilby hat, with a red carnation buttonhole. Her companion, Roger Smith, wears a similar suit in navy blue with chalk stripe. They are flying to Los Angeles, where she will promote her film, *Carnal Knowledge*.
28th January, 1972

A coffee and white striped silk dress from Mattli's spring collection.
3rd February, 1972

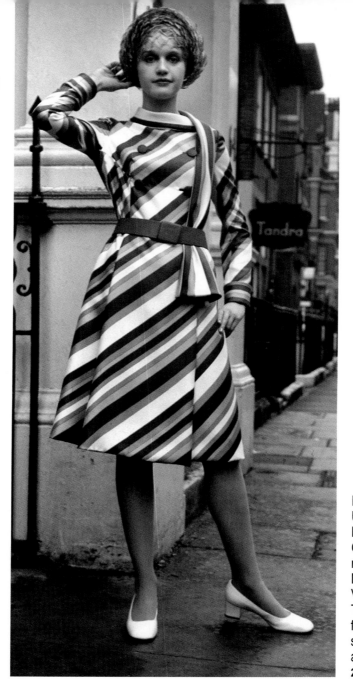

Facing page: Manchester United soccer star George Best surrounded by 'The Gangsters', four Manchester models: (L-R) Carolyn Moore, Kathy Anders, Verena and Mandy Preston. They are modelling clothes from a Manchester fashion show organised by Best and a fashion house in London.
29th April, 1972

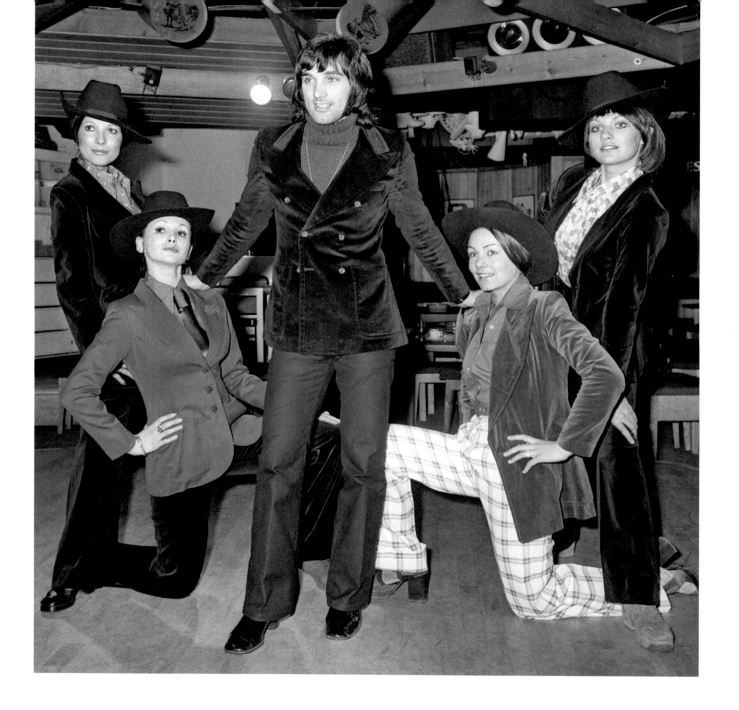

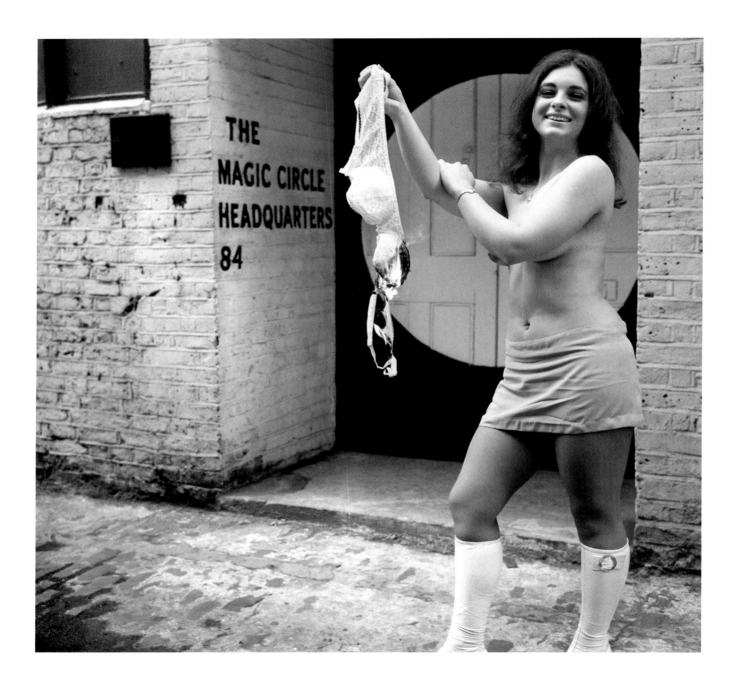

Facing page: Diane Matthews, 23, protests against sex discrimination by burning her bra outside The Magic Circle society headquarters in London. The society is dedicated to magic and illusion and at that time only men were eligible to join.
21st May, 1972

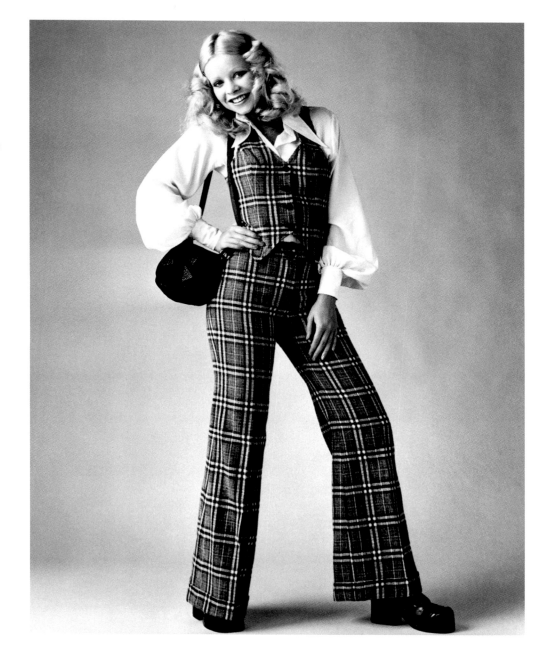

Model Jo Howard wearing an acrylic and wool outfit. She later married Rolling Stone guitarist Ronnie Wood.
29th September, 1972

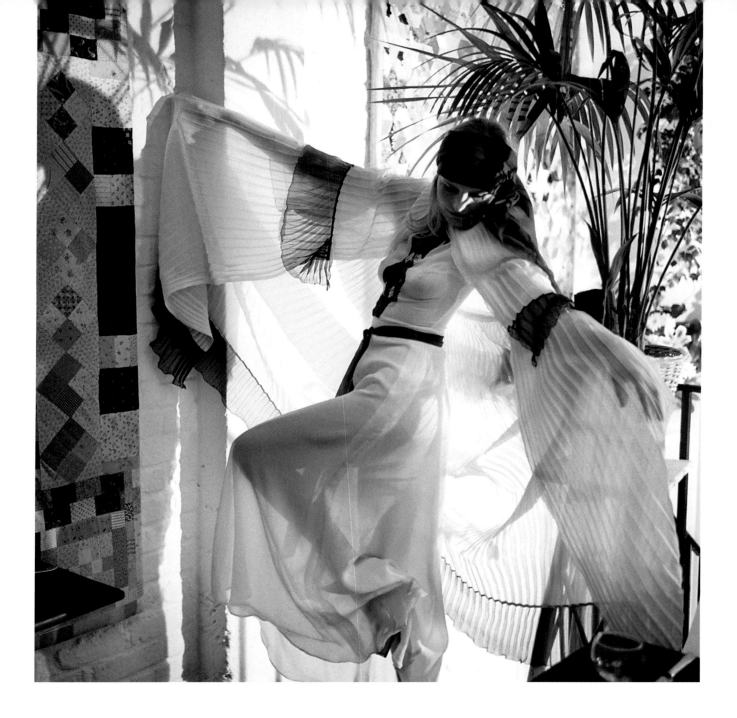

Facing page; Pleated cape over a blue and white embroidered chiffon dress from the Thea Porter summer collection.
5th December, 1972

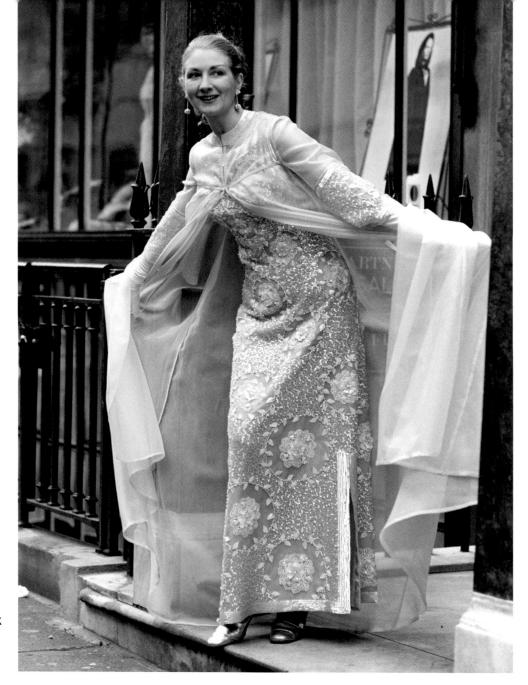

'In Love', a dress by Norman Hartnell, embroidered in pink and green, with organza coat.
6th March, 1973

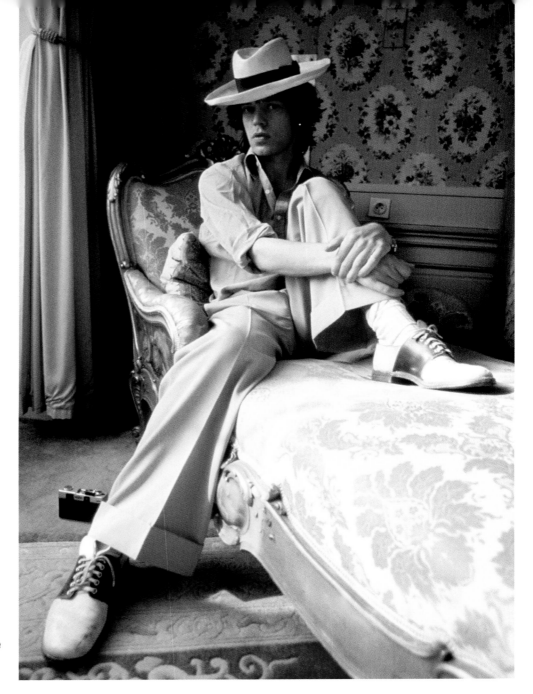

Rock star Mick Jagger of the
Rolling Stones.
1st October, 1973

A grey and tan check trouser suit worn with a shirt and trilby hat, and a printed jumper suit with pleated skirt, both from the Jean Allen autumn and winter collection.

10th June, 1974

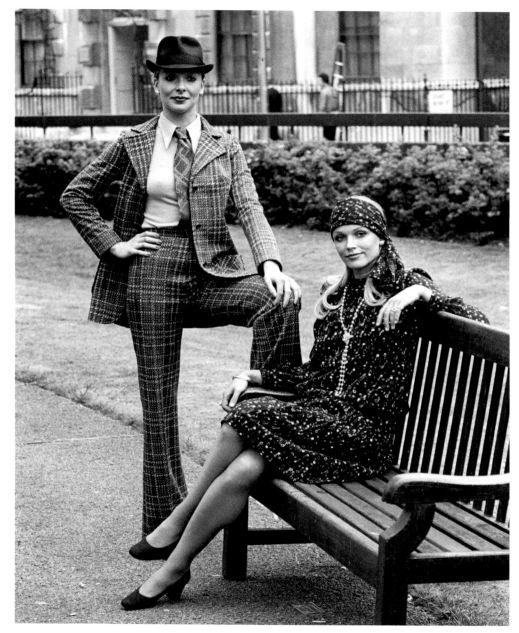

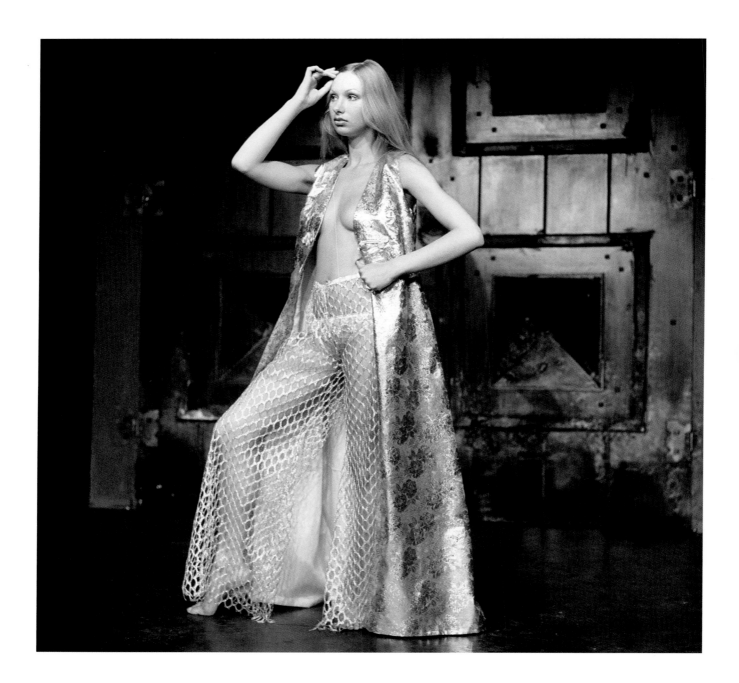

Facing page; An evening suit from the Louette Whitby collection, made up of blue and silver lamé coat over a pair of silver lurex trousers.
26th June, 1974

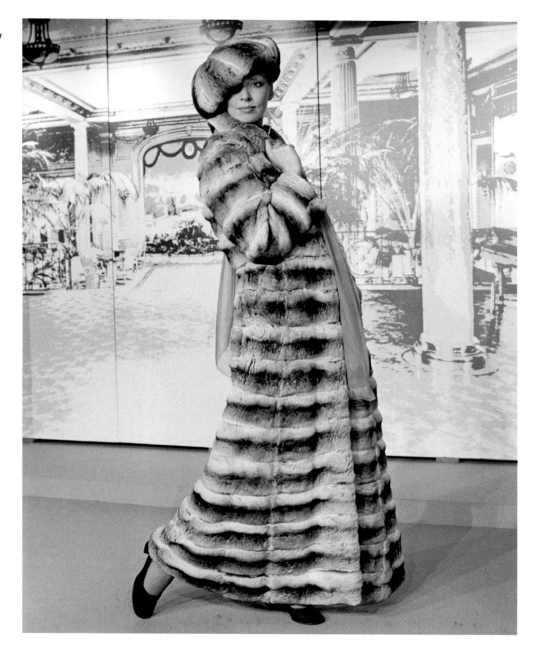

From a range of furs shown at Selfridges's fashion show, this long chinchilla coat is the most expensive at £3,500.
10th September, 1974

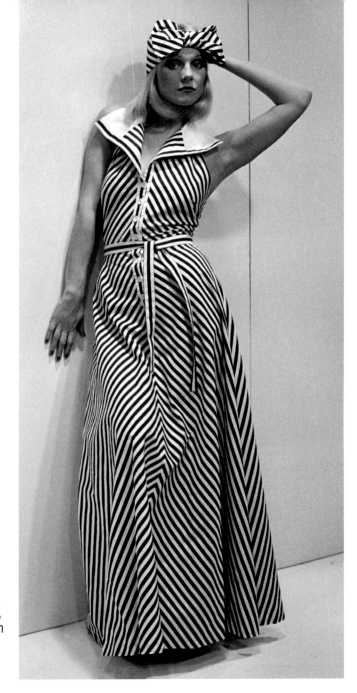

Facing page: A Russian influence in Thea Porter's spring collection, but still in keeping with his reputation for sensuous and exotic clothing: (L) red chiffon, and (R) black georgette, both embroidered in gold.
28th November, 1974

'Apple Tart', a brown and white striped halter neck dress with white piqué collar, teamed with a bandeau, from the Mary Quant summer collection for 1975.
20th November, 1974

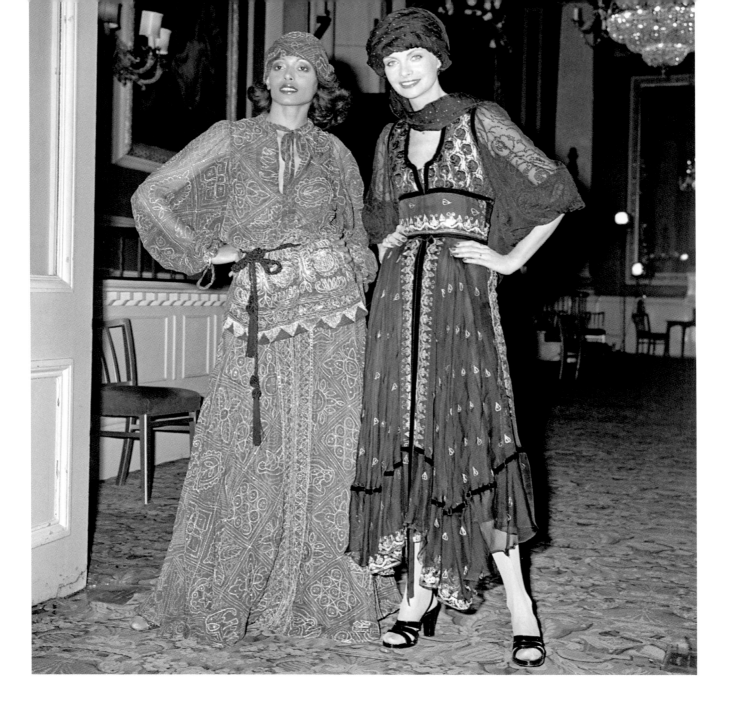

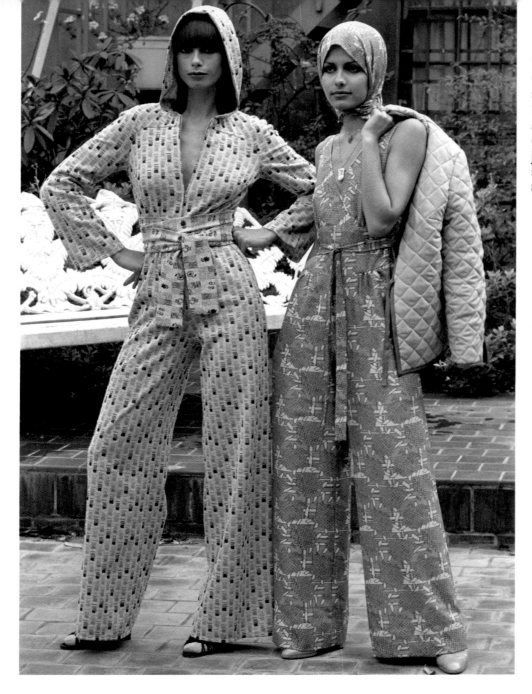

'Dodgem' (L), a jumpsuit in Crimplene, polyester and silk in grey and beige, and 'Arabesque' (R), a light sage and tan jumpsuit in printed Crimplene with a quilted jacket. From the Mary Quant spring collection.
8th October, 1975

Hardy Amies' designs for
cabin crew uniforms for
British Airways' *Concorde*.
14th January, 1976

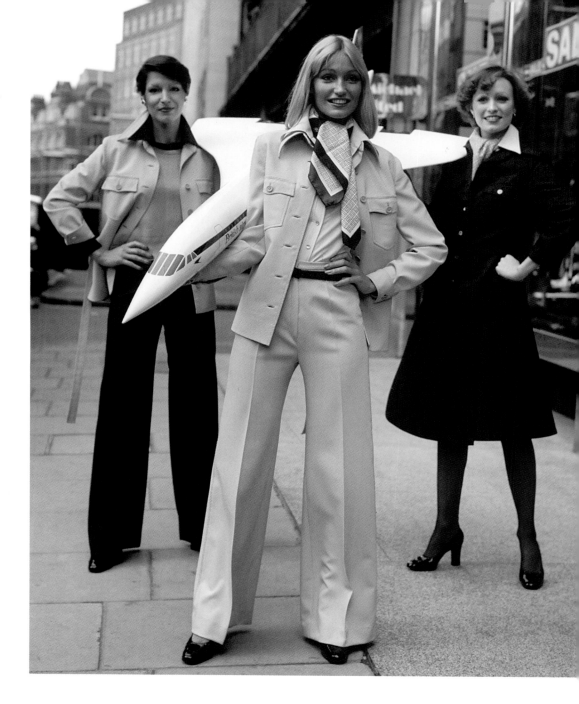

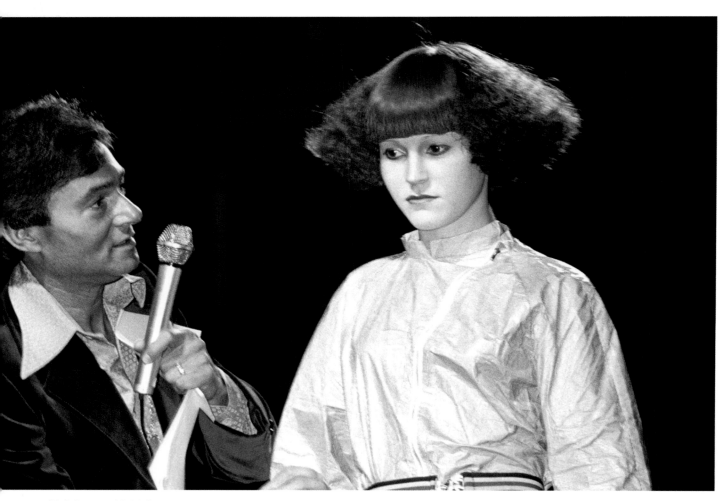

Hairdresser Vidal Sassoon
introduces one of his
creations during a two-day
spectacular at the Royal
Albert Hall.
26th January, 1976

Navy and white striped shirt with matching headscarf, worn with a navy skirt, from the Mary Quant collection.
7th April, 1976

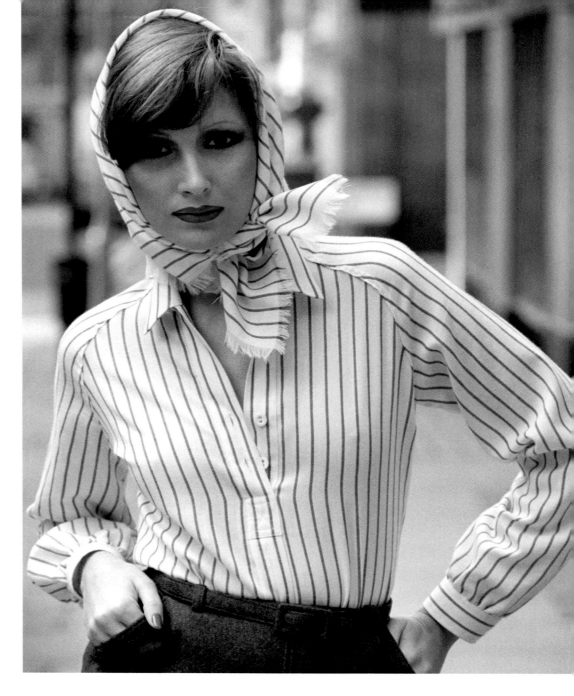

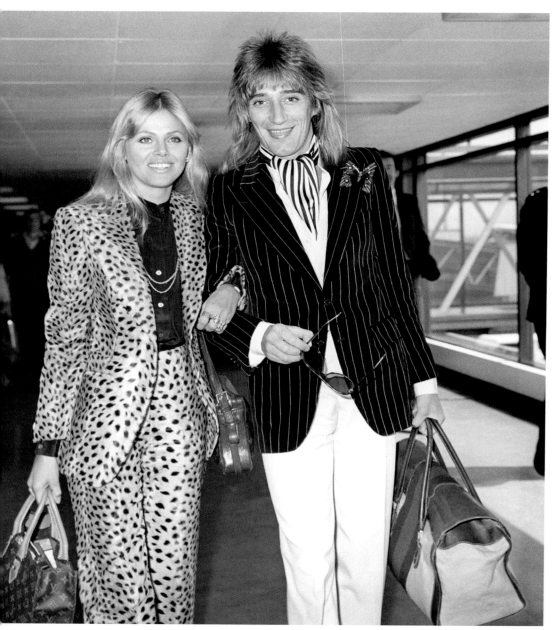

Facing page: Soccer star Kevin Keegan (L) with Gerry Francis (C) and Mick Channon at Heathrow Airport before flying to Glasgow for the final match of the British Championship.
12th May, 1976

British pop star Rod Stewart and Swedish film actress Britt Ekland, on arrival from Paris.
28th April, 1976

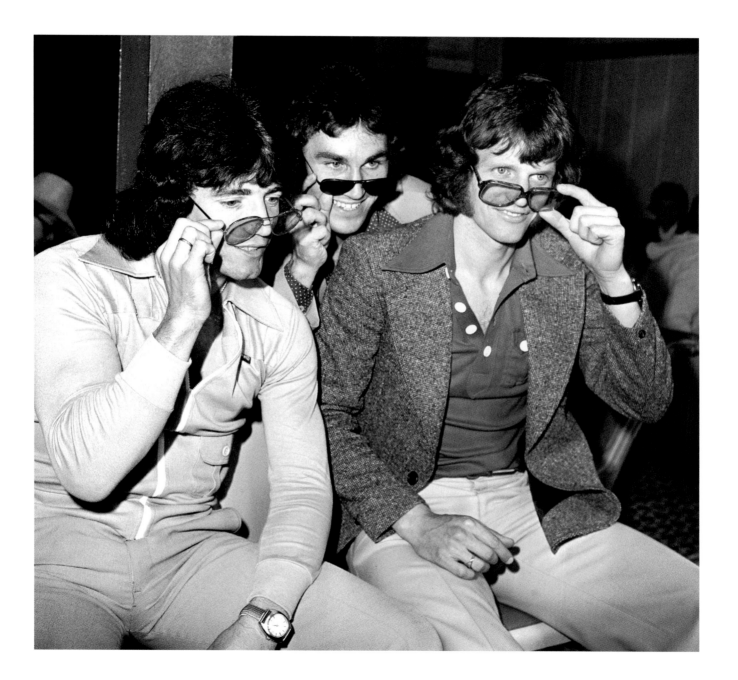

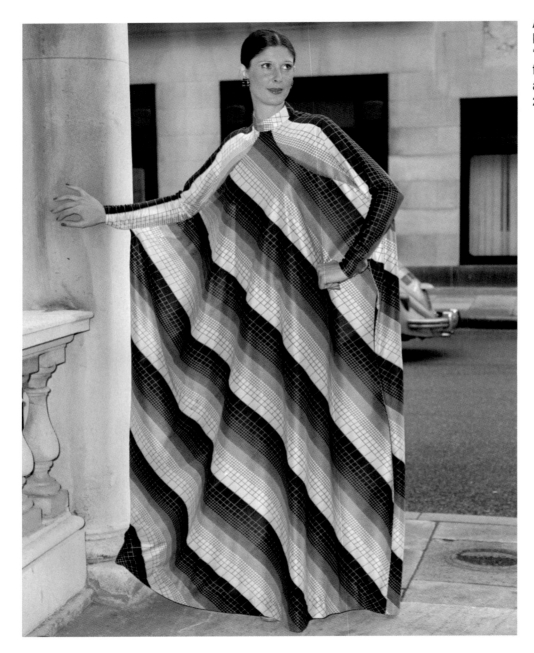

A black and white checked kaftan-style dress called 'Chequers', in 100% dicel, from the Jean Allen spring and summer collection.
26th November, 1976

Actor Ian Ogilvy, who was to play Simon Templar in a new television series *The Return of the Saint*, surrounded by young women.
28th April, 1977

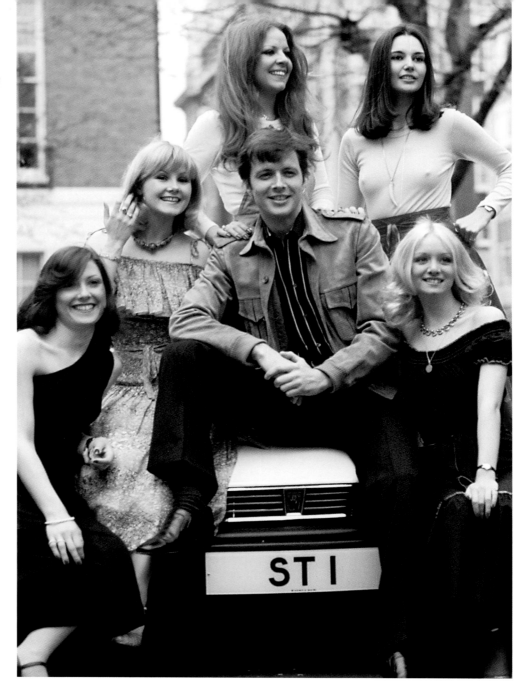

STI

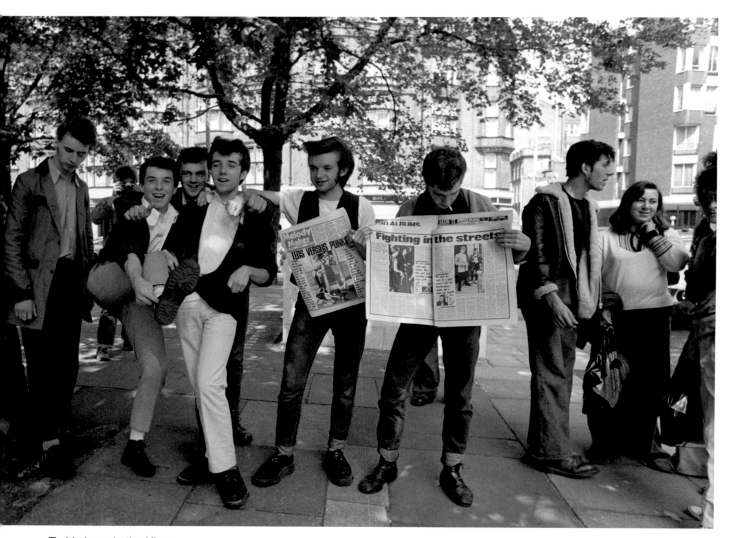

Teddy boys in the Kings
Road, Chelsea, read about
their battles with punk
rockers.
30th July, 1977

Sid Vicious (L) and Johnny Rotten, members of the controversial punk rock group The Sex Pistols, at London's Heathrow Airport before leaving for Luxembourg. As they walked to their aircraft, they hurled abuse at reporters and photographers.
3rd November, 1977

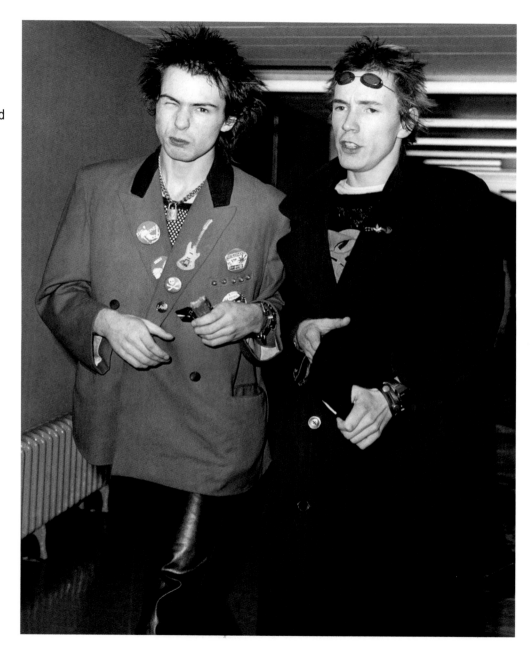

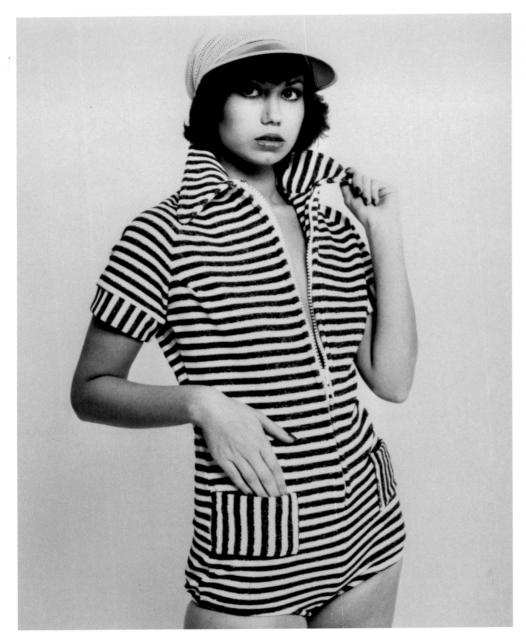

Entitled 'Hawaii', this terry towelling striped jumpsuit is from the Sunarama collection for 1978.

8th November, 1977

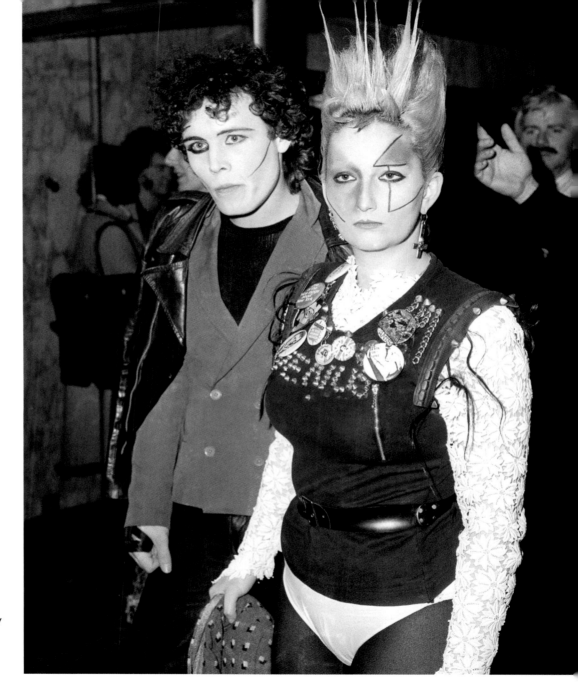

Punk Rockers Adam Ant and Jordan attending the movie premiere of *Saturday Night Fever* at the Empire, Leicester Square.
23rd March, 1978

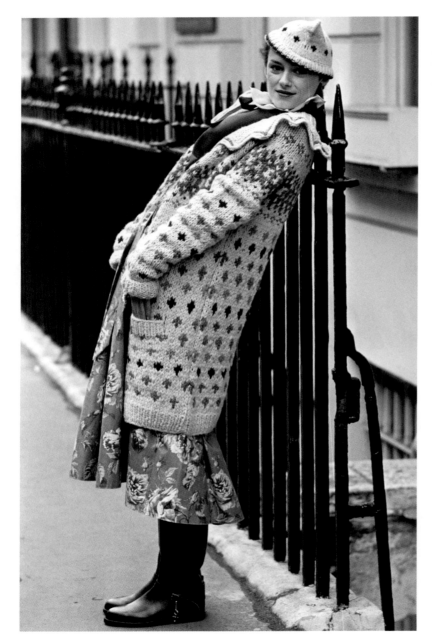

Pure wool hand-knits,
ribbed cord, chintz
and leather from
the Sarah-Jane Owen
autumn collection.
18th April, 1978

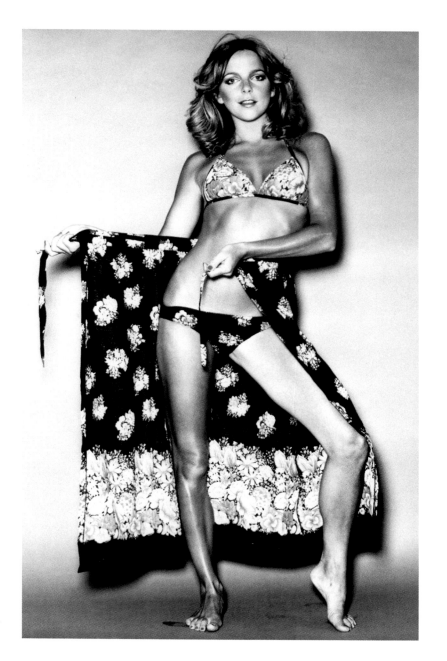

A flower print bikini with
matching wrap-around skirt.
12th October, 1978

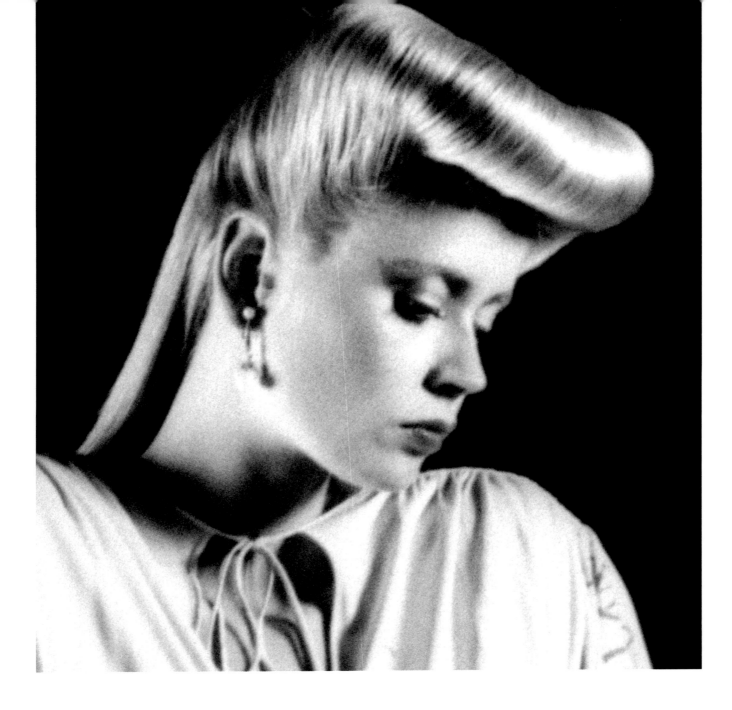

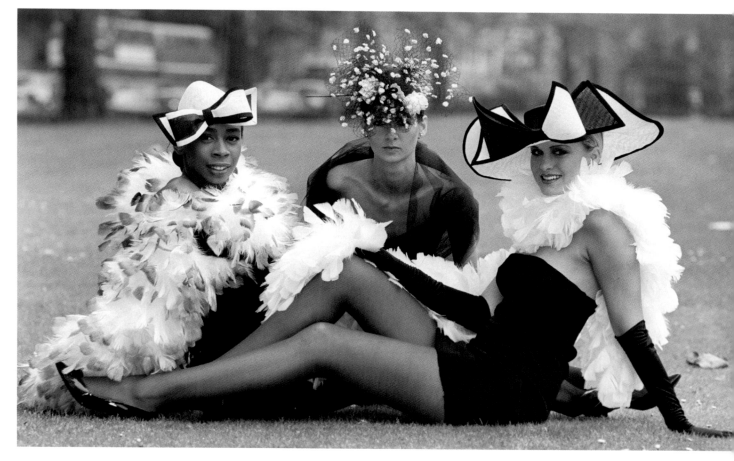

The new season's hats from David Shilling are named with Ascot in mind – (L-R) 'Double Forecast', 'Dotty Runner' and 'First Past the Post'.
1st June, 1980

Facing page: An adaptation of a 1940s hairstyle.
16th February, 1980

Kevin Keegan models
a Shetland wool v-neck
pullover with the KK
emblem, part of the Kevin
Keegan collection sold at
Harry Fenton menswear
shops. The pullover retailed
at £7.99.

1st September, 1980

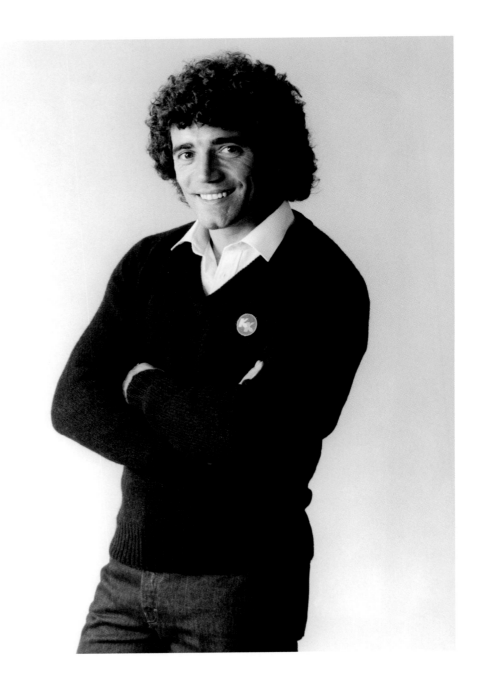

Nappa leather and velour suits from the Gucci autumn and winter collection.
26th November, 1980

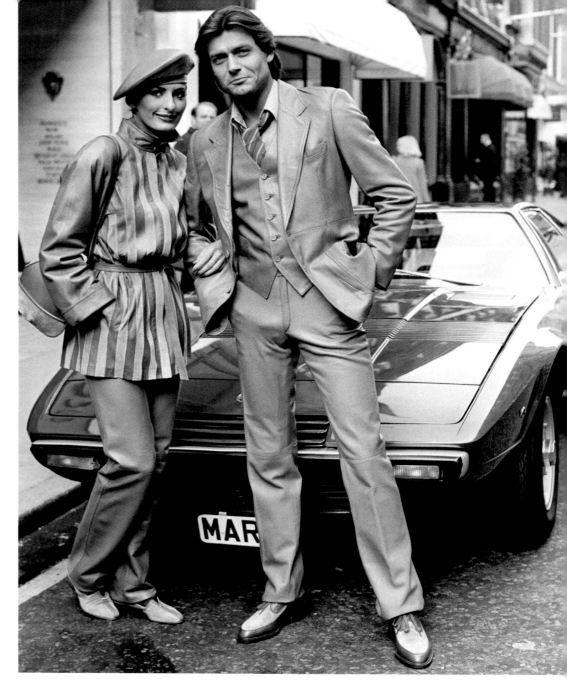

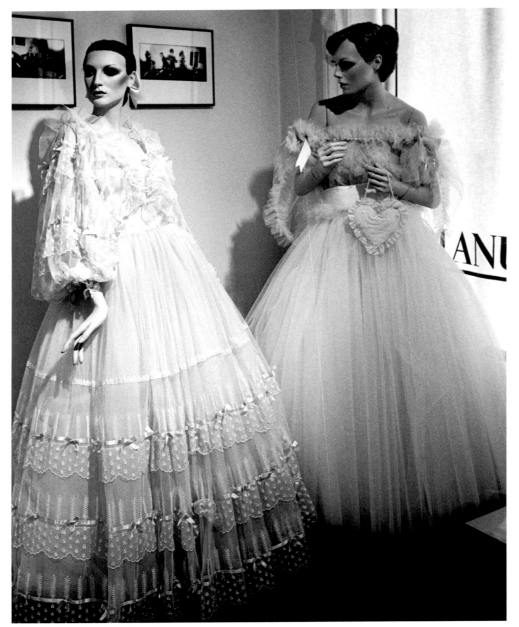

Facing page: The Princess of Wales in her wedding dress at Buckingham Palace. **29th July, 1981**

Dresses by David and Elizabeth Emanuel, the designers of Princess Diana's wedding dress. **26th March, 1981**

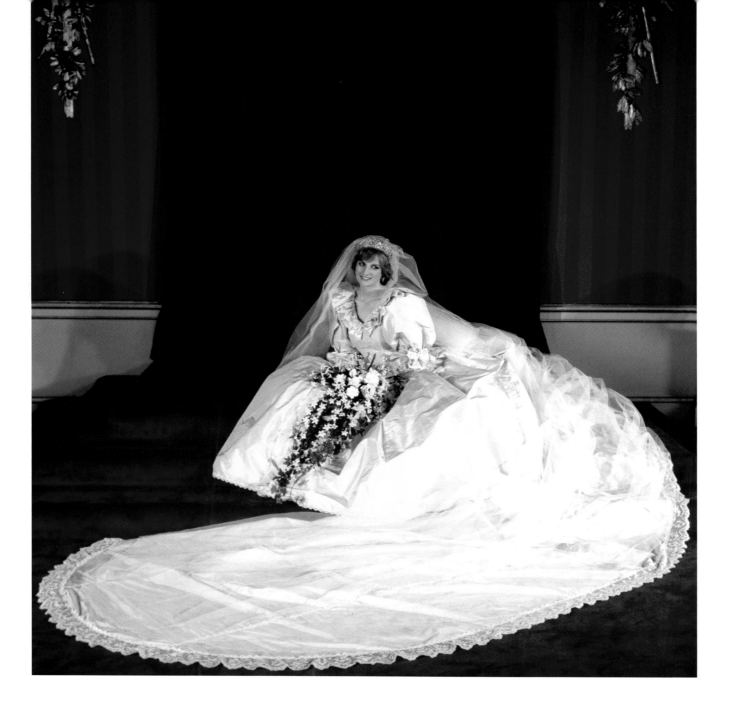

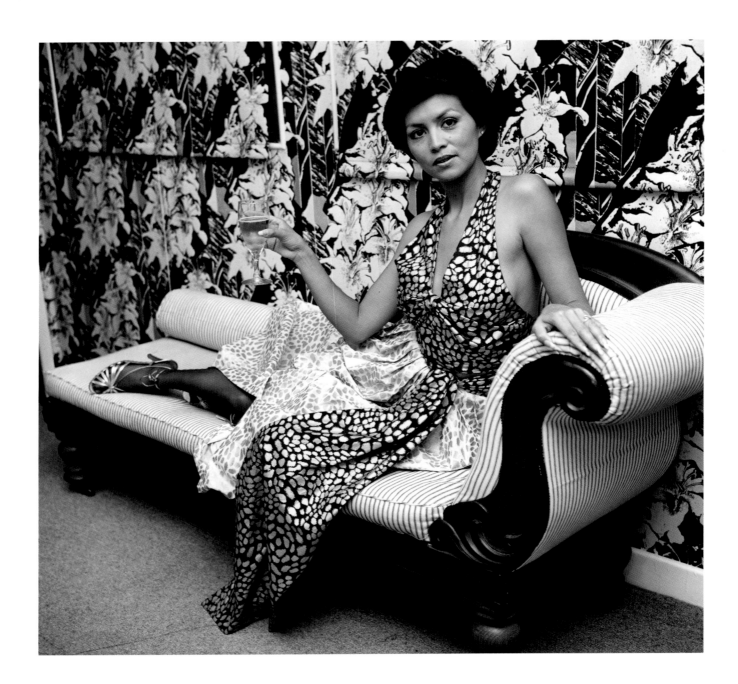

Facing page: American model Angela White in a Thea Porter dress at the launch of the designer's collection. The outfit has a halter-neck top and front slit skirt.

12th October, 1981

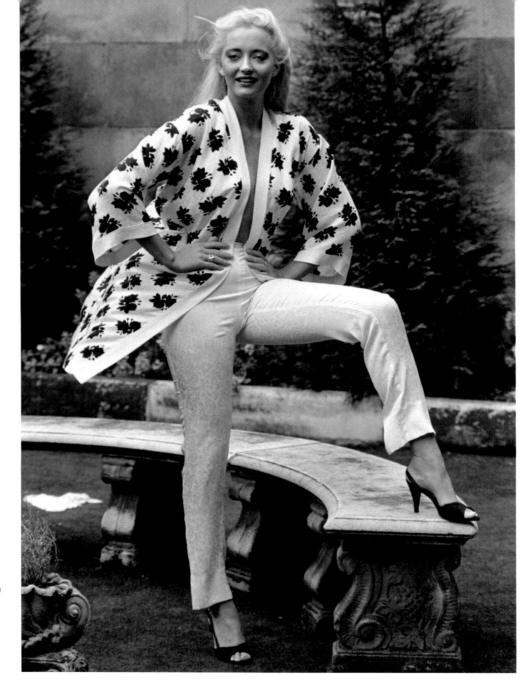

Trouser suit with kimono top by Gucci, shown at the Ritz Casino Garden in London as part of the Gucci spring collection.

2nd November, 1981

Sarah Brightman, pop singer
and ex-Hot Gossip dancer,
wears a hand-painted chiffon
and studded leather outfit in
red by Sasha Hetherington.
30th November, 1981

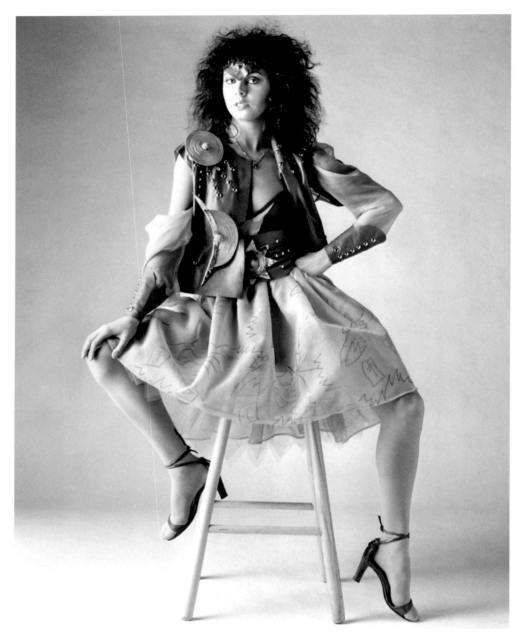

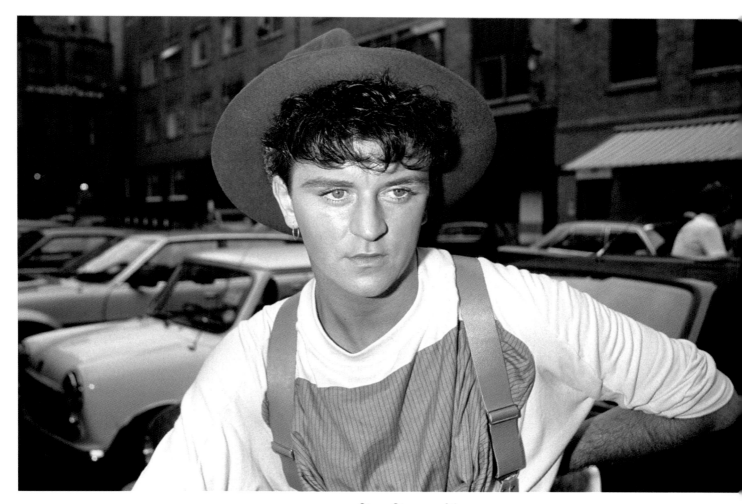

Steve Strange of the pop
group Visage.
8th September, 1982

Lena Masterton, the reigning Miss Scotland, wears multi-coloured knitwear by Raiment of Edinburgh, shown at the Scottish Development Agency's Trade Development Centre in London as part of a 'Scotland in London' promotion.

19th January, 1983

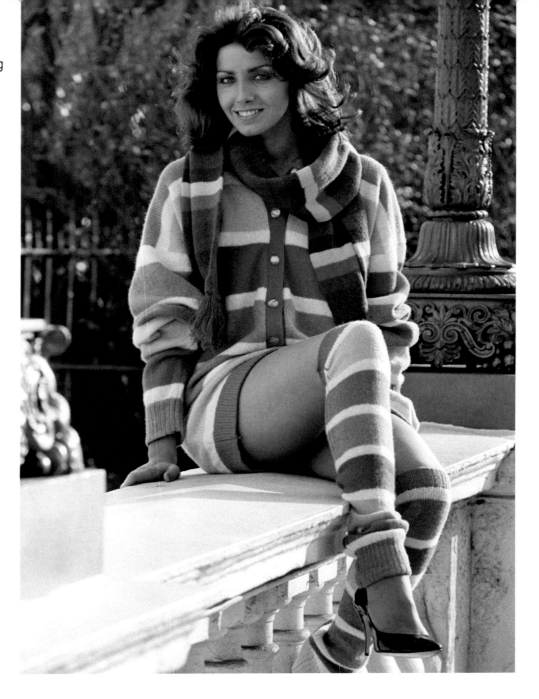

A futuristic outfit in waterproof silk by Maoro Benedetti (L), and a gilet and mini-skirt with matching boots in Tuscan lambswool by Rufus for Florence (R), shown at the Tuscany Fashion Show.

21st February, 1983

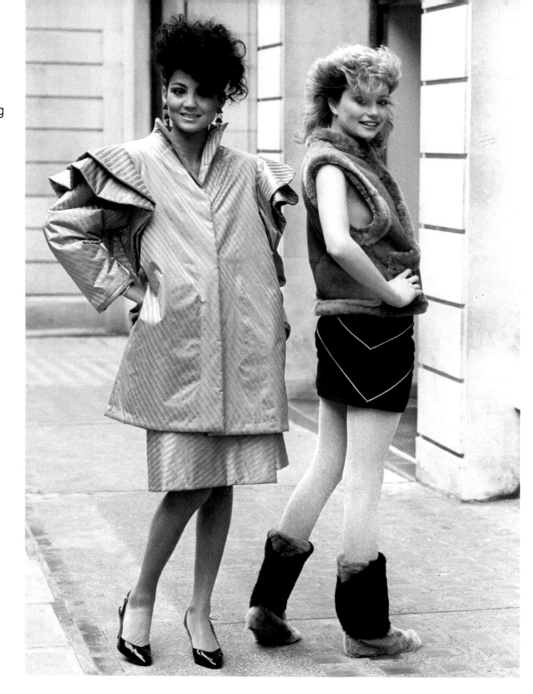

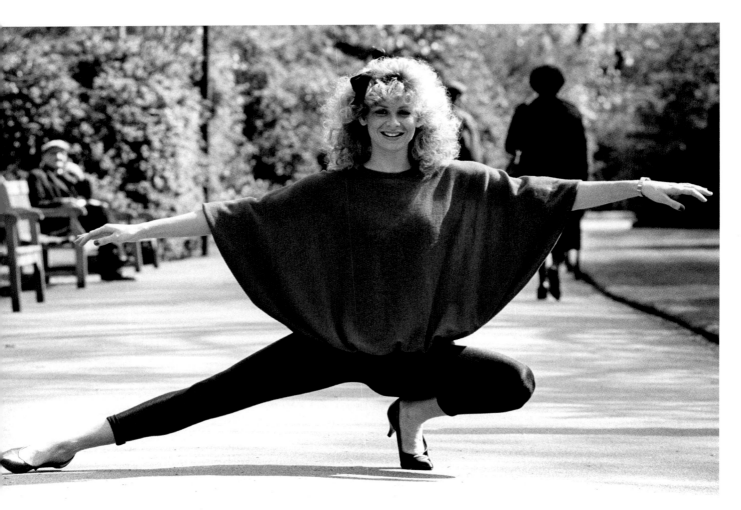

Batwing sleeve sweater and
leggings, part of a collection
from Finland being shown in
London.
11th May, 1983

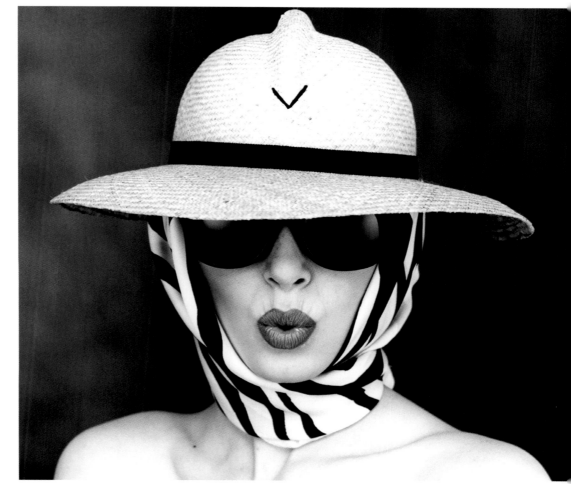

Safari style hat by student Josephine Mary Hudson of Epsom School of Art and Design, who was among the winners of the Young Designers of Great Britain competition. The hat was copied and incorporated into the British Home Stores spring range, and sold at £4.99.

11th May, 1984

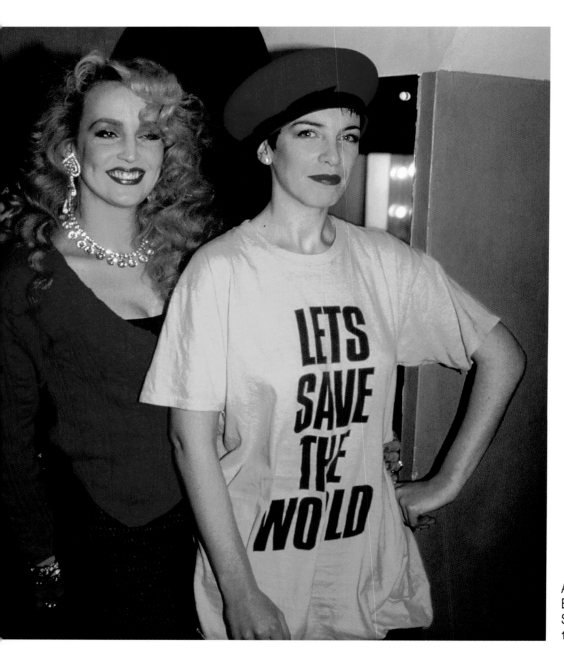

Annie Lennox of the Eurhythmics wearing a 'Let's Save the World' t-shirt.
1985

Dolman sleeve tops figure strongly in the fashion show at the Scottish Development Agency's Trade Development Centre in London.
4th February, 1985

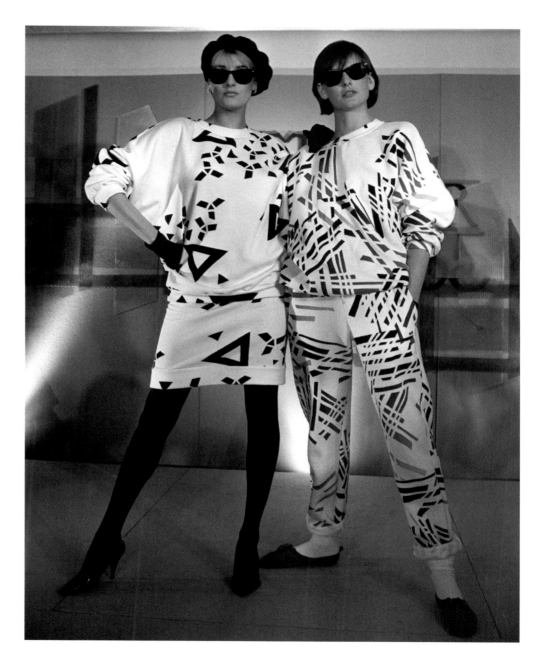

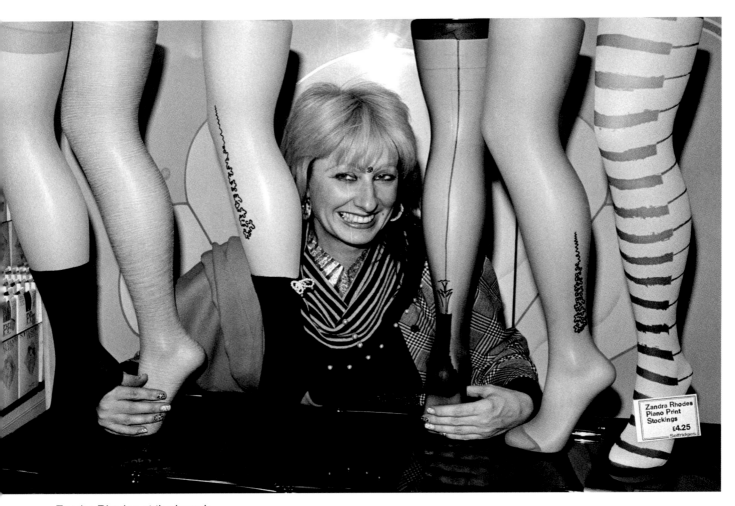

Zandra Rhodes at the launch
of her own line of hosiery at
Selfridges in London.
1st April, 1985

A fantasy dress from Koji's collection in wool and cashmere, with ribbon sleeves, by Reid and Taylor. The wools include fleece from Ross-shire Blue Cheviot sheep. Shown at the Festival Fashion Show in Edinburgh.
21st September, 1985

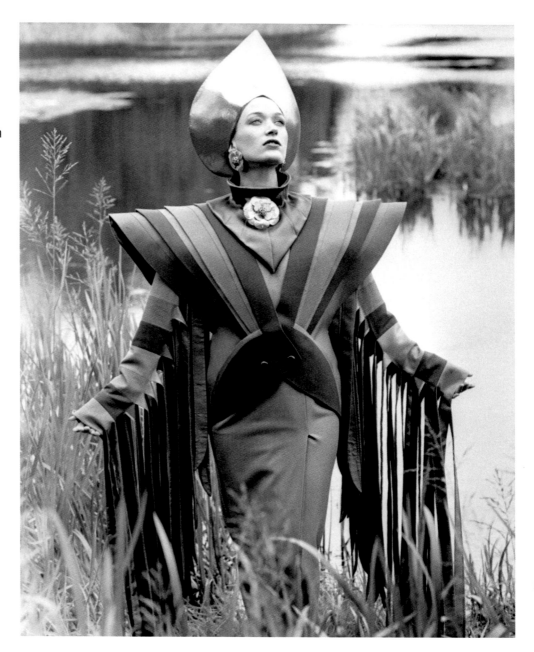

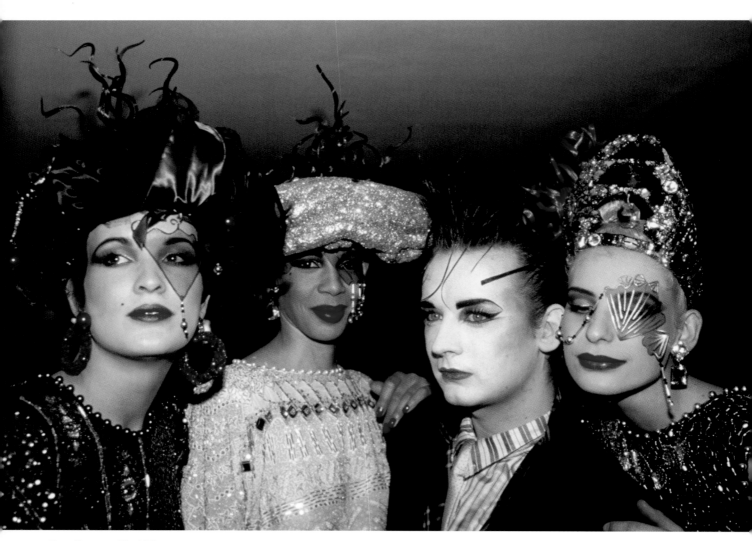

Boy George (2nd R)
and friends backstage.
5th November, 1985

The Princess of Wales, in a man's style tuxedo with scarlet bow tie, during the 'thank you' party thrown by the Royal couple at a London West End recording studio for pop stars who donated tracks to a charity record in aid of the Prince's Trust.

19th November, 1985

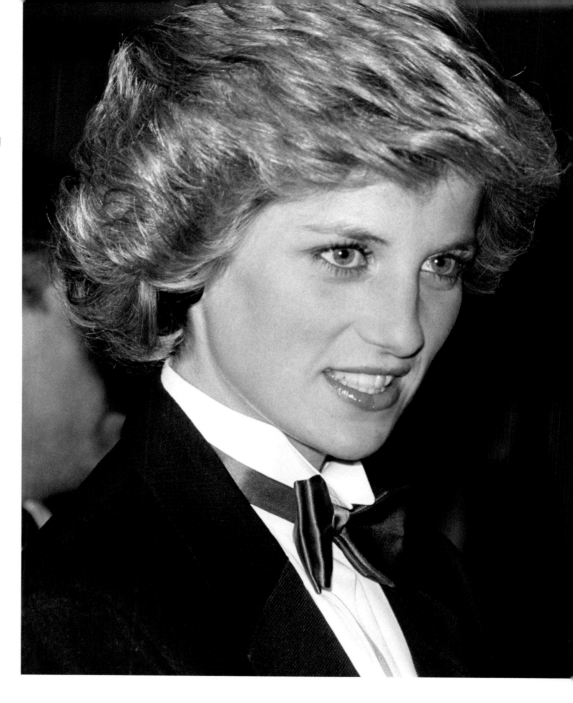

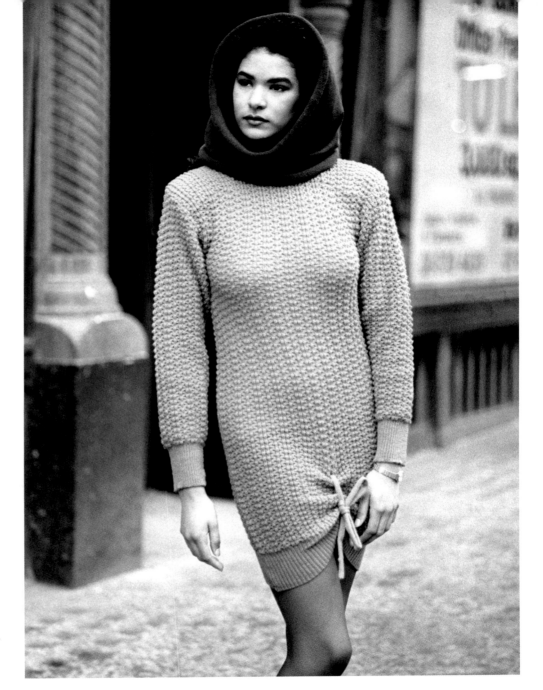

Botany wool tunic sweater
and cowl in orange and
purple by Jane Jeffrey of
Strathclyde, shown at the
Scottish Designer Knitwear
Show in London.
14th January, 1986

A brown leather blouson jacket with saga mink, designed by Lynne Butcher of Harrow College of Higher Technology, won an award in the Saga Designs competition, which had the theme 'Fashionable Furs for Today's Lifestyles'.
3rd February, 1986

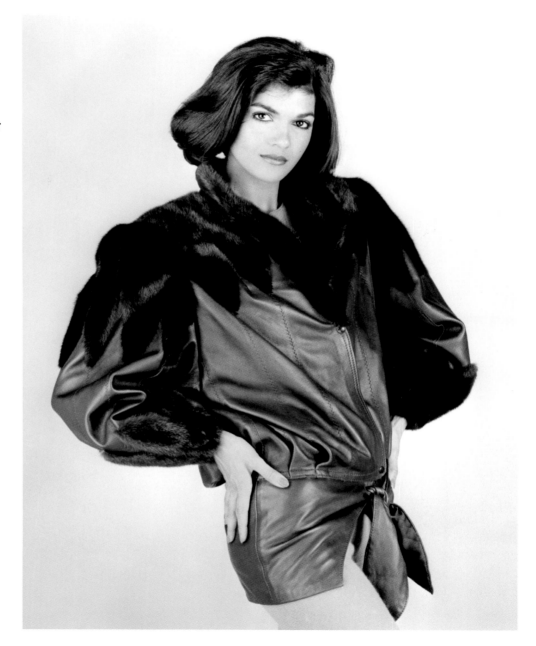

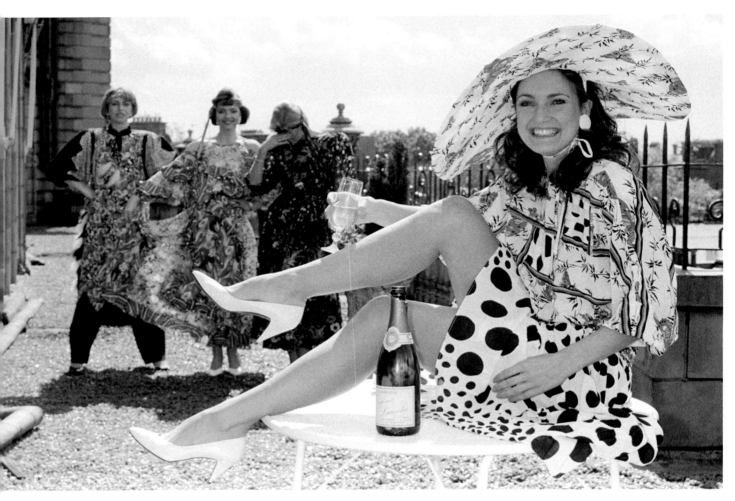

Heavily patterned dresses
shown at Harrods of
Knightsbridge. The dress in
the foreground sold at £249
– expensive for its time.
13th June, 1986

Facing page: Hat with
'diamond' peephole by
milliner Phillip Somerville
worn with yellow diamond
pendant from Cartier costing
£1.6m.
16th July, 1987

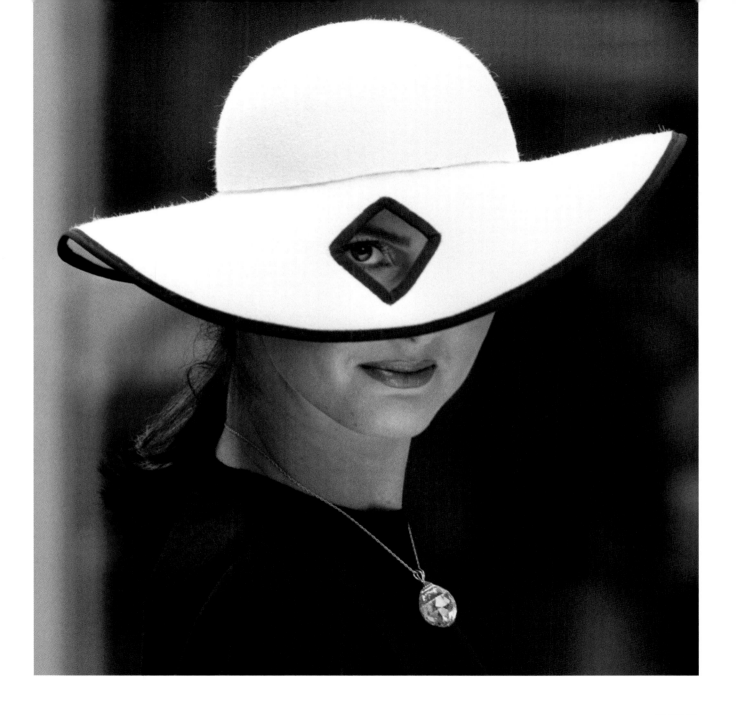

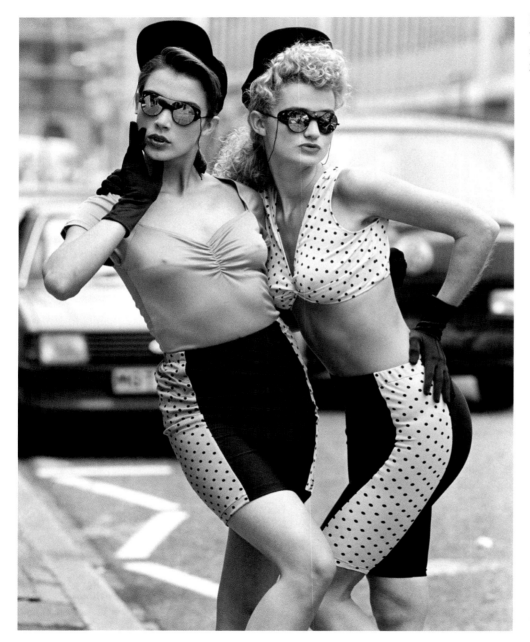

Figure-hugging Lycra in
vibrant colours from Kumar's
summer collection.
28th April, 1988

Black and white check
jacket with narrow skirt
from the London launch of
Louis Féraud's collection for
autumn/winter.
28th February, 1989

Dress by Debbie Moore
for Pineapple.
27th April, 1989

100 Years of Fashion • Twentieth Century in Pictures

Recording artist and entertainer, Madonna, performing to a crowd of 74,000 fans at Wembley Stadium, in London.
20th July, 1990

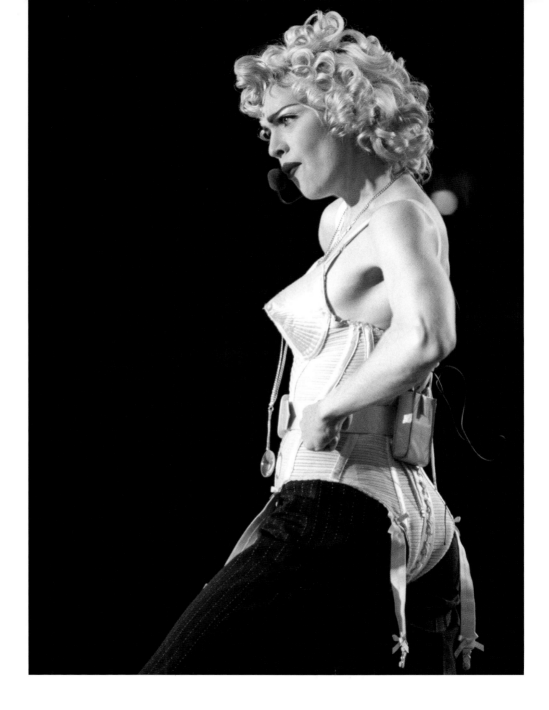

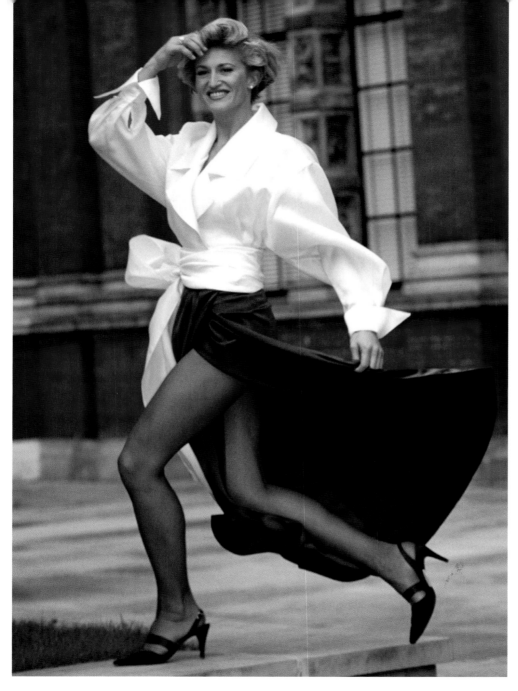

An outfit from designer
Amanda Wakeley, shown
at the Lloyds Bank Fashion
Awards nominations in
London.
28th September, 1992

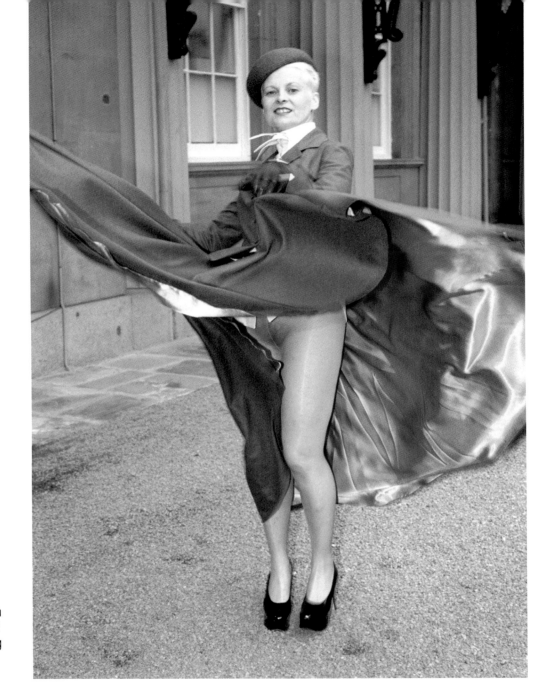

Designer Vivienne
Westwood at Buckingham
Palace to collect her OBE
from the Queen – wearing
no underwear!
15th December, 1992

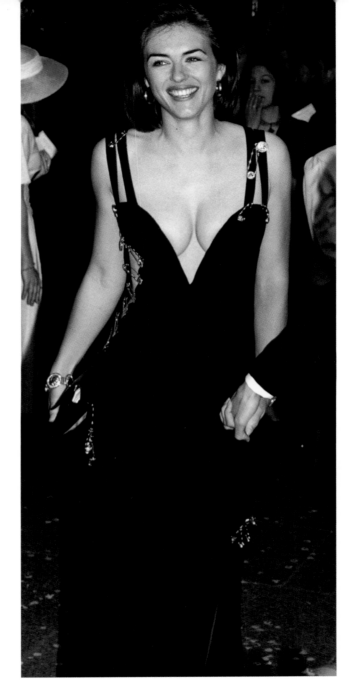

Actress and model Liz Hurley in a dress by Versace, arriving for the charity premiere of the film *Four Weddings and a Funeral*. "*That dress was a favour from Versace because I couldn't afford to buy one. His people told me they didn't have any evening wear, but there was one item left in their press office,*" said Hurley of the event. 'That dress' landed her the position as the face of Estée Lauder.

11th May, 1994

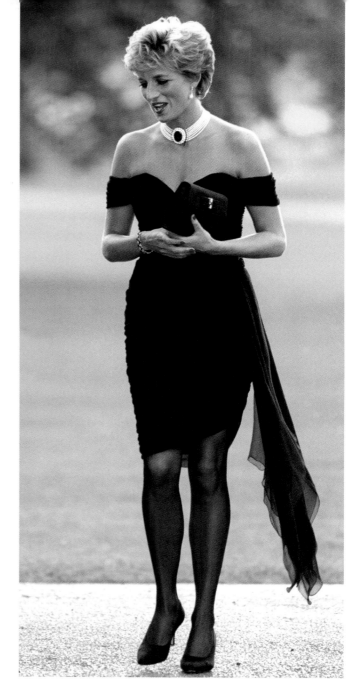

Diana, Princess of Wales, wearing a black pleated chiffon dress, with floating side panel, by Christina Stamboulian, during a party given at the Serpentine Gallery in London.
29th June, 1994

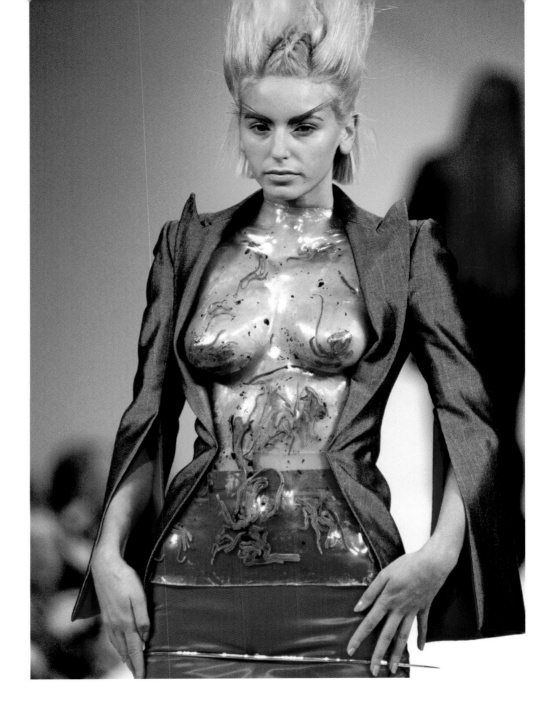

An outfit from designer
Alexander McQueen
on show at London
Fashion Week.
13th March, 1995

Alternative Fashion Week kicks off at Old Spitalfields Market in London with 'Recycle Redress Rethink' by the year's organizers, Oxfam.

18th March, 1986

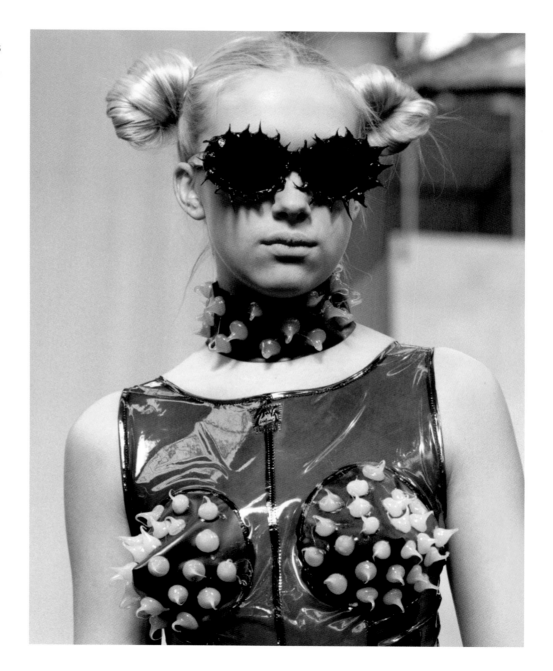

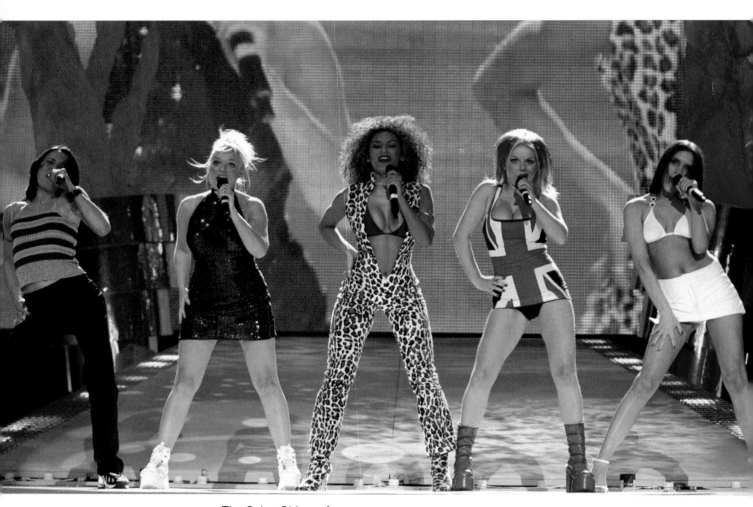

The Spice Girls perform
on stage at the Brit Awards
ceremony.
24th February, 1997

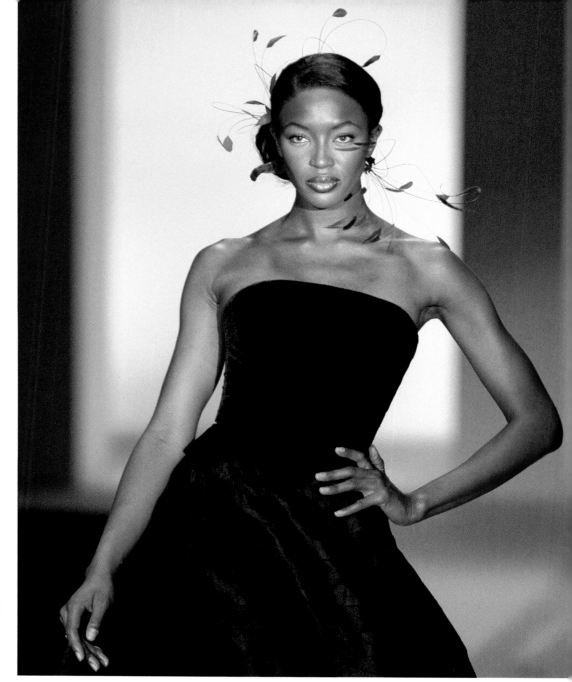

Naomi Campbell in a blue velvet evening dress, with feather headdress, designed by Jasper Conran, on the fifth day of London Fashion Week.

27th February, 1997

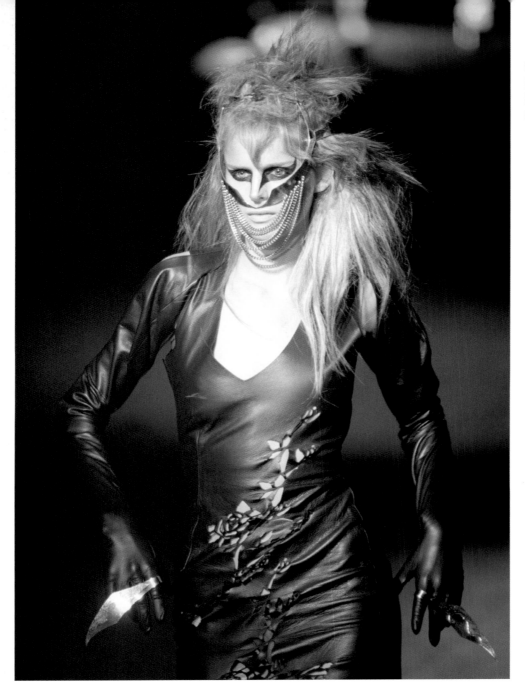

Slashed leather and chains
by Alexander McQueen at
London Fashion Week.
27th February, 1997

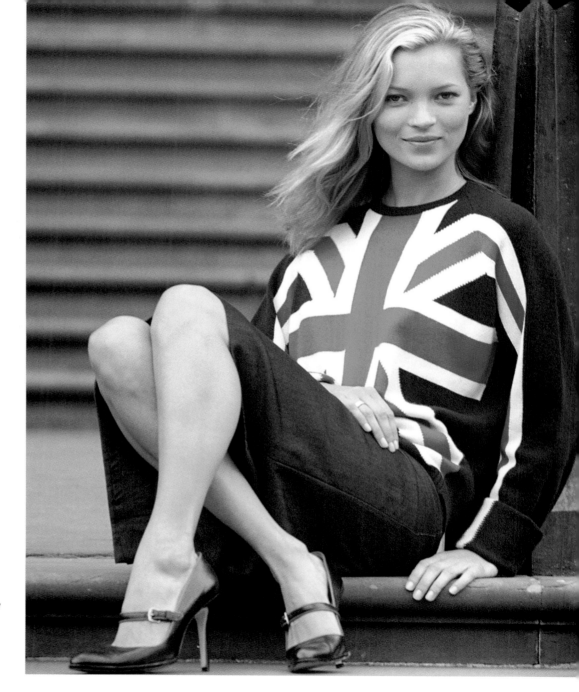

Supermodel Kate Moss poses for the media on the steps of the Natural History Museum in London for the start of London Fashion Week.

25th September, 1997

Supermodel Sophie Dahl takes part in a unique Virtual Art Gallery, inspired by and using Oil of Ulay's new Colour Collection cosmetics at the ICA in London. Ms Dahl was an integral part of the installation of Nina Saunders' conceptual art piece – three extravagantly holstered chairs using cosmetic powder puffs and interesting fabrics, plus a white leatherette foot stool elaborately embroidered with the words 'Sit on me'.

20th October, 1997

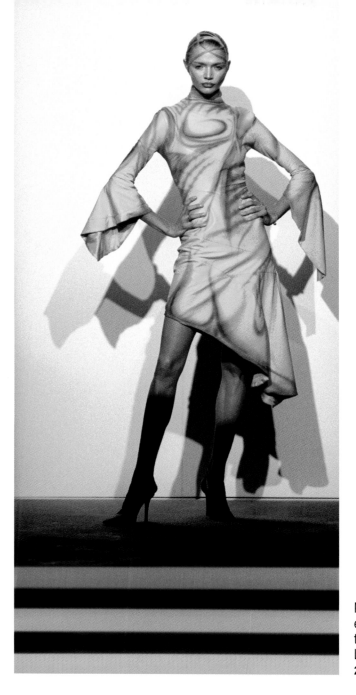

Model Jodie Kidd makes her entrance on the catwalk for the Tristan Webber show for London Fashion Week.
27th September, 1998

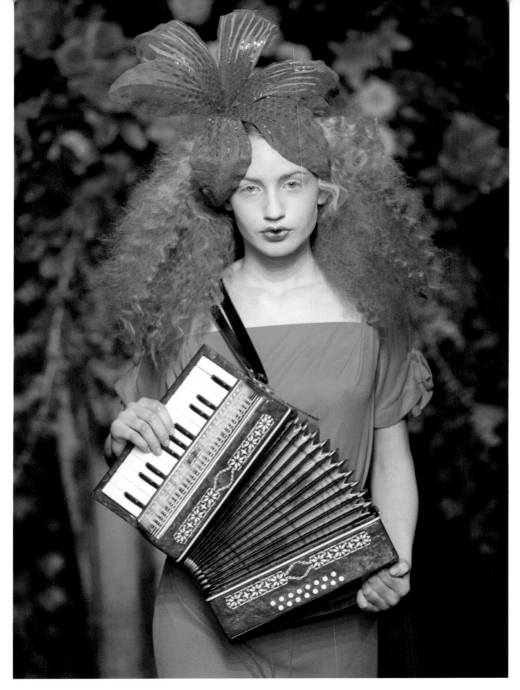

Facing page: Former boxing champion Chris Eubank modelling tartan trousers and feather top by Vivienne Westwood at the Scottish Exhibition and Conference Centre in Glasgow.
29th January, 1999

Elizabeth Jagger, daughter of Mick Jagger and Jerry Hall, makes her London catwalk debut at the Vivienne Westwood Red Label show for London Fashion Week.
27th September, 1998

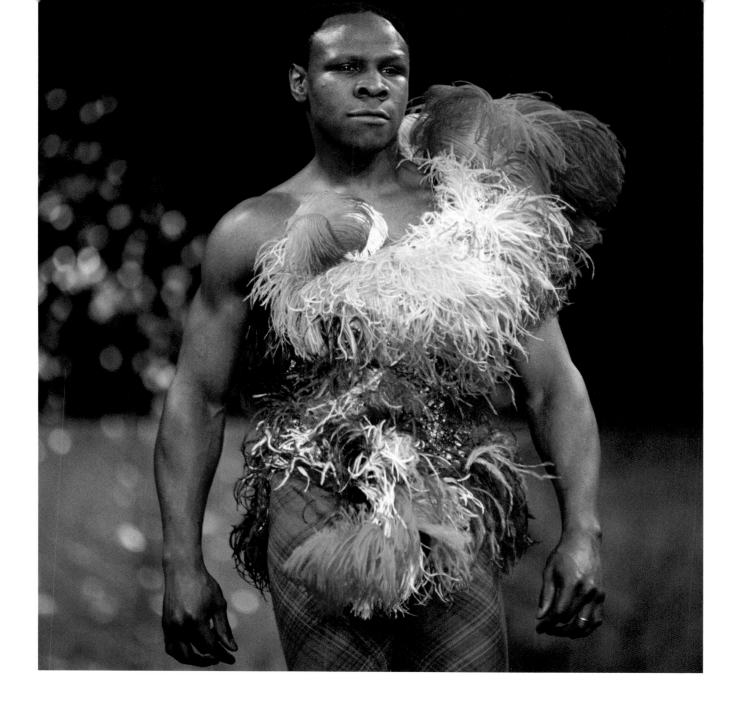

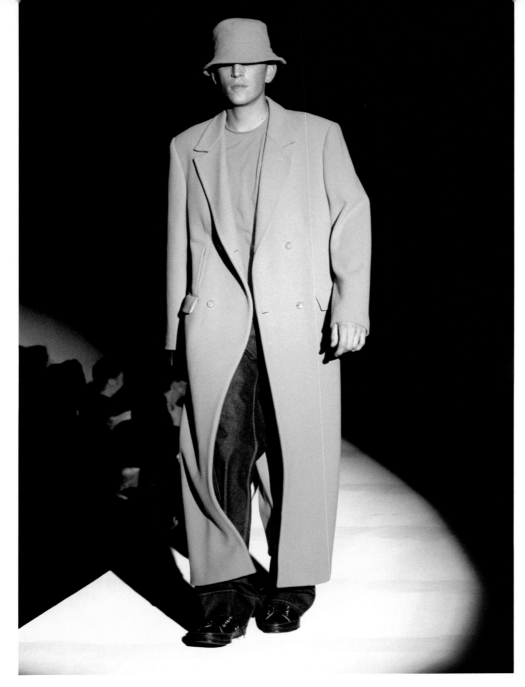

Facing page: Actress and singer Grace Jones models a hat by Philip Treacy at London Fashion Week.
21st February, 1999

Long coat over pink t-shirt and jeans by John Richmond, shown at the Royal Horticultural Halls in London for Men's Fashion Week.
2nd February, 1999

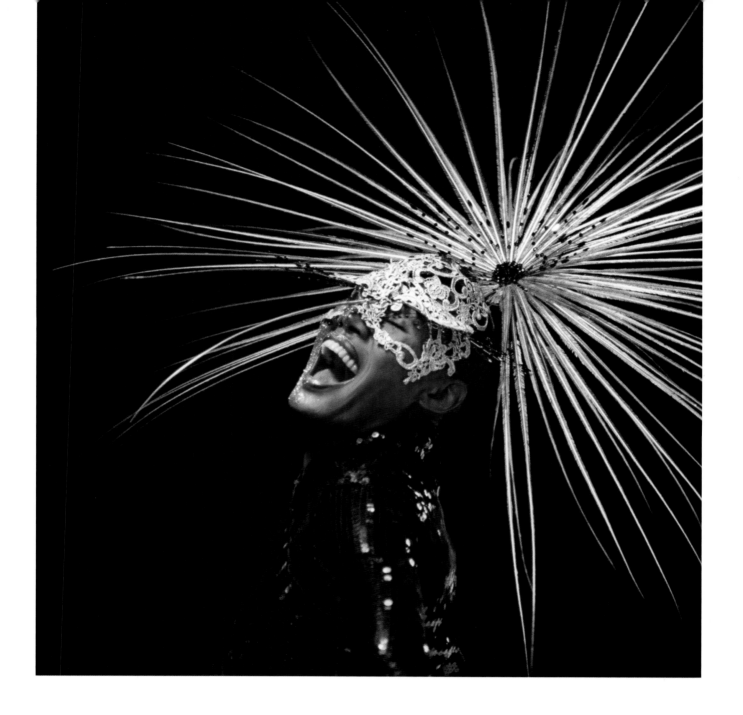

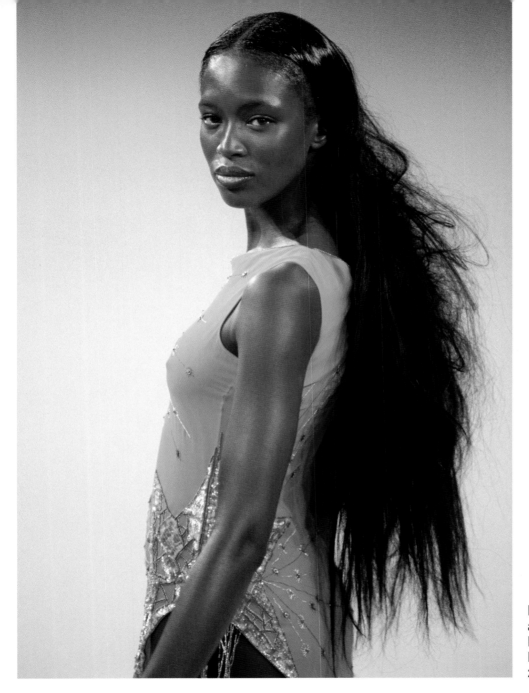

Naomi Campbell wearing
a dress by British designer
Matthew Williamson, during
London Fashion Week.
23rd February, 1999

Model Sophie Anderton
arrives at the Natural History
Museum in London for the
British Fashion Awards,
wearing a black Chloe
dress designed by Stella
McCartney.
17th March, 1999

Hat designer Philip Treacy and fashion guru Isabella Blow arriving at the Natural History Museum in London for the British Fashion Awards. Ms Blow wears Givenchy Couture designed by Alexander McQueen.
17th March, 1999

Oscar nominee actress Cate
Blanchett arrives at the 71st
Annual Academy Awards
in Los Angeles, California,
wearing a dress by John
Galliano.
22nd March, 1999

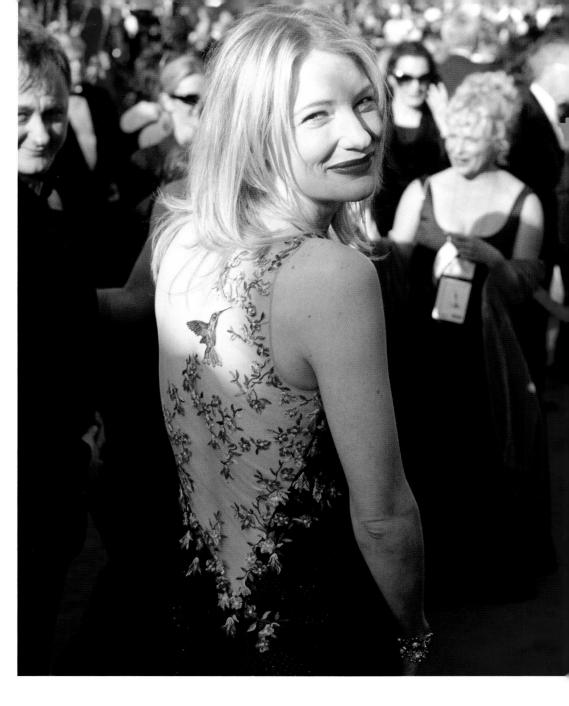

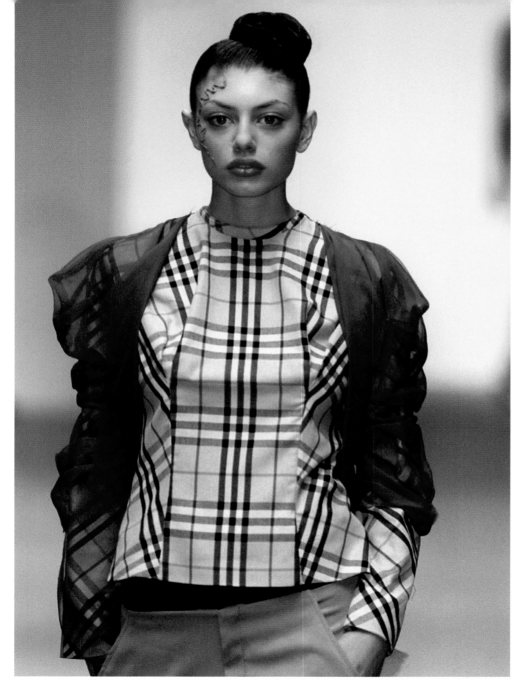

Fashion by Burberry at the autumn/winter 2000 show, part of London Fashion Week.
16th February, 2000

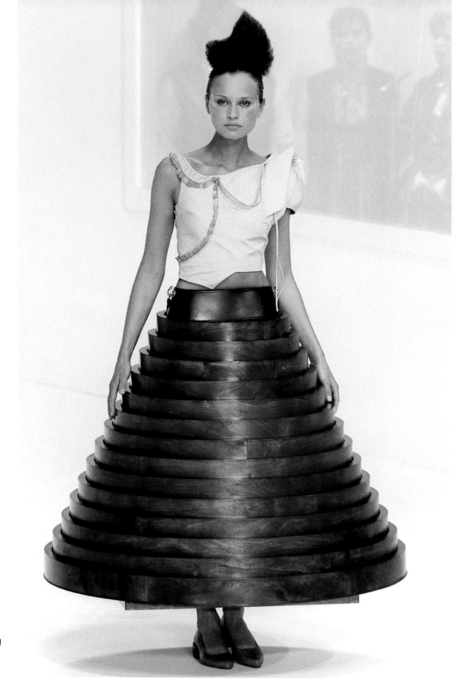

A wooden skirt by designer
Hussein Chalayan at London
Fashion Week.
16th February, 2000

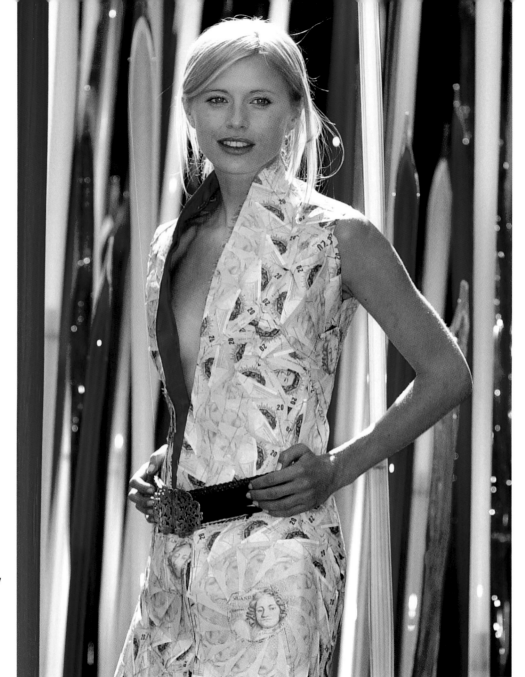

Top model Laura Bailey at the Victoria & Albert Museum, wearing a dress covered in banknotes to the value of £6,000. The money garment, designed by Russell Sage, was donated to the Museum by Britannic Money who provided the £20 and £50 banknotes that make up the dress.
12th July, 2001

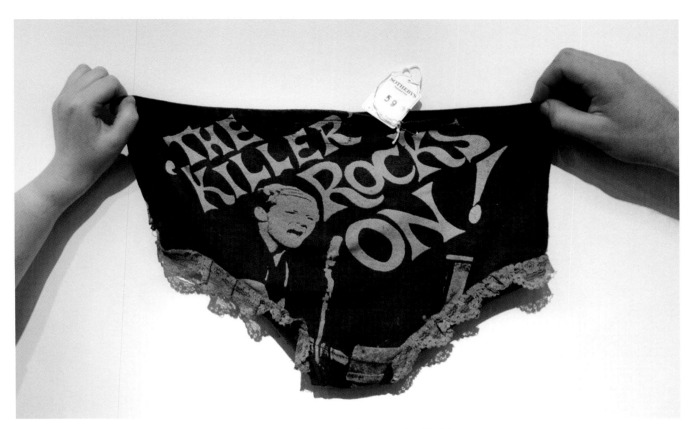

A rare pair of knickers
designed by Vivienne
Westwood and Malcolm
McLaren, at the Olympia
auction house saleroom in
London.
16th September, 2001

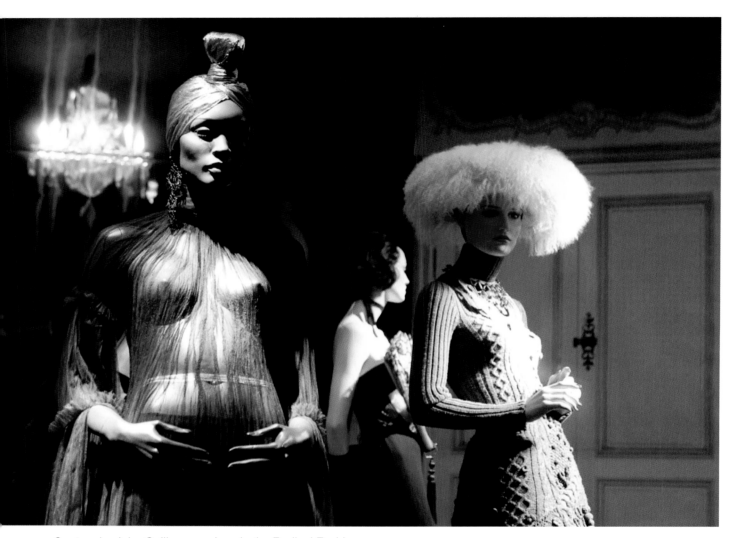

Couture by John Galliano on show in the Radical Fashion
exhibition, which celebrated the work of eleven cutting edge
fashion designers at the Victoria and Albert Museum.
16th October, 2001

Dress by Betty Jackson
shown on the catwalk at
London Fashion Week.
18th February, 2003

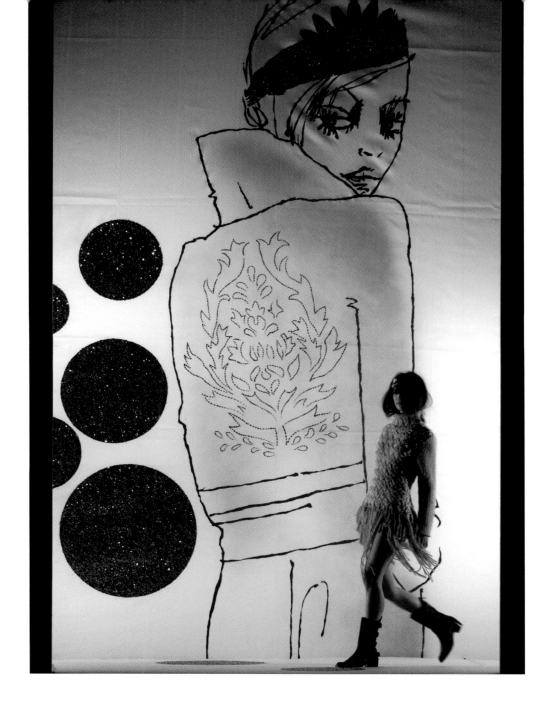

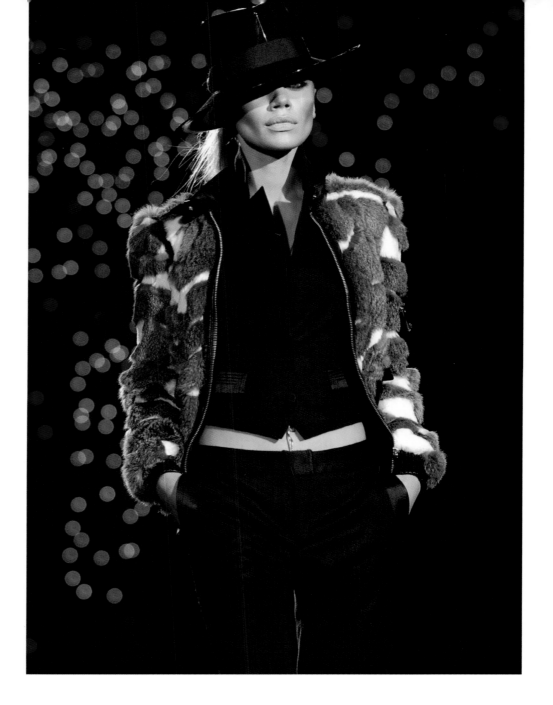

A catwalk model at the
Julien McDonald Fashion
Show, part of London
Fashion Week.
19th February, 2003

Singer Ms Dynamite
performing on stage during
The Brit Awards 2003 at
Earls Court 2, London.
20th February, 2003

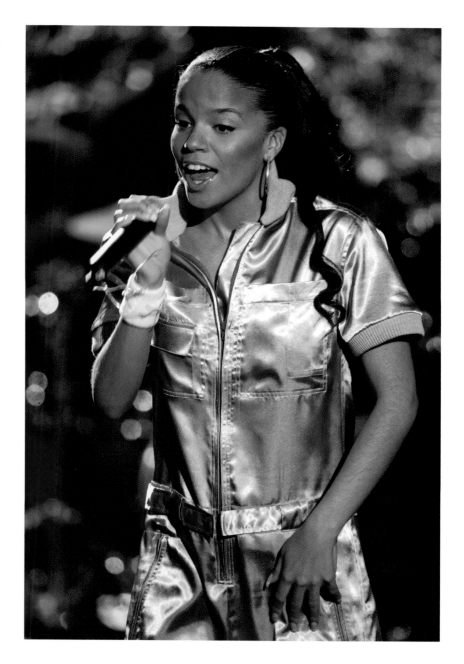

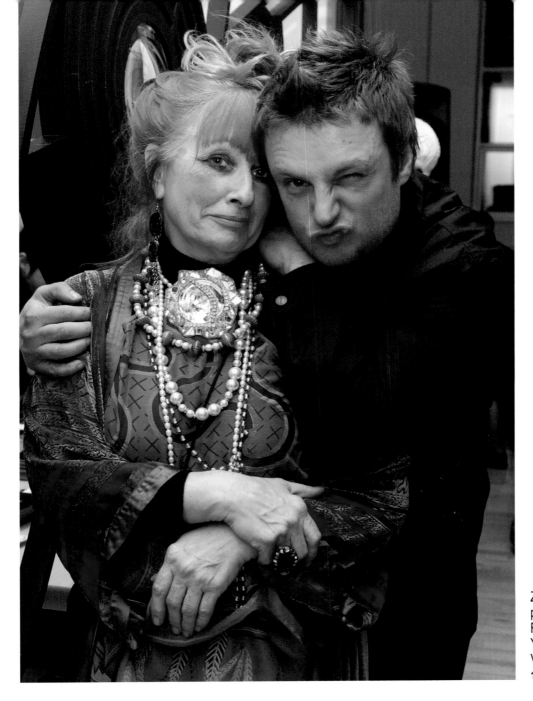

Zandra Rhodes with
photographer Rankin at the
Re-Creation Awards for
Young Creative Talent at the
Victoria and Albert Museum.
19th March, 2003

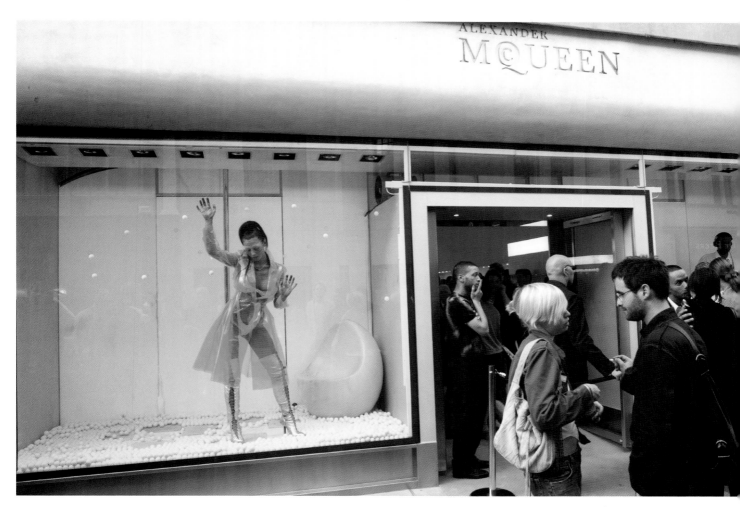

Alexander McQueen's new store in Old Bond Street, London.
7th May, 2003

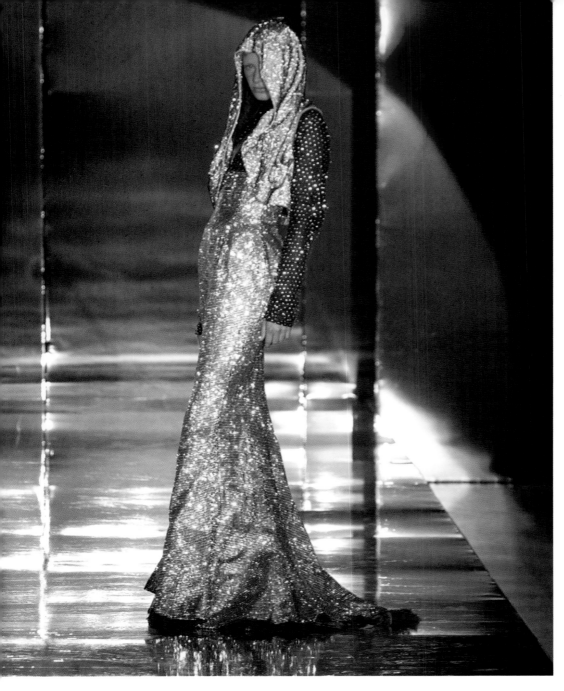

A design by Vivienne Westwood shown during her 'Fashion in Motion' show at the V&A to complement a major exhibition of her work at the Museum.
30th April, 2004

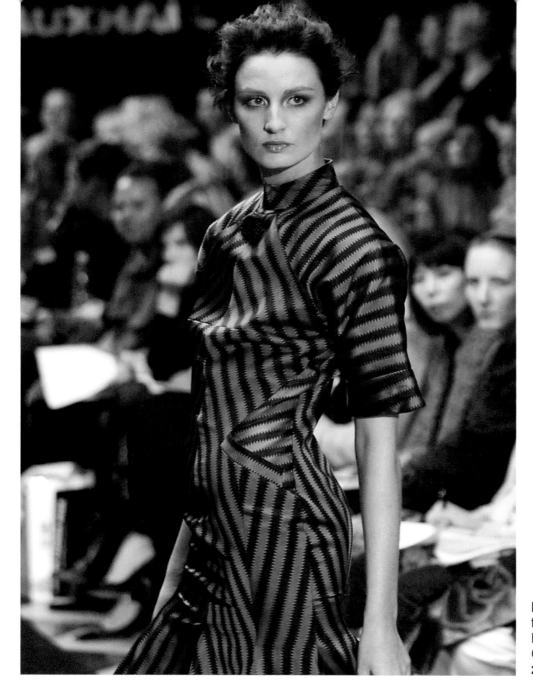

Model Erin O'Connor on
the catwalk during London
Fashion Week in a dress by
Giles Deacon.
20th September, 2004

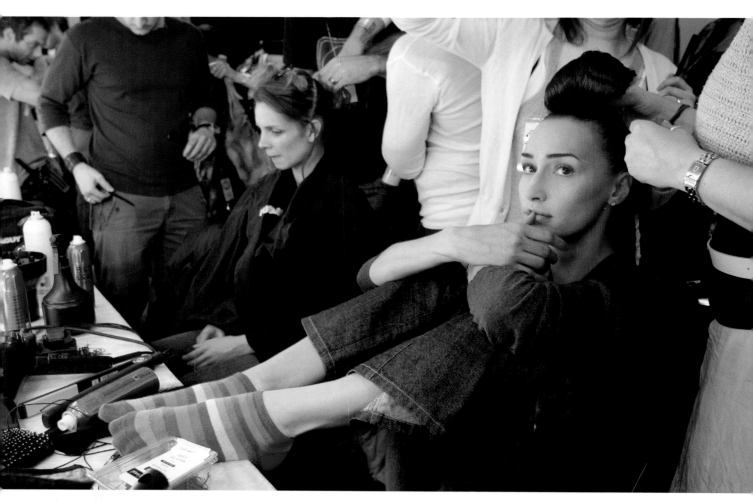

A model backstage during the Basso & Brooke London
Fashion Week autumn/winter 2006 show at BMW
Westminster, in Marsham Street.
13th February, 2005

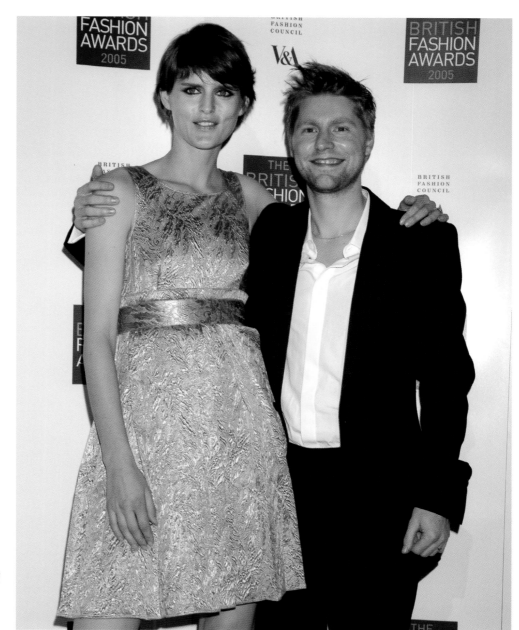

Scottish model Stella
Tennant with designer
Christopher Bailey during
the British Fashion Awards
that celebrate the creativity
and international influence of
British design, at the Victoria
& Albert Museum.
10th November, 2005

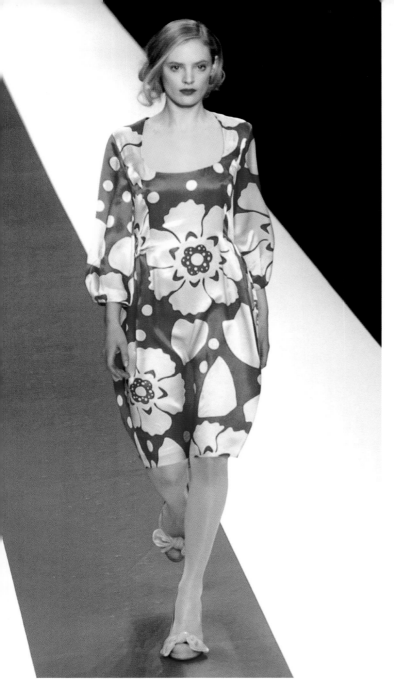

Dress by Betty Jackson
shown during the designer's
London Fashion Week
autumn/winter show.
16th February, 2006

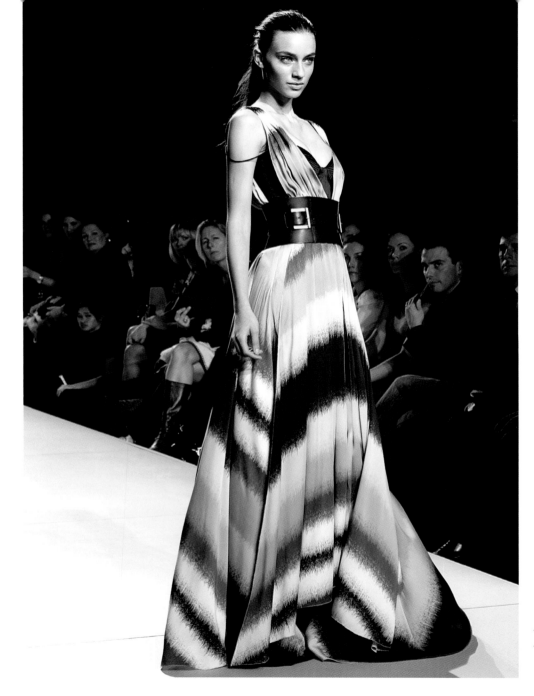

A model wears a dress by Amanda Wakeley at London Fashion Week.
13th February, 2007

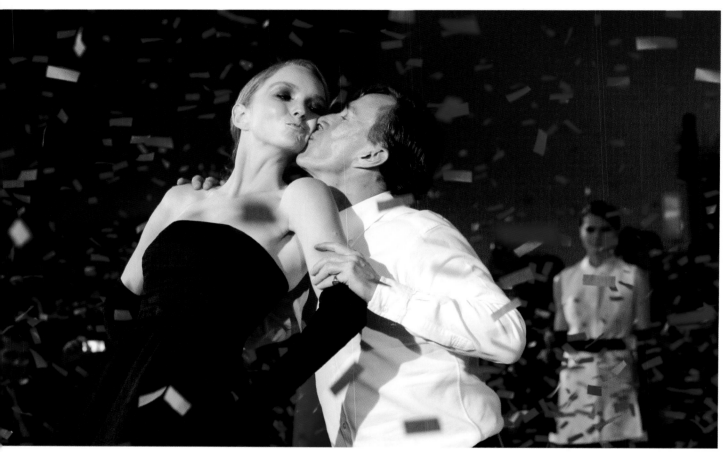

Designer Jasper Conran
kisses a model during his
London Fashion Week
autumn/winter 2007 catwalk
show at the Royal Academy
of Arts in central London.
14th February, 2007

Facing page: Boots by Betty
Jackson, shown at London
Fashion Week.
12th February, 2008

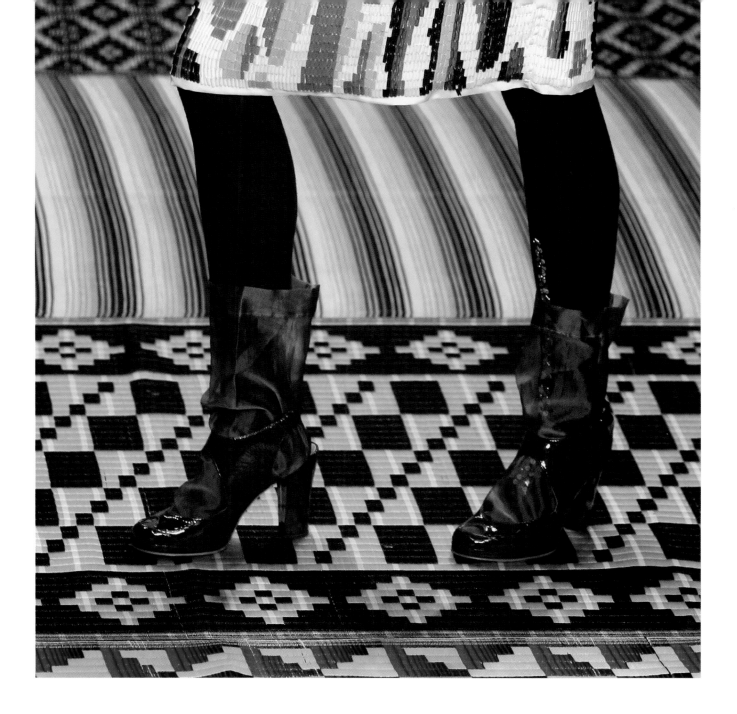

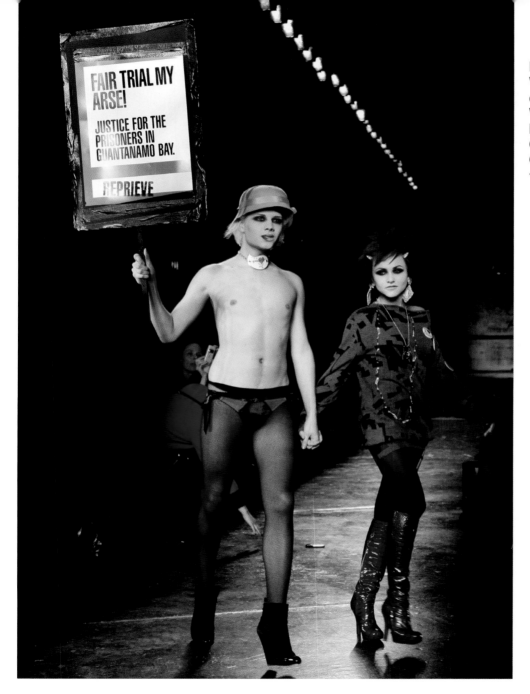

British actress Jaime Winstone (R) wears a creation by Vivienne Westwood Red Label, during London Fashion Week at the Old Sorting Office in New Oxford Street.
14th February, 2008

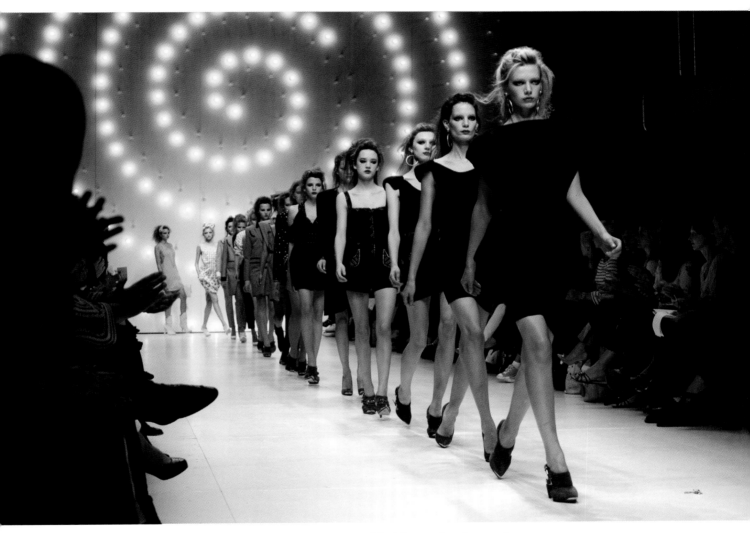

Models wearing dresses by
Topshop Unique, a range
from the high street store
Topshop, during London
Fashion Week.
14th September, 2008

Outfit by Paul Smith, shown at London Fashion Week at the Claridges Ballroom, London.
15th September, 2008

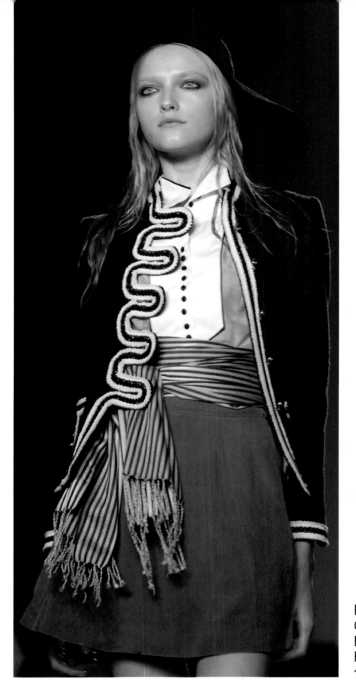

Facing page: Helmet by Giles, shown during London Fashion Week at The Milk Factory in central London.
16th September, 2008

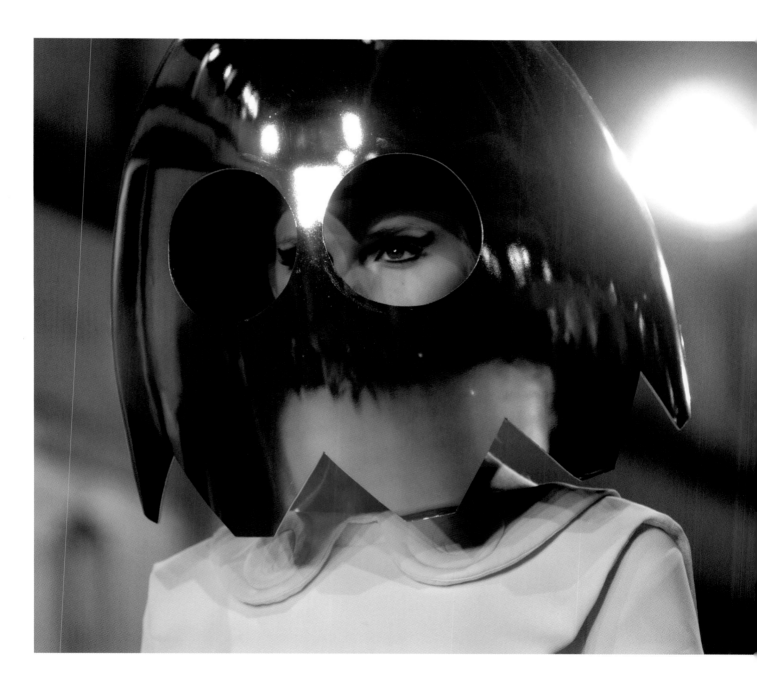

The Publishers gratefully acknowledge Press Association Images, from whose extensive archives the photographs in this book have been selected. Personal copies of the photographs in this book, and many others, may be ordered online at www.prints.paphotos.com

For more information, please contact:

Ammonite Press

AE Publications Ltd, 166 High Street, Lewes, East Sussex, BN7 1XU, United Kingdom
Tel: +44 (0)1273 488006 Fax: +44 (0)1273 472418
www.ammonitepress.com